WE ARE THE REAL-TIME EXPERIMENT

FACT
[Foundation for Art
and Creative Technology]

First published 2009 by FACT
(Foundation for Art and Creative Technology)
88 Wood Street
Liverpool, L1 4DQ
t +44 (0) 141 707 4444
f +44 (0) 151 707 4445
www.fact.co.uk

Design by www.smilingwolf.co.uk

Printed by Editoriale Bortolazzi-Stei, Verona

Set in FF Din, NB Grotesk and Granjon

Distributed by Liverpool University Press
4 Cambridge Street
Liverpool, L69 7ZU
www.liverpool-unipress.co.uk

ISBN 9781846312298

FACT is a registered charity
No. 702781

Company limited by guarantee
Registration No. 2391543

FACT
FOUNDATION FOR ART AND
CREATIVE TECHNOLOGY

A
Contexts:
Mike Stubbs
Lewis Biggs
p006 – p015
–

B
The Video
Positive Years
1989–2000
p016 – p025
–

C
Art & Technology
Sarah Cook
Sean Cubbit
p026 – p033
–

D
Projects/Building
& Growing
1998–2002
p034 – p049
–

E
Commissioning,
Curating and
Collaborating
2003–2009
p050 – p191
–

F
Futures:
Laura Sillars
Andy Miah
p192 – p201
–

Appendix
p202 – p203

Preface

The world does not give straight answers. It is complex and needs to be dissected, explored and debated. You might not always find an answer or identify a solution, but intellectual and imaginative stimulation stems from the untangling and analysis of the situations presented, a creative process FACT strongly believes in.

Over the past twenty years, FACT has established a method by which to interweave art with education and technology with research. Its approach is unique; it may be deemed bold or even incongruous, but this is precisely what generates its effectiveness. It makes people think.

This publication illustrates FACT's journey and the ways in which it has interacted with and impacted on the demands and changes of the past twenty years. Its intentions are to reflect, to debate, to educate; to contextualise the past, critically assess the present and imagine the future. These are, after all, the things that FACT does best.

–

Sir Drummond Bone
FACT Chair

« The world does not give straight answers. It is complex and needs to be dissected, explored and debated. »

—

Contexts

—

Essays by
Mike Stubbs
& Lewis Biggs

—

I am not an island, nor am I stranded on an island. I am a member of the CIA – the Collective Intelligence Agency – and the latest version of the networked condition has arrived. I have always welcomed the future and despise being in a state of dread.

William Gibson inspired me and popularised cyberspace in his classic cyberpunk novel, *Neuromancer*:

"Cyberspace. A consensual hallucination experienced daily by billions of legitimate operators, in every nation, by children being taught mathematical concepts… A graphic representation of data abstracted from banks of every computer in the human system. Unthinkable complexity. Lines of light ranged in the nonspace of the mind, clusters and constellations of data. Like city lights, receding…" [1]

In the struggle to conceptualise, communicate and compare our perceptions we have invented new forms, new language, new visualisations, and nowhere more so than at FACT. In 2009, Liverpool's Year of the Environment (following the massive spectacle of the city's year as European Capital of Culture in 2008), we at FACT are attempting to demonstrate pioneering strategies of cultural leadership through an open-ended laboratory project, *Climate for Change*, in which we are working with 120 community groups to investigate and deconstruct systems of economy and sustainability.

Over the last twenty years, facts have become less definitive and increasingly speculative. Have we become less certain of the future, or is it that modernism and the promise of 'progress' has not always come up trumps? Most versions of science fiction and Futurism turn out to be a bit dumb. Facebook and Twitter may be the current ubiquitous manifestations of collective intelligence, but by the time you read this, will they sound quaint and old hat? And with the development of ever speedier methods of exchanging information and comparing views, does this synchronous flow take account of bias, differences of perception, and diversity of culture?

Bearing this in mind, it is not possible to compare perceptions across time and generalise about 'one' world, or certainly not until everyone has access to microblogs and PDAs. My grandfather related stories of deepest, darkest Africa, the Amazon and shrunken heads. Living a bread-and-jam existence in the shadow of rationing, post-war Britain needed hope. And as a product of that time, I have been privileged to have filmed in zero gravity and am planning an artists' residency programme on the moon. The unimaginable really has got closer.

My own view of the world has radically shifted, not only in terms of what I know, but in terms of how I know it. The world has gone non

linear, and not just in relation to analogue video editing being replaced by Avid (the Hoover of the digital editing world). As we are witnessing through such phenomena as YouTube, distributed models of production and exhibition and every conceivable variation between the two, artists no longer have the monopoly on creativity. Collaborative practice, together with cheap access to new tools and new skills, has enabled new models of research and practice to flourish. A perfect example of this is our own community TV station tenantspin, which over the past ten years has seen people of different ages and backgrounds creating their own media, exploring compelling new relationships as both producers and audience. A relational exchange, whether televised or otherwise, is only as good as the energy put into it. This is about real people in real life, not about technology itself. We increasingly accept the broad philosophical premise that we create the world in perceiving it, or at least that objects, circumstances, events and data are affected through mediation.

Conversely, with the shift from conventional perceptions of broadcast and narrowcast, time and space have been up-ended. Entire systems of belief and dogma have tumbled. Not only does 2009 mark twenty years of FACT, it also marks twenty years since the fall of the Berlin Wall.

Bastions of traditional power have been significantly weakened and peer-to-peer information exchange has to a considerable extent replaced broadcasting. With the ending of the Cold War, previously powerful assumptions were further challenged and it became increasingly possible for us to listen to new voices. With these shifts, traditional systems of knowledge transfer, pedagogies and histories have been put into question. Who would have thought that in 2008, twenty years on from the bloody civic uprising in Tiananmen Square – one of the first televisual thorns in the side of the Chinese Communist Party – FACT would be representing Britain in the Cultural Olympiad programme as part of *Synthetic Times*, the world's largest survey of media art, at NAMOC, the National Art Museum of China?

Not only have we observed massive change, we have also played our part in making it happen. In deciding whether to take part in Synthetic Times, I had to make a call on whether the perception of FACT in this context was going to be positive or negative, and on whether by taking part we were sanctioning a repressive regime. In retrospect I think it was the correct decision. While it is hard to quantify what the real long-term impact of our contribution will be, I hope that some of the projects we presented in 2008 illustrating new contexts

« Conversely, with conventional perce broadcast and na and space have b entire systems of have tumbled. »

he shift from

ptions of

owcast, time

en up-ended.

elief and dogma

in which to connect the arts with issues around health, disability and climate change – may have brought new ideas to communities previously less familiar with interdisciplinary practice and its relation to the social realm.

Despite a healthy scepticism towards the new instrumentalism, whereby art loses its intrinsic value and becomes instead the 'cure' for many areas of social failure, talking in the pub, influencing people and organisations beyond the art world and its closed systems has always been of interest to me personally and at the heart of FACT. Asking how we can maintain quality and interest, how we can build on excellence and engage more people, is part and parcel of being an accountable, publicly funded institution. We need both spread and depth.

As the world's geo-political axis has shifted, so too has FACT. Indeed, if Liverpool has dubbed itself the centre of the creative universe, perhaps FACT has been one of the axes around which that creativity has revolved and evolved. The FACT Centre may originally have been conceived as a technocentric media arts centre, but it has blossomed through love, time and need into a true twenty-first-century arts centre, the embodiment of contemporary hybrid research and practice-based knowledge exchange, rich in participation, forging strong, deep

and essentially social connections to a wide range of communities and places. The fascination here is the real-time negotiation of those relationships and nuanced interchanges which motivate communication, exchange and action. It is through comparing differences that we learn – the process, the comparison of what is both out there and in here, is the end in itself. The idea that art can be a container for meaning, or directly representational, is less and less interesting as methods of direct translation prevail. An ontological approach is where art excels, and artists' work that is observation and direct experience is difficult to measure and quantify.

In post credit crunch UK, in the later stages of industrial capitalism, empiricism is on a half-life to nowhere. FACT's story is congruent with the popularisation of chaos theory. Complexity and a state of emergence are conditions for FACT to thrive in, demonstrating social development in the context of the global, finding new audiences and new forms of engagement while maintaining criticality and excellence in new media practice in the public realm. Since its inception, FACT has demonstrated innovation and commitment to collaboration and to making a difference. While the world has itself become more relational, the staff at FACT have demonstrated, with infectious enthusiasm, pioneering strategies

of cultural leadership and arts-led regeneration. Such an approach remains essential if FACT and the arts 'industries' are to avoid becoming part of a wider cultural bankruptcy.

Twenty years ago, artists, curators and activists were not knowingly creating a new paradigm or starting a 'digital' revolution; it is only now that we can rationalise *post facto* and reassemble those connections. This is important not only to ensure our place in history, but to also remind ourselves of where innovation often begins: with the experiments of artists, designers and technologists. FACT actively encourages experimentation, provocation and interference. Repeatedly, it has been artists who have provided early warnings of the cultural, economic and political ramifications of new technologies, through a variety of media and tactics, gesture, performance and resistance.

Equally, it is our responsibility to acknowledge the importance of diverse historical practices, contextualising media art and its histories in relation to the current explosion within digital and networked society. In demonstrating the significance of pioneering practices by artists, technologists, curators and our partners, we can chart how these influenced and helped to form emergent models of organisation and the application of peer-to-peer

communication technologies, social media and personalisation opportunities across a variety of sectors and in the new networked conditions. The ramifications of these types of – video, media art and new media art practices have extended well beyond the development of discrete artworks, questions of genre and the practice of art. While these are important areas in themselves, even more significant is the fact that video, media and new media art have been forerunners in what is now termed a digital revolution – a revolution that is redefining all rules of engagement, collaboration and economy. Beyond the body, beyond biology and technology, post-human, we are dispersed across time and space, wearing multiple data-bodies in a chaotic matrix, joined as one ceramic ribbon through silicon chips and virtual memory.

If artists since Futurism have embraced exponential acceleration, complex power systems and traditional politics of argument are now becoming increasingly indigestible, reduced to soundbites and spectacle, giving little comfort where specialism and volume and sheer quantity of data are overwhelming. Without trust in knowbots, robots, basic forms of Artificial Intelligence and ubiquitised filters, increasingly we must trust our instincts and the direct experience:

"For to perceive, a beholder must create

his own experience. And his creation must include relations comparable to those which the original producer underwent… Without an act of recreation the object is not perceived as a work of art." [2]

Art is about being, about being actively involved, about doing it. The artists who have made FACT what it is have had little choice in this; it is their life.

Pioneering artists need pioneering organisations and individuals advocating that work. In this context it is impossible to write this introduction without mentioning my first meeting, in 1989, with Eddie Berg, the founding director of Moviola, then based at the Bluecoat. Eddie had been given a list of emerging video artists to consider for the first *Video Positive*, Britain's most significant festival of video and media art, which took place between 1989 and 2000, and alas I was one of those artists. Working with Bryan Biggs, curator at the Bluecoat, I produced an artwork titled *Desert Island Dread*, an ironic deconstruction of love, romance and pollution linking the strange virus that killed many seals that year with the HIV virus and the proliferation of cancer cases in South Humberside around the RTZ-owned Capper Pass re-smelting plant. At that point I considered myself an artist/curator and was the coordinator of a cooperative, Hull Time Based Arts. Over a ten-

year period Eddie and I both worked with real commitment, respectively on the west and east coasts of England, linked by the M62 and collaborating regularly on what would later become a range of programmes, including new commissions such as *Modell 5* by Granular Synthesis, which premiered at the Tower in Hull and Cream in Liverpool; and *Systems Maintenance* by Perry Hoberman, commissioned by HTBA and shown in the Ferens Art Gallery as part of the *ROOT (Running Out of Time) Festival* and at Cornerhouse as part of both *Artranspennine 98* and *ISEA 98*. What was really clear about Eddie was his determination that Liverpool should have something special; and the more he became aware of good design and the significance of electronic media and video art, the stronger became his determination to realise a major capital project – in Liverpool, for the people of Liverpool.

It has been my pleasure to inherit that legacy and to work for the past two years with an incredible group of people. Still slightly exhausted from delivering our *Human Futures* programme as part of Liverpool's year as European Capital of Culture in 2008, we are now working on our 2009 *UNsustainable* programme, already launched with the *Climate for Change* exposition – itself suggestive of FACT's next stage as a cultural leader and policy-former, for whom 'the only currency is

cooperation'. This is a time of unprecedented opportunity for FACT as a hub of innovation, a pioneer of interdisciplinary international partnerships, and a centre of excellence developing new models of local connectivity and collaboration. Sharing will make our journey easier. As you Twitter and muddle your way through exponentially networked conditions, you can blame us.

How can we begin to thank the countless staff, partners, media organisations and funders over the last twenty years for their trust and faith? These people have enabled FACT to become what it is today - a hotbed of creativity and education. We are indebted to each and every person who has contributed to the organisation, and to the many projects that have all involved a diverse range communities – internal and external – to bring them to life. Currently we are grateful to be working with Arts Council England, Liverpool City Council, DCMS, UK Legacy Trust, Liverpool Primary Care Trust, Arena Housing, Northwest Vision and Media, UK Film Council, the Wellcome Trust, British Council, Youth Opportunity Fund, Biffaward and the Foyle Foundation, who are helping us make the leap into the next phase of FACT's history.

We invent the society we want to be. We are the real-time experiment.

1: William Gibson, *Neuromancer* p69, (1984), Ace Books, New York.

2: John Dewey, *Art as Experience*, p54, (2005) first published (1934), The Berkeley Publishing Group, New York.

The Foundation for Art and Creative Technology describes itself as an 'organisation for commissioning, exhibiting, promoting and supporting artists' work and innovation in the fields of film, video, and new media'. It's a Liverpool organisation all right, but is it a Liverpool invention? In what sense is it original?

The love affair between artists and new technologies goes back at least as far as Leonardo da Vinci, but a turning point in the broad public acceptance that art could concern itself with 'new technologies' was 1968, when the London ICA staged the exhibition *Cybernetics Serendipity*. The show demonstrated robotics and Artificial Intelligence as well as more conventional 'kinetics'. That show demonstrated once again that there is no such thing as 'creative technology': technologies come and go, and some people use them and stretch them creatively, while others don't.

As far as moving image is concerned, portable video cameras were circulating among arts organisations in the regions of the UK, courtesy of the Arts Council, by the early 1970s. There were numbers of touring exhibitions of film and video, including 'expanded' installation work, by the early 1980s – the ICA toured *About Time* in 1980. Film and Video Umbrella began curating and producing artists' film, video and new media projects, commissioned and presented in collaboration with galleries and venues across England, in 1983. As regards building-based 'media' centres, Watershed, Bristol was founded in 1982; Broadway, Nottingham operated from the mid-1980s and became building-based in 1990; Lighthouse, Glasgow was founded in 1999, and so on.

So what's original and distinctive about FACT? Its unique qualities emerge from the detail of its history. Necessity is the mother of invention, and passion is the father of creativity: what were the necessities and passions surrounding its emergence?

I suggest that there are four main contexts to consider: the regional and international context of innovative artforms; the economic context; the academic and local knowledge resources; and the social context of collaborative activity and engagement with audiences.

The key personalities in relation to the emergence of FACT within these contexts include Eddie Berg, founding director of Moviola; Sean Cubitt and Roy Stringer, both from Liverpool John Moores University and artists Lisa Haskel, Clive Gillman, Simon Robertshaw and Mike Stubbs.

The bones of one early self-history are laid out in the publication *Factors*, published by FACT in 2003. Merseyside Moviola was established in 1985 by two students at Liverpool University, Josie Barnard and Lisa Haskel, as an 'occasional project for screening independent and experimental film and video'. A weekend event of film and video was repeated in 1986 at the Unity Theatre. In 1987 Josie moved to London and Eddie Berg began supporting Lisa on the project and established an office at the Unity Theatre (where Eddie was working). They set up a series of temporary 'mobile cinemas' around Merseyside. In 1988 Lisa moved to London and Merseyside Moviola was reconceived as a commissioning and exhibition agency for film and video, with an office now at the Bluecoat, and the ambition to produce the UK's first festival to focus on moving image installation, *Video Positive*. The choice of title suggests a hope or maybe an injunction: a corrective to the perception – which I don't believe was there, in fact – that video art was neglected, even ignored.

Video Positive '89 was accounted a success, at least by those most closely involved, and that included the funders. The following year, the organisation became a registered charity and company limited by guarantee, and dropped its 'local' moniker, becoming simply Moviola. In 1991, in addition to organising the second *Video Positive* festival, Clive Gillman and Eddie Berg conceived the idea for MITES (the Moving Image Touring and Exhibition Service), which became and has remained essential underpinning for everything FACT undertakes.

Then in 1992 the enterprise really began to take off, with the establishment of MITES, the formalisation of the Collaborations Programme and the expansion of Moviola's offices and store at the Bluecoat. The idea of moving out into an independent and permanent building for exhibition (under the name of MICE) began to be discussed in 1995. The company was renamed FACT in 1997 and its centre was finally opened in the spring of 2003.

As Eddie Berg notes in his introduction to *Factors '89*, the late 1980s was 'a pretty dark period in Liverpool's cultural history'. Eddie was left 'holding the baby' when Lisa and Josie moved to London. That move to London signals the real issue here: what kind of a cultural life could be sustained and grown outside the capital?

Laura Sillars suggests one reading of the situation when she highlights the context of urban regeneration. She writes (blog, March 2009):

"There was a particular moment in the late 1980s when a few things for this city seemed to come together… The opening of Tate Liverpool [was] a response to social unrest in Toxteth".

I remember it as being a lot more complicated than that.

« It was based on a pragmatic approach to the context and resources it inhabited, an organic growth driven by a passionate concern for artists. »

The broad context was regionalism, not regeneration. Regeneration was of no interest to the Thatcher government except as a by-product of market forces. The Tory government was dedicated to 'modernising' the country through the forced application of the medicine of 'the free market'. The imposition of a radically free market was the ideological end point of Thatcher's desire to sweep away the 'protectionism' of communities, of traditional industries, of the remaining local and regional 'interests' that still provided resistance to corporate consumerism. By the end of the decade the international financiers, based in the capital, reigned supreme and the manufacturing industries, based mainly in the North, were decimated. Liverpool was lucky to have a 'Tory wet' as a champion in the form of Michael Heseltine.

The Tate Trustees had taken the decision in 1979 to open a northern gallery, before the 1981 riots, and Liverpool had been selected, for cultural and infrastructural reasons, by the end of 1980. The idea was to create a bigger audience for the national collection of modern art, drawn from the 85 per cent of the people who owned it but who did not live in the capital. Liverpool was chosen on the advice of the architect Jim Stirling, who had liked Albert Dock since his student days in Liverpool, and because the biennial *John Moores Painting Exhibition*

and the Walker Art Gallery were a significant showcase for contemporary visual art.

When the 1981 riots came, including those in Toxteth, the Tate Trustees were almost persuaded not to commit the collection to Liverpool (although it seems the Brixton riots did not threaten the continued presence of the Tate collection in London). The eventual arrival of Tate Liverpool in 1988 was a positive contribution not only from a regionalist perspective, but from an internationalist one too. It's hard to remember now how little art from outside the UK was available to audiences in the 1980s and how rare it was (relative to today) for UK artists to show internationally. Arts Council grants funded only UK-based artists, and although the British Council funded UK artists to show abroad the funds available were very limited. But of course, as with any new movement, the adherents tend to be both very well networked and very widely dispersed: making a festival of 'new media' art from one country didn't make a lot of sense. Eddie Berg was entirely candid about the need to involve the Tate brand in *Video Positive '89*: without it, he couldn't persuade artists living outside the UK to participate, and nor would he have been able to raise the sponsorship needed for the equipment. The cultural support system at the end of the 1980s was bitterly embattled on local, regional and

national levels. Liverpool City Council had been relieved of its responsibility for arts and culture with the formation of the Metropolitan County Councils in 1974. City-based arts organisations such as Open Eye Gallery (founded in 1978) survived on a mixed economy – broadly, the Merseyside Arts Association funded the exhibiting function while the City funded its teaching/community engagement activities. With Thatcher's abolition of the Metropolitan County Councils in 1986, the Militant Labour Liverpool City Council was not about to pick up the cost of any arts organisations, and the now universally accepted idea that culture is a prime factor in enabling successful regeneration was at that time (and into the 1990s) simply ridiculed by local elected members, as perhaps by the wider population. In 1990, Merseyside Arts Association merged with the Northwest Arts Association to become the Northwest Arts Board, based in Manchester, its Liverpool office reduced to a vestige.

By the end of the 1980s, Thatcher's determination to make the UK the most centralised state in the world (with the possible exceptions of Burma/Myanmar and North Korea) had succeeded in the effective destruction of local government, and the conventional responsibilities of citizenship along with it. Already in the mid-1980s, the reaction to those policies was apparent in the

Militant tendency in Liverpool. For artists, the option of remaining in Liverpool – or in any of the regions of England – must have seemed bleak indeed. But Eddie Berg dug in rather than leaving because Liverpool was not only his home town, it was in a real sense his horizon also. Faced with a desperate situation, his breakthrough was to treat the 'London imposition' of Tate Liverpool and Heseltine's Merseyside Task Force (deeply resented by many people locally) as an opportunity for the city rather than as a threat to it. Supported by his contacts with new media experts at Liverpool Polytechnic, Eddie positioned Moviola as a representative of the 'sunrise industries', part of the future of the city rather than its troubled past or present.

It was a message that went down well. Every single piece of equipment for the 1989 festival was provided as in-kind sponsorship, mostly by the Samuelson Group, and the Arts Council provided the funds for fifteen new commissions. The exhibition was shown at Tate, the Williamson Art Gallery in Birkenhead, the Philharmonic Hall and the Bluecoat. The Tate and Bluecoat at least contributed the costs relating to the overheads of the building and the installation. This mixed economy – Arts Council grants, sponsorship and contributions from partners – was a radical break from the standard model of exhibition

touring, in which the originating organisation would pay the bulk of the costs and the receiving venue would pay a hire fee. The partnership model of exhibition delivery became standard for collaborative exhibitions across the city and has remained the basis of the Liverpool Biennial.

Moviola's involvement with commissioning new art from artists brought it head to head with the difficulties of sourcing equipment – both for production and for exhibition – at a cost artists and galleries could afford (when sponsorship in kind was not available). Clive Gillman encouraged Moviola to think of investing in a pool of equipment – especially soon after its introduction, when it could still only be found at premium costs – that could be hired out to venues receiving touring shows. It was not rocket science (think of artists or record labels sharing recording studios) but they were the first to do it, and they did get the status of national franchisee from the Arts Council. The foundation of MITES was an entrepreneurial breakthrough in sharing resources, and investing and maintaining technical expertise in Liverpool. The equipment bank, the pooled staff expertise, and the cash-flow generated, all provided a solid foundation on which the organisation could move forward. How did Eddie Berg manage to engineer a collaborative exhibition/festival, when Liverpool was chiefly

characterised in 1989 by fierce competition between different organisations and groups of artists in the sub-region for the meagre public funds that were available? First, Tate's arrival did shake things up, and it was open to collaboration because it wanted to ingratiate itself with the existing organisations. Although its resources came from Westminster, they were at that time little better than those of any other organisation. But the basic lesson was that shared resources go further. Second, because of its emphasis on new media, Moviola's slender cash contribution was nevertheless 'new' funds, outside the existing competitive field. Thirdly, Moviola's roots in engaging with communities made it an attractive partner to city-centre organisations always hungry to attract new audiences. Although *Video Positive '89* meant that Moviola had to refocus on city-centre activity in that year, by 1990 Simon Robertshaw was invited to create a series of community programmes that piloted the fully fledged Collaboration Programme set up in 1991 by Louise Forshaw. Whether on an institutional or a community level, collaboration was a guiding principle in getting the organisation embedded in the city and growing it quickly to maximum effectiveness.

Moviola in those early years received considerable support from Liverpool John Moores University. Eddie Berg's own initiation into video art in 1984

was conducted by Sean Cubitt, professor of media studies. Then the imaginatively titled Learning Methods Unit spawned (or 'spun off', as the jargon has it) first Roy Stringer's company Amaze (1995) and then Phil Redmond's ICDC – International Centre for Digital Content (2000). Stringer was a board member of Moviola from 1993 and Chair of FACT from 1999 to the time of his death in 2001; ICDC's founding director was Simon Robertshaw, who had exhibited in *Video Positive '89*. The circle has been nicely closed by the appointment of Mike Stubbs, who also exhibited in *Video Positive '89*, as a professor at LJMU within his role as Director of FACT.

Although Moviola had academic support, it was far from being a development of a theoretical model. It was based on a pragmatic approach to the context and resources it inhabited, an organic growth driven by a passionate concern for artists using innovative technology. It's almost a textbook example of that 'organic creativity' described by Liverpudlian and sometime Head of Education at the Getty Foundation, Ken Robinson. If creativity is meeting the challenge of difficult times, there's plenty of evidence of exactly that in the story of the original Liverpool invention that is FACT.

—

1989–2000

—

—

The Video
Positive Years

—

Video Positive was a biennial festival of video and new media art with a strong focus on new commissions and collaborative projects. The festivals took place across Liverpool and were hosted by partner venues including Tate Liverpool, the Bluecoat, Open Eye Gallery and the Walker Art Gallery. A major part of the artistic heritage of Liverpool and the UK, *Video Positive* formed the basis of FACT's ongoing commitment to new and emerging media art forms.

'89

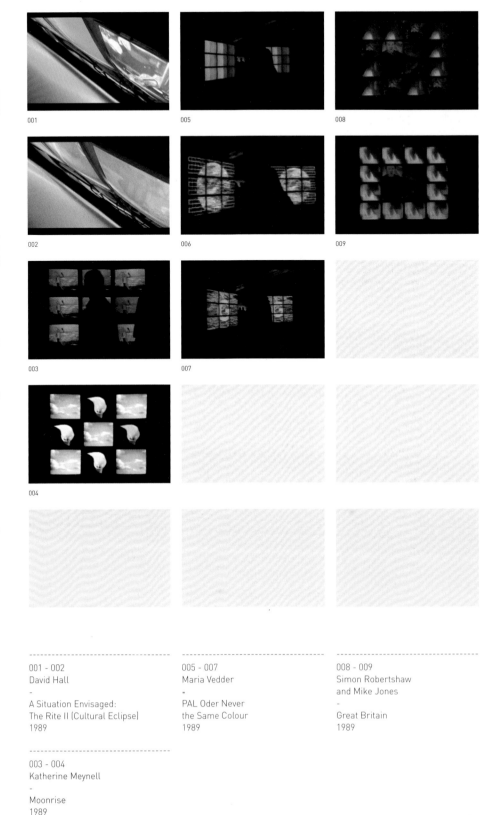

Video Positive '89 was curated by Eddie Berg and Stephen Littman and took place at Tate Liverpool and the Bluecoat in Liverpool and the Williamson Gallery in Birkenhead from 11–26 February 1989. Artists commissioned for the Video Wall at Tate Liverpool included Judith Goddard, Simon Robertshaw and Mike Jones, Stephen Littman, Katherine Meynell, Stephen Partridge and Maria Vedder. A package of Canadian short works made for a videowall context, commissioned by Public Access Collective in Toronto in 1989, included work by Victor Burgin, Laura Mulvey, Rhonda Adams and Denis Day/Christine Martin/Su Rynard. Exhibition commissions included David Hall, Andrew Stones, Mike Stubbs, Marion Urch, Jeremy Welsh, the Closet Media Company, Mineo Aayamaguchi, Stephen Dowsing, Christopher Rowland, Joanna Millet, Zoe Redman, Daniel Reeves, Urban Jazz Ritual and The Goat People. Screenings from Electric Eyes, organised by Film and Video Umbrella, were shown in the Bluecoat Performance Space.

Text extracted from *Factors*

001 – 002
David Hall
–
A Situation Envisaged:
The Rite II (Cultural Eclipse)
1989

003 – 004
Katherine Meynell
–
Moonrise
1989

005 – 007
Maria Vedder
–
PAL Oder Never
the Same Colour
1989

008 – 009
Simon Robertshaw
and Mike Jones
–
Great Britain
1989

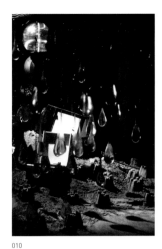

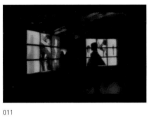

011

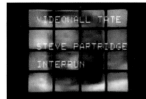

013

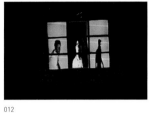

012

010

012

« After 20 years or so of unprecedented development in image–making technologies and a decade of new innovations and practices among artists, it seems appropriate that we should hold a festival which celebrates video art today and takes a look at what we might expect to see in the '90s.

So there was *Video Positive '89.* »
–
Eddie Berg & Stephen Littman (VP 89 Festival Directors): Foreword, *Video Positive '89* catalogue.

010
Mike Stubbs
-
Desert Island Dread
1989

011 - 012
Stephen Littman
-
On A Clear Day You
Can See Forever
1989

013
Stephen Partridge
-
Interrun
1989

'91

014

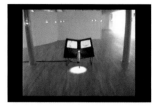

017

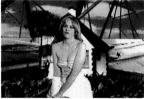

015

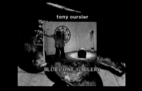

018

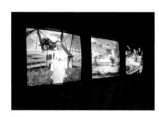

016

Video Positive '91 was organised by Moviola, curated by Eddie Berg and took place at Tate Liverpool, the Bluecoat Gallery, Open Eye Gallery, the Walker Art Gallery and in St John's Shopping Centre in Liverpool from 20 April to 06 May 1991. Artists commissioned included Breda Beban/Hrvoje Horvatic, Lei Cox, Madelon Hooykaas /Elsa Stansfield, Judith Goddard, Tony Oursler and Clive Gillman. Other artists exhibiting were Simon Biggs, Daniel Dion, Maria Vedder at Tate Liverpool; Peter Callas and Catherine Elwes at the Bluecoat Gallery; a Video Diaries series directed by Simon Robertshaw and produced by Moviola at Open Eye Gallery; Australian music and video exploration group Severed Heads and artist Julie Myers, Louise Forshaw and Krysttyan Borg at St John's Shopping Centre. Screenings included a three-part selection of material from the archives of LVA, including work from 1972–1990, programmed by Michael Mazière and Art & Science, a programme selected by Film and Video Umbrella; highlights from *Not Necessarily...*, a collaboration between students from the Electronic Imaging course at Duncan of Jordanstone College in Dundee and artists such as Judith Goddard and Lei Cox. Performances were also staged at the Unity Theatre.

Text extracted from *Factors*

014 - 016
Judith Goddard
-
The Garden Of
Earthly Delights
1991

017
Simon Biggs
-
Alchemy
1991

018
Tony Oursler
-
Triune
1991

'93

The festival, containing more than 40 different events, performances, screenings and seminars, took place between 01 and 09 May 1993 at sites across Liverpool (including the Unity Theatre) and the installation programme took place at Liverpool Tate, Open Eye Gallery, the Bluecoat and the Walker Art Gallery during the entire month of May. Artists included Jon Bewley, John Conomos/David Haines, Peter Callas, Lei Cox, Ingo Gunther, Catherine Ikam, Shirley Mac-William, Alanna O'Kelly, Simon Robertshaw, Barbara Steinman, Andrew Stones, Jonathan Swain, Cathy Vogan and Richard Wright.

The Collaboration programme included projects with the Ashworth (North) Hospital, Maghull, Knowsley Community College, Merseyside Centre for the Deaf, NACRO, Liverpool, St Helens Community College, Southport College, University of Central Lancashire and Training and Vocational Education Initiatives in Sandwell.

Text extracted from *Factors*

019

022

025

020

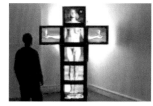

023

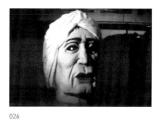

026

021

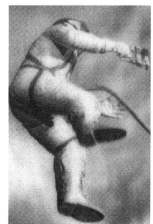

024

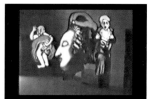

027

028

029

019 - 021
Andrew Stones

-

The Conditions
1993

022 - 023
Lei Cox

-

Sufferance
1993

024
Jonathan Swain

-

Weightless
1993

025 - 029
Peter Callas

-

Men Of Vision:
Lenin and Marat
1993

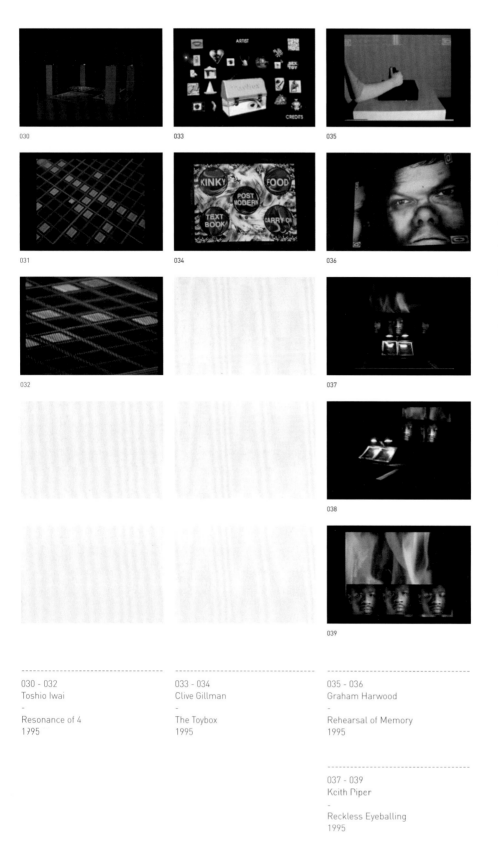

030

031

032

033

034

035

036

037

038

039

« Graham Harwood's *Rehearsal of Memory* is an interactive CD–ROM for which he recorded patients' life experiences at Ashworth high security psychiatric hospital. Presenting the personal stories of many individuals, the piece culminates with the anonymous 'personality' of a computer, depersonalising experience such that it becomes merely data. In giving space to the voices of those at the extreme of abnormal behaviour - serial killers, rapists, those considered a danger to them—selves and to others - Harwood's work confronts us with our own unwillingness to recognise the existence of such behaviour in our society. »

Karen Newman, Curator, FACT

030 - 032
Toshio Iwai
-
Resonance of 4
1995

033 - 034
Clive Gillman
-
The Toybox
1995

035 - 036
Graham Harwood
-
Rehearsal of Memory
1995

037 - 039
Keith Piper
-
Reckless Eyeballing
1995

040

041

042

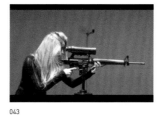

043

044

045

046

047

048

049

The festival, containing more than 40 different events, performances, screenings and seminars, took place between 29 April and 04 June 1995 at sites across Liverpool including the Unity Theatre, the Bluecoat Concert Hall and Tate Liverpool. The exhibition programme was at Tate Liverpool, the Open Eye Gallery, the Bluecoat, the Walker Art Gallery, the Grand Hall, Albert Dock and Warrington Museum and Art Gallery. Artists included Lei Cox, Graham Ellard & Stephen Johnstone, Boris Gerrets, Judith Goddard, Marion Kalmus, Stephanie Smith & Edward Stewart, Dana & Boaz Zonshine, Toshio Iwai, Susan Alexis Collins, Lynn Hershman, Keith Piper, Marty St James & Anne Wilson, Liza Ryan-Carter, Julia Griffin & Phil Tune; projects by Tjark Ihmels, KP Ludwig John, Michael Touma & Stephan Eichhorn, Wigan and Leigh College, Graham Harwood and Ashworth Hospital, BICA (Black Issues in Community) with Mukhtar Dar and Shareen Merali and the Sefton Women's Radio Project.

Text extracted from *Factors*

040 - 042
Lei Cox
-
Flowerfield
1995

043 - 046
Lynn Hershman
Leeson
-
America's Finest
1995

047 - 049
Susan Alexis Collins
-
Every Dog
Has Its Day
1995

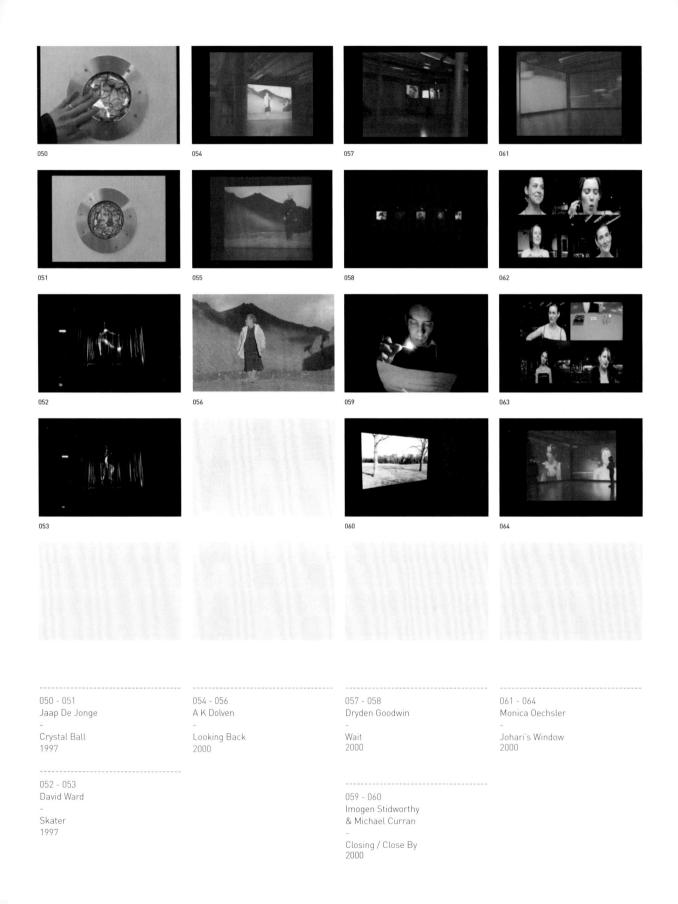

050

051

052

053

054

055

056

057

058

059

060

061

062

063

064

050 - 051
Jaap De Jonge
-
Crystal Ball
1997

052 - 053
David Ward
-
Skater
1997

054 - 056
A K Dolven
-
Looking Back
2000

057 - 058
Dryden Goodwin
-
Wait
2000

059 - 060
Imogen Stidworthy
& Michael Curran
-
Closing / Close By
2000

061 - 064
Monica Oechsler
-
Johari's Window
2000

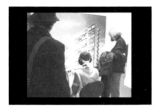

065

066

067

068

'97 '00

The festival, containing more than 40 different events, performances, screenings and seminars, took place between 11 and 20 April 1997 (the exhibitions ran between 11 April and 18 May 1997) at sites across Liverpool and Manchester including the Bluecoat Arts Centre, Cream at Nation, 68 Hope Street Gallery, Open Eye and Wade Smith Outdoor Athletic, Castlefield Gallery, Cornerhouse, Green Room, Manchester City Art Galleries, The Museum of Science and Industry, Manchester. Artists included Bobby Baker & the Ashworth Hospital Women's Art Project; Roderick Buchanan with MediaBath, Helsinki & Halton College; Sera Furneaux & Common Ground Sign Dance Theatre with Silent View; Lyndal Jones; John Wood & Paul Harrison with ARTSKILLS; Richard Layzell with Liverpool University of the Third Age; Mikko Maasalo & John McDonald with Queens Road Neighbourhood Centre; Alan Currall; David Ward; Simon Robertshaw; Luchezar Boyadijev; Gordon Bennett; Thecla Schiphorst; Stephanie Smith & Edward Stewart; Bill Viola; George Barber; Annee Olofsson; Graham Gussin; Jaap De Jonge; Dieter Kiessling; Julie Myers; Michael Curran; Yael Feldman; Jane & Louise Wilson; Tony Oursler; Jon McCormack; Jane Prophet; BICA Project & Asia Community Arts; Arvind Mistry & Clive Gillman; Simon Biggs; Leon Cmielewski; Martine Corompt; Brad Miller; Keith Piper; Lloyd Sharp and Josephine Starrs.

Text extracted from *Factors*

The festival took place between 04 March and 01 May 2000. Projects included Sonia Boyce with Liverpool Black Sisters, web-based audio works curated by Micz Flor by Christoph Kummerer, Jan Robert Leegte, lo-swer and radioqualia, works by Ugo Rondinone and Superflex presented at Bluecoat Gallery; projections from ASCII computer programme by Vuk Cosic onto St George's Hall; projects by Michael Curran & Imogen Stidworthy at Open Eye New Media & Photography Gallery; A. K. Dolven, Dryden Goodwin and Monika Oechsler at Tate Liverpool; projects by George Barber at The Citadel, St Helens; Fanni Niemi Junkola with Kirkby Women's Community Action Group at Kirkby Gallery; Spacecraft; an exhibition of work in various media curated by Iliyana Nedkova presented at Bluecoat Display Centre; and Crossing Over Time, a selection of videoshorts presented at the Unity Theatre.

Text extracted from *Factors*

« The final festival skipped a year to end on the millennium; the anticipation and anti-climax of which was a theme, along with the hyper speed of contemporary life and the burgeoning dialogues between the local and the global that new technologies enabled. By 2000 FACT was also focused on the development of the purpose built FACT Centre which opened in 2003 and became the natural successor to Video Positive. »

–

Marie-Anne McQuay and Lux 2006. Reproduced from www.luxonline.org.uk

065 - 067
Superflex
-
Coronation Court
2000

068
Vuk Cosic
-
ASCII Architecture
2000

Art &
Technology

—

Essays by
Sarah Cook &
Sean Cubitt

—

"The crisis of originality is really just one variation of another, larger crisis: the crisis of radicalism. One of the great received ideas of the 20th century is the notion, enshrined in art-school culture, that it is the sacred duty of every artist to be radical in some way, whether it be political or philosophical or merely technical. So artists anxious to discover every unmapped corner of radical thought and gesture have made art out of more or less everything that art was once supposed not to be made out of. When everything has been done, all that remains to do is to do it again. And the result is necessarily odd: art that looks radical but cannot actually be radical because its language has been depleted by over-use; academic radicalism; conformist radicalism." [2]

In the process of writing this essay I attended a conference in Amsterdam about the current state of media arts.[3] The first panel concerned politics and as I sleepily sipped from a cup of calming mint tea I found my mind being coerced into attention by artist Hans Bernhard as he read what he later released as Ubermorgen's manifesto of practice (2009).[4]

Even before hearing the manifesto I would have been inclined to label Ubermorgen's particular brand of new media art 'radical', and not only because they get sued every month. They have fought domain name registration battles and won (*TOY-WAR: etoy.com vs. eToys.com*, 2000). They have a project in which a

piece of software automatically buys up Google Ad space and uses the proceeds from the advertising to buy Google shares (*GWEI – Google Will Eat Itself*, 2005). They hacked Amazon.com's 'search inside' feature in order to liberate (i.e. download) the full text of some 3000 copyrighted books (*Amazon Noir*, 2006). They worked to allow voters in the United States to auction off their voting rights to the highest bidders (*[V]ote-Auction*, 2000). They have a software text generator which will automatically dispense 'foriginals', or forged original documents, such as bank statements, court orders, drug prescriptions, and now also rendition orders.

The manifesto was a reminder to the many other artists working in this field of networked social activism (including Steve Lambert, Jeff Crouse, Superflex and N55, all seen in FACT's *Climate for Change* project in 2009, and the many others out there such as irational.org, Heath Bunting, Horner/Antlfinger, Annina Rüst, e-team, Kate Rich, The Center for Land Use Interpretation, Future Farmers and Josh On) not to become complacent about the place of art in the world. As Bernhard urged, somewhat controversially,

"We are artists, we need to be free of responsibility, to not have to think about consequences, to not limit ourselves just because it could have an effect on
this or that, or could be used for us or against us or other people. We learned very early [on that] hacking optimizes the attacked system; we accept that, and we [have] learned to not give a fuck about it. [...] If art and art production politicizes itself, it becomes politics and ceases to be art."[5]

The separation of art (how we see the world) from art production (how we make the world) is indeed a tricky one to enforce within new media art, which, as with the work of the Situationists, seeks to join process to practice through its tools and methods. For an illustration of this one need only look at the work of the artist-couple JODI (Joan Heemskerk and Dirk Paesmans) – so beautifully presented in an exhibition at FACT in 2004 – which takes everyday computing culture, the banality of the office cubicle and the windowed screen, and completely disrupts, disturbs and transgresses it, in thousands of glorious colours and interminable lines of software code.[6] Yet if, as Andrew Graham-Dixon argues in the epigraph above, the radical artist seeks to make work from that which wasn't originally intended to be used for art, then new media artists such as JODI and Ubermorgen, even if the end results of their tactics are different, are definitely both onto something. By continually and voraciously investigating and channelling the networks of culture – such as the web, online gaming platforms,
and the online commercial world – they have secured themselves a never-ending supply of new material for their art practice: the public domain. As Bernhard states;

"The only real artistic production happens with input-feedbacks, when you send out information and you know you will not be able to control it anymore, the information lives on in mass media, it gets manipulated and opportunistically used by journalists, politicians, lawyers and business-people and other artists. Then through the media the story comes back to you and you can spin it, kick in abstract or surreal content, and send it out again to a huge audience."[7]

The landscape of new media art is populated by numerous artist-run organisations, ateliers, labs and collectives that seek to promote the use of open source software and release projects into the public domain to the benefit of as big an audience as can be garnered. These places, such as Eyebeam Art and Technology Center in New York, aren't that interested in what the art world thinks of what they produce, which is great for the constant redefining of art practice that such efforts engender.[8] But at the same time, in my opinion, the educational and outreach efforts of these new hybrid media art labs risk turning new media art into something (be it a product or an object) that has to change the world,
rather than just something which can change how we collectively see or think about the world and, by extension, how we act within it. In the years since FACT opened its new building it has tried to strike a balance in this by working with artists and community groups to make work about the issues which are at play in the life of Liverpool, such as economic regeneration (with *The Bold Street Project* in 2007) and environmental sustainability (with the *Climate for Change* projects in 2009).

It is not my aim in this essay to question the radical intention of the artist's gesture, its relationship to avant-garde practice, or the question of originality within the field of new media art or even the wider field of art (it's just too big a question, and one about which others – such as Charlie Gere, Sadie Plant, and the late Nicholas Zurbrugg, who would have been perfect to take up this task – have written clearly and well).[9] I take as a given that the radical in art can be in method, in means, in material and in intent. I also take as given that in visual art (more than in new media art) originality is often valued more highly than being radical, and so I would seek to separate out questions of originality . m questions of mass reproductioɪ or the mass 'pervasion' of media. In other words, I would suggest that, unlike so-called 'original' works of art, 'radical' works would not

necessarily be one-of-a-kind or singly authored projects. It is surely possible to be both radical and subversive, or radical and activist, even in unoriginal terms, using outdated modes of practice. In fact, after discussions with Lisa Haskel, the founder of Merseyside Moviola, the precursor to FACT, I am inclined to agree with her that there are no radical works of art, only radical ways of working:

"I think it is the approach and work of individual groups that is groundbreaking rather than single works that people have produced. The world of non-spectacular media arts – network practices – are much more like social experiments. The mindset of individuals and the way that they communicate how they think about the world and its problems is what has really been important. It's people's thinking and approach, intervening in culture, working in groups, working together. Experimental media practice isn't about pieces of work." [10]

It could be posited that radical ways of working are most often based on skill-sharing and collaboration – if the practice of artists and curators in the field of new media art is anything to go by – and there are as many kinds of collaboration as there are genres of art. A great example is FACT's longstanding Collaboration Programme and its support of the artist group Superflex and Sean Treadway in setting up the tenantspin

project using the Superchannel toolkit.[11] Running since March 2001, tenantspin is a weekly hour-long programme broadcast from a live interactive webcasting studio managed by and for tenants of Liverpool's Arena Housing. They've generated over 600 hours of programming, about life in Liverpool and the activities of FACT, even while many of the members of the collaboration have changed along the way.

Andrew Graham-Dixon goes on to say that "[it] is in the nature of any radical gesture that it should lose its power with repetition". And yet the practices of JODI, Superflex and Ubermorgen all deliberately contradict this, because they twist and kick in new content with each repetition, each recursive loop, practically, technically and aesthetically. So there is something to unpack here after all. New media art is itself essentially reproducible, distributed, computational and, in many cases, repeatable if not re-enacted, reinterpreted and restaged. So the more interesting question to ask is: how can the ways of working introduced through the practice of new media art, which themselves are radical in their time-based, multi-authorial, distributed, computational and telematic ways, be reproduced? In writing this essay, and without yet having that question in mind, I conducted a straw poll of artists and other cultural practitioners in the field of new media in the UK

and asked them about radical ways of working. Lisa Haskel admitted to being a great believer in projects that have a finite goal for a group of people and then "seeing where that gets you; produce something, evaluate it, and move on to the next". Irational.org co-founder Rachel Baker suggested that it is projects and practices that usefully explore and 'upset' the modes and languages of the artistic with the activist and entrepreneurial opportunities of networked practice that seem the most radical in gesture. Curator Ele Carpenter pointed me back to FLOSS (free/libre and open source software) methods and using the technology available rather than the newest toys, making toolkits rather than products or objects. FACT curator Karen Newman stated that artists need collaborators as a way to tap into other communities and other skillsets, such as those in the sciences, if they are to make challenging works: "no-one can be an expert in everything," she wrote. These are all useful lessons in trying to create a model for radical practice.

The responses from artists were more pointed. One wrote of being put on a blacklist by the director of a media arts institution – for being too radical, perhaps? Another, Armin Medosch (whose collaboration with Shu Lea Cheang resulted in the *Kingdom of Piracy* 'file-sharing' projects commissioned for FACT's opening show in 2003), warned of not being seduced

by new media art's fake radicalism, whereby "media artists and media art gurus appear radical, when in fact they are, on a certain level, socially conservative, because they can take their eyes off the social relationships reproduced by [...] technology. Rather than looking at the political economy behind the technologies they use, [they only focus on] the ability of those technologies to engender new 'meanings'".[12] This echoed the thoughts of curator and producer Helen Sloan, who commented that in the 1980s and 1990s network-based practice was 'anything but radical even though theorists tried to make it that way. The reality was far more underwhelming than the rhetoric'.[13] All the responses played down the common artist-as-genius model in favour of artists working in groups, sharing skills and knowledge, workshops, outreach, and what Lisa Haskel called the 'daily grind of educational work':

"In the early days we collaborated with a group called Jackdaw Media (Laura Knight, Yvonne Eckersley, Strinda Davies) who were fantastic educators in animation and could do amazing things in just one day with a roomful of kids, a clockwork Bolex camera, a Soviet-made home developing tank for 16mm film and a hairdryer. So probably not aesthetically radical, but definitely committed to the daily trials and tribulations of what's now called grassroots work." [14]

Perhaps in today's fast-paced, commercially driven, media-saturated and technologically enhanced world a commitment to a hands-on daily grind is indeed radical. That is certainly the feeling I get when I tell people about the Star and Shadow Cinema in Newcastle – a venue run by a volunteers' collective that has been hand-built, recycled, and designed for building social networks and showing all forms of moving image work.[15] FACT has proven itself as a venue in which the results of this way of working can be best shown, with an international programme that integrates gallery exhibitions with cinema screenings and artist talks and workshops, such as, for example, in the retrospective of the Black Audio Film Collective (2007).

Having argued that it is in practice rather than in specific projects that radicalism emerges in new media art, I have been asked to include in this essay some ideas about what gestures or actions artists might undertake today that could still seem radical in a hundred years' time. I have no interest in prognostication, knowing that horoscopes are only interesting when read a day late; however, I leave you here with a list of projects by artists whose practices I believe to be collaborative, socially engaged and open, and to contain the potential to be politically and aesthetically radical:

Seen recently at FACT, Luke Jerram's The Dream Director invites visitors to sleep in the gallery in specially designed pods wearing movement-tracking eye-masks which then trigger ambient sounds, so that the dreamer effects the programme which then affects their dream. The project is being developed in collaboration with sleep scientists.

Jamie O'Shea has proposed building a coal-fired rocket and aiming it down at the planet in order to try to move Earth slightly out of orbit. If we're all going to die in an environmental catastrophe of our own making, we may as well try to do something monumentally useless in the process.

Community radio pioneer Susan Kennard has proposed giving the FM band completely over to artists when the commercial companies and national trusts now ruling the airwaves all move to digital channels.

Wafaa Bilal has proposed having a camera inserted into the back of his skull which takes a photograph every minute, archiving online images of all the places he leaves behind.

Jae Rhim Lee is working on transforming the embalming industry by developing suits and coffins with genetically modified mushrooms to speed up the decomposition

process by promoting the growth of harmless fungi.

Lisa Jevbratt is working on plug-ins for image manipulation software which would transform pictures so that they might be more easily read by other species, such as dogs or birds. (Imagine a Flickr site made just for your cat! It seems they already control YouTube.)

Simon Pope has been working on projects that exist only in the mind's eye, memories and spoken recollections of the visitors to and participants in the place and time in which the project takes place.

Whether these projects, once fully realised, if indeed they ever are, seem radical or not, we'll just have to wait and see.

1: A line from the song *We're Hardcore* by Gordon Downie, from the album *Battle of the Nudes* (2003).

2: Andrew Graham-Dixon, *Radical chic and the schlock of the new* in The Independent, February 1993.

3: Positions in Flux, organised by the Netherlands Media Art Institute, May 8, 2009.

4: Ubermorgen is an artist group which consists of Hans Bernhard and Lizvlx. www.ubermorgen.com

5: Hans Bernhard, 2009. *Ubermorgen manifesto*. www.ubermorgen.com/manifesto/

6: www.jodi.org or www.wwwwwwwww.jodi.org

7: See endnote 5

8: www.eyebeam.org

9: See for example: Charlie Gere, *Digital Culture* (2002) Reaktion Books, London; Nicholas Zurbrugg, *Critical Vices: The Myths of Postmodern Theory* (2000) G&B Arts International, Amsterdam; Sadie Plant, *The Most Radical Gesture: The Situationist International and After* (1992) Routledge, London.

10: As told to Sarah Cook in a phone conversation, May 14, 2009.

11: www.superchannel.org and www.superflex.dk

12: Armin Medosch in an email to Sarah Cook, April 13, 2009

13: Helen Sloan in an email to Sarah Cook, May 8, 2009

14: Lisa Haskel in an email to Sarah Cook, May 12, 2009.

15: www.starandshadow.org.uk

« Artists, like engineers, have a habit of revisiting orphan technologies and rebuilding them for present purposes. »

There were a number of discussions in venues across Merseyside about the new name. There was, it has to be said, a degree of opportunism in the phrase 'creative technology': we wanted to be able to attract funding not only from arts agencies but from the far richer funds available to science and technology. But there was also a fundamental vision to the term. For many people throughout the Twentieth Century and before, technology had been the opposite of creative. In Blake's vision of 'dark Satanic mills', in Dickens' satire on industrialisation in *Hard Times*, in Charlie Chaplin's paranoid comedy of the machine devouring the worker in *Modern Times*, all the way to 1999's *The Matrix*, technology has appeared in all sorts of media as the enemy.

True, there had also been a vital tradition of artists and engineers as disparate as El Lissitzky in revolutionary Russia and Buckminster Fuller in Eisenhower's USA who saw in machinery the possibility of liberation, in every possible sense. What now seems in retrospect a golden age of libertarian idealism sprang up with the opening of the Internet to mass participation in the 1990s. Here was a technology for us. This was the device that would open up radical democracy, and put the tools for infinite creativity in everybody's hands. Perhaps the subsequent commercialisation of the web has dimmed that utopian

flame. But each new scientific discovery, every new technology, seems still to lift our hearts with the thought that this time we might be able to bring about something absolutely wonderful.

There are two senses to the phrase 'creative technology'. In the context of the UK's premier venue for the media arts, there is the meaning of 'creative use of technologies'. But with MITES and the Medialab, a second meaning is also clear: 'the creation of new technologies'. Typically, in the highly specialised societies we have grown up with in the advanced industrialised countries, these two things seem to be the tasks of quite different groups of people. These groups map what C. P. Snow, back in the 1950s, called the 'two cultures': arts and sciences, which seemed to have drifted so far apart that there was no commerce between them.

What has been fascinating to watch over the twenty years of FACT's history has been the intense collaborations which produce innovation in both of these senses. Take for example Madelon Hooykaas and Elsa Stansfield's *A Personal Observatory*, included in *Video Positive* in 1990. One element of the installation was an early LED screen which could only be viewed from a position directly in front; a second was a video projection set up so that the projector was close to the wall and at an angle

to it, making the image fan out across the wall in a kind of anamorphic distortion. While the content of the work also had much to say, the comparison of these two ways of looking, two ways of making a personal observatory public, extended the operation of both display technologies, revealing more about them than any standard use.

Then there are those incremental innovations that we call technique. Every technology, especially electronic and digital technologies, comes with a set of instructions. They may take the shape of an actual manual. Or they may be buried in the design. Electronic screen technologies, for example, all use a system of lines and columns, the raster grid. They depend on compression-decompression algorithms which work better with some kinds of image than with others. They have colour spaces and ways of encoding them that impact on what colours can be achieved. So when an artist is looking for colours that simply aren't in the palette available, they have to find a way to produce them. This is what Judith Goddard did in 1992 with *Descry*, an eight-monitor installation which used the flicker of the screens and a progression of colour fields passing from one to another to create colours that existed only in the eye of the perceiver.

Goddard's installation included a small monitor showing details of

an operation in which a human lens is being replaced with an artificial one. Her work is, in one sense, also an operation on the eye, but it is also an indication that there is no clear separation, especially when it comes to visual perception, between the perceiver and the technology. That this also applies to sound was clear from Granular Synthesis' performance of *Noisegate* at Cream for the opening of *Video Positive* in 1998. Here innovative midi software devised by the artists and a one-off assemblage of sound equipment created a visceral experience of subsonics that made your inner organs dance around inside your body. 'Hearing' happened with your feet, your chest, your bones, even muscles and skin seemed to vibrate and turn to standing waves.

In small and large ways, creatives tinker with the tools they inherit, making them into new things as they seek out the effects they imagine, or simply through playing with them in ways they were never designed to be played with.

The history of technology is littered with roads not taken. Perry Hoberman's *Faraday's Garden*, installed at the Cornerhouse for *ISEA '98*, was a treasure trove of office equipment and household appliances, many of them dead-ends of development such as Viewmasters and eight-track cassettes, triggered to start working when you walked

through the installation. Suddenly flickering into life, a junk-shop 8mm film projector would show a loop of some lost family movie, or a Dictaphone play back a long-forgotten memo. Among the many things to say about this wonderful contagion of contraptions, I want to notice just one: the resurrection of dead technologies. This has an honourable history: the plasma screen, for example, was an equally abandoned dead-end when Larry Weber, then a PhD student, began his forty-year career developing it into the commercial giant it is today. Artists, like engineers, have a habit of revisiting orphan technologies and rebuilding them for present purposes.

This isn't just about those filters you find in video editing software that allow you to add dust and scratches, as a way of making new things look old. It's about how technological innovation occurs. Adobe Photoshop added the lens flare plug-in at the request of founder Thomas Knoll's brother John, then working with Industrial Light and Magic. The idea was to emulate the presence of a camera in place (like the *Star Wars* universe) where there were no 'real' cameras. So emulating an unloved artefact of physical cameras became a way of signalling that a digital image was related to the actual presence of a camera. Soon enough, people started using the flare plug-in to create

other effects, such as giving an impression of three dimensions to a two-dimensional image – a trick that is now one of the universal marks of digitality.

This type of innovation on the fly, followed by the repurposing of a technology which finally turns into exactly the opposite of what its designers first intended, is not at all untypical. There are stories about how Picasso mistreated his engraving tools while producing what is probably the most significant intaglio print of the Twentieth Century, the *Minotauromachia*.

Abel Gance tied cameras to horses or dangled them from ropes to enliven his epics of the late 1920s. Jean-Luc Godard and Bill Viola are two of many artists to work closely with camera designers. Even Bing Crosby took a major hand in the development of videotape. In Crosby's case, he was tired of touring from TV station to TV station to give live performances: recording was a way of maximising his time. Very quickly others, from Ernie Kovacs to Frank Zappa, recognised the potential of instant playback, video feedback and the various by-products of tube cameras, such as flare, comet tails and later colour bleed, to produce effects that film could not.

Creative technology is not the exclusive zone of engineers. Many artists have made themselves into

engineers in pursuit of effects that the current tools simply don't supply. In the 1980s, a number of video artists, including Jez Welsh, used analogue techniques to emulate and in some ways satirise the emergent digital language of music videos, adverts and TV title sequences. The whole arena of software art has developed in close relation to this tradition, going back at least as far as Graham Harwood's 1995 innovations, developed in order to produce one of the most emotionally harrowing of all the achievements of the Collaboration Programme, the interactive installation (and later CD-ROM) *Rehearsal of Memory*.

The interplay of technique and technology is scarcely acknowledged, but it has an honourable history, and its own place in the articulations of creativity and commerce. For example, manufacturers have often been extremely generous in giving or leasing equipment in return for insights into the unforeseen uses to which artists might put their machines. Xerox art, video art, computer art are almost unimaginable without the participation of Xerox, Sony and IBM at crucial stages in their development.

This has to raise the question: is creative technology a Good Thing? Vilém Flusser, the Czech-Brazilian philosopher of media, argued in his book *Towards a Philosophy of Photography* that the photographic

apparatus – by which he meant the whole ensemble of people, institutions, manufacturers, manuals, magazines and exhibitions – was a single machine. As a machine (he didn't specify a capitalist machine or a disciplinary machine, but we could add those ideas), it was no good at innovation. The apparatus needs photographers to supply the missing randomness which its ordered way of working cannot produce. He thought that the purpose of the photographic apparatus was to take all possible photographs, and that photographers were merely functionaries to that end, but that they also supplied the creativity, the unforeseeable elements, that made that a possibility.

We can use this way of thinking to look critically at the idea of creative technology. Is creative innovation in technique (innovative use) and technology (innovative tools and functions) just a way for the technology industry to benefit from the unpaid creative labour of the people who use their machines?

This isn't an easy one to answer. You could say there is a kind of contract: even if we pay for our computers, software and Internet connections ourselves, and produce content and ideas for no pay, we are the ultimate beneficiaries of the innovations that result from our unpaid work. Take away the profit motive from this circuit and

you have the basic concept for the peer-to-peer economy: I give an hour's work to a project such as Wikipedia or Linux, and in return I get thousands, hundreds of thousands of hours of other people's work. The difference between the two systems is only money. Some of us prefer one to the other; most of us operate in both economies, especially when we are being creative.

The word 'creative' has behind it, in the West at least, the shadow of Genesis, of God creating the world out of nothing. Actually, the Bible is a little more specific than that: "the earth was without form, and void; and darkness was upon the face of the deep. And the Spirit of God moved upon the face of the waters". The Hebrew phrase translated as 'without form, and void' is *tohu wa bohu*, a phrase that the French use to describe any chaotic brouhaha. The universe was full of stuff, but had no form. Then God created light and – this is the key expression – "divided the light from the darkness".

Creativity is about giving form, and form is about distinguishing one thing from another. It is a process of ordering. Not being a religious man, I prefer to think that there is in human beings something like an instinct towards order. Like our other instincts, it can become obsessive – to the point of fascism. And like our other instincts it can turn into its opposite. As hunger can turn into disgust and love into hatred, the rage for order can turn into destructive and chaotic behaviour, ripping down and ripping up the careful order with which we protect ourselves from the horror of an unformed universe.

Art and technology are both ways of working with that rage to order. Both can turn to the dark side, of course, and it is the function of critical thinking and cultural practice to keep tabs on that. But now and for the foreseeable future they are of the same root stock. They both speak to the relationships between humans, the laws of physics and the instruments we use to mediate between them, to find our ways towards better relationships between the three orders of the world: political, physical and technical.

Writing this, I heard one of the children playing football in the street saying "We just have to move the goalposts". That's pretty much what it's all about.

D

—

1998–2002

—

Projects/
Building
& Growing

—

FACT entered a transitional phase at the turn of the millennium, approaching the last *Video Positive* festival while construction took place on the new, permanent building on Wood Street that was to become the central hub of its core artistic programme. At the same time, FACT took on a number of other major projects, staging *ISEA '98*, initiating tenantspin, and forming a relationship with the recently established Liverpool Biennial, through an impressive range of new commissions, exhibitions and events.

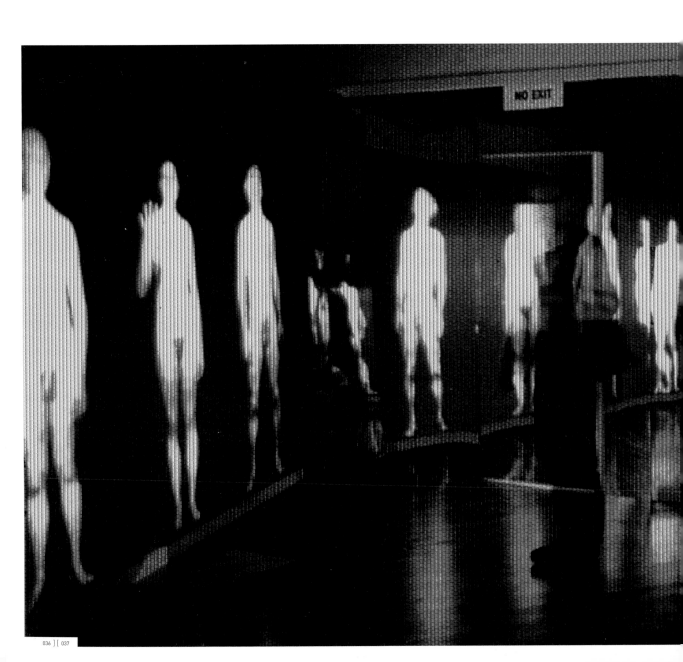

Under the directorship of Eddie Berg, with Charles Esche as lead curator, FACT brought the *International Symposium on Electronic Art (ISEA)* to Liverpool and Manchester in 1998, under the title *revolution98*. The symposium was jointly organised by Liverpool John Moores University and Manchester Metropolitan University, themed 'Revolution', which explored the potential of the human-computer interface; and 'Terror' which examined how the fear of technology could impede future developments. Taking place across 25 sites and venues including galleries, warehouses, theatres, clubs and trains as well as the Internet, *revolution98's* core artistic programme investigated how the digital revolution failed to deliver its predicted utopia. *ISEA '98* included the presentation of 60 multimedia artworks, screenings and performances of which half were new commissions. Key works included: Gina Czarnecki, *Stages, Elements, Humans*; Kristin Lucas, *Screening Room*; Willie Doherty, *Somewhere Else*; Johan Grimonprez, *Dial H-I-S-T-O-R-Y*; Nedko Solakov, *The Right One*; Cornford & Cross, *Cosmopolitan*; Keith Piper, *Robot Bodies*; Perry Hoberman, *Faraday's Garden*; Feng Membo, *Taking Mt Doom by Strategy*; and collaborative projects such as *Revolting Temporary Media Lab* and *Mercurial States* managed by artists Micz Flor and Kooj Chuhan respectively.

069
Stages,
Elements,
Humans
-
Gina Czarnecki
-
Ferens Gallery,
Hull

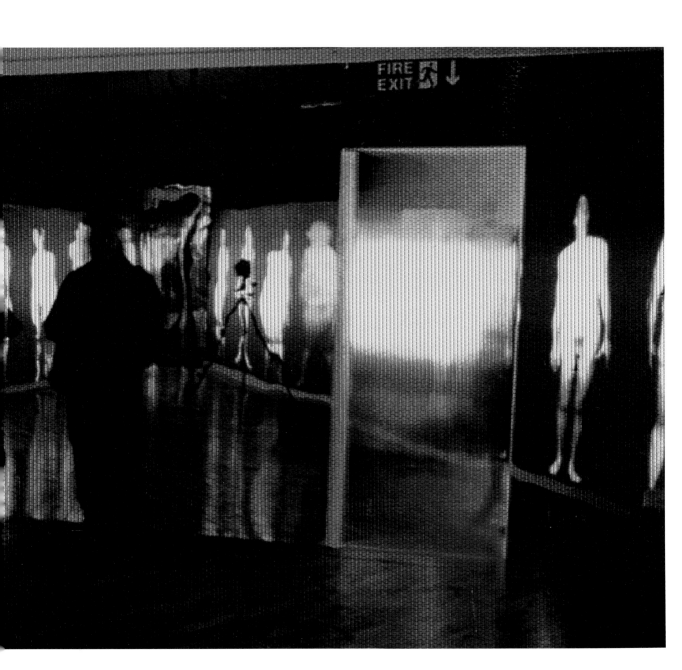

'99

The rise of the Internet in the mid-to
late 1990s and its evolution through-
out the early years of the Twenty-First
century has seen a plethora of new
tools and modes of working become
available to the cultural sector.
Defined as Web 2.0, the second
phase of the Internet's evolution
as a platform is characterised by

« tenantspin is about what happens
when residents, most of them in their
60s and 70s, from more than 30
tower blocks, join forces to forge
a unique cultural voice.

It's about how the histories and
perceptions of the city of Liverpool
have shaped and defined this
project. It's about what happens
when its objectives are achieved,
and what might happen next. »
—
Eddie Berg
http://ext.cdu.edu.au/newsroom/a/20
06/Pages/1351/aspx

070
the tenantspin
show
-
photographed
at The Fifth Floor
exhibition, Tate
Liverpool 2008

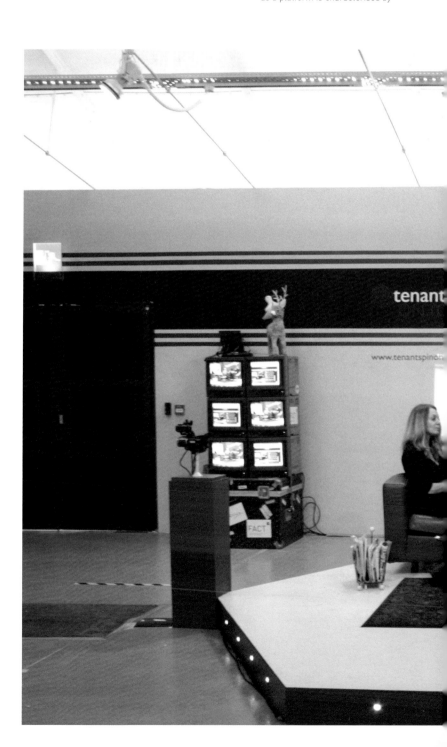

social media websites and open source philosophies. FACT has challenged and experimented with these 'new tools' since its early days, with tenantspin, our online broadcasting project, widely recognised as one of the world's first experiments in social media. Throughout our history we have endeavoured to challenge, subvert and utilise new digital developments. Fast forward to 2009, and the technological landscape in which we operate is radically different. We have become technologically dependent in many areas of our lives and we routinely use technology every day, whether it is the television, the personal computer or the mobile phone. The vast majority of us are users, lacking the knowledge of how to build these tools ourselves, instead becoming consumers of technology – dependants. We are also witnessing the convergence of different media: no longer is the personal computer hidden in a corner while the television enjoys the full attention of the living room's inhabitants. The digital switch-over means that mobile, broadcast and online technologies are now merging – we are connected.

—

Patrick Fox, tenantspin
Programme Manager, FACT

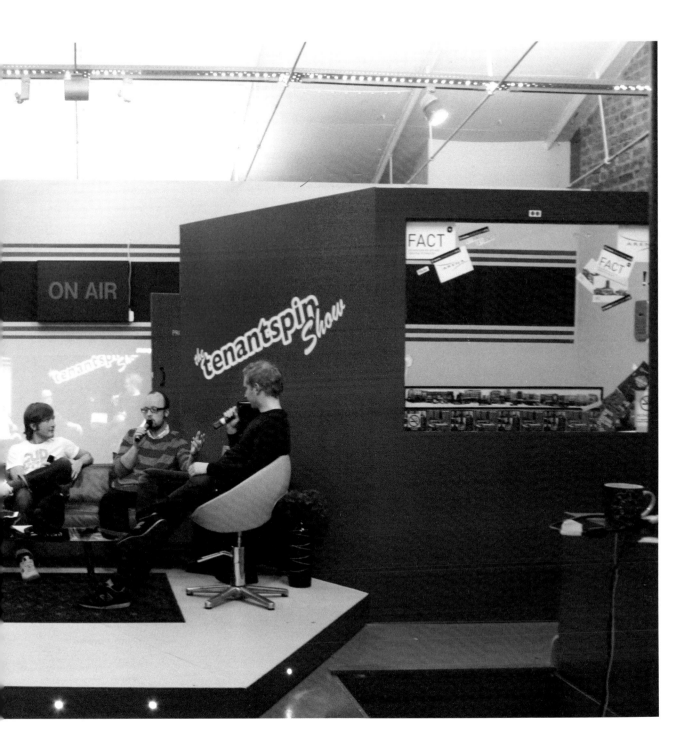

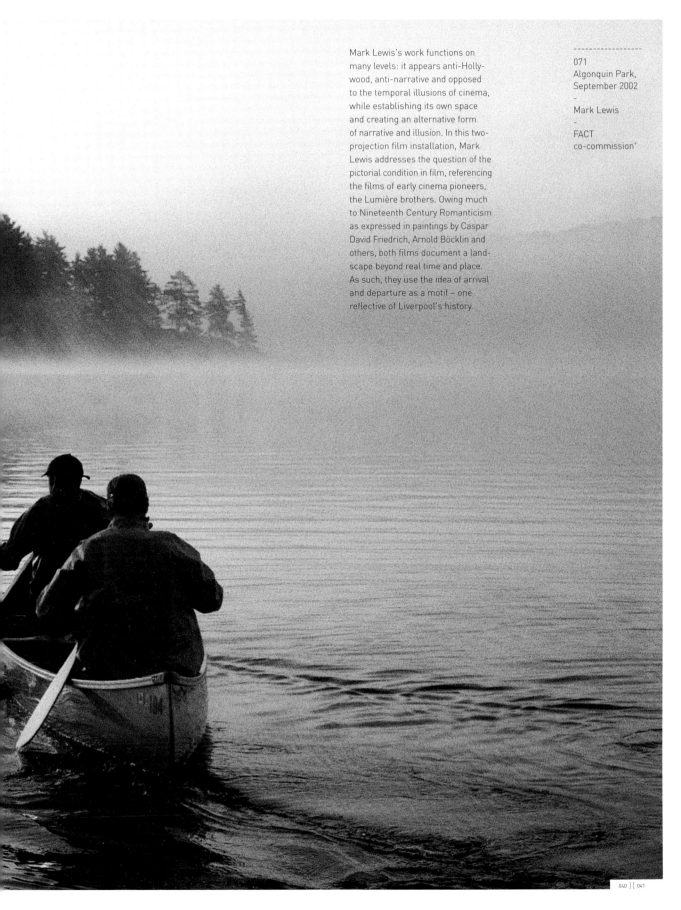

Mark Lewis's work functions on
many levels: it appears anti-Holly-
wood, anti-narrative and opposed
to the temporal illusions of cinema,
while establishing its own space
and creating an alternative form
of narrative and illusion. In this two-
projection film installation, Mark
Lewis addresses the question of the
pictorial condition in film, referencing
the films of early cinema pioneers,
the Lumière brothers. Owing much
to Nineteenth Century Romanticism
as expressed in paintings by Caspar
David Friedrich, Arnold Böcklin and
others, both films document a land-
scape beyond real time and place.
As such, they use the idea of arrival
and departure as a motif – one
reflective of Liverpool's history.

071
Algonquin Park,
September 2002
-
Mark Lewis
-
FACT
co-commission*

'99 — 02

D
Building
& Growing
—
Building
—
Construction
1999–2002
—

072

076

073

077

074

078

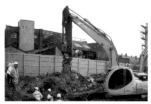

075

079

We were fast approaching the furthest limits that we could go as an agency. We needed to move on. In time, we needed to establish our own space, to tell our own story, to provide facilities and resources to more effectively and pro-actively support practice and ideas and create a more measured and strategic approach to infrastructural support. But we also needed to establish a place where a wider field of artistic expression through the moving image and new media could be experienced and explored.

In September 2000, demolition of the former Gold Crown Foods site in Wood Street commenced. Later that year building work began on what would become the first purpose-built arts project in Liverpool since the completion of the Philharmonic Hall in 1939. On 22 February 2003, almost eight years after I'd written two pages of A4 describing the project, the FACT Centre opened to the public.
-
Eddie Berg,
Text extracted from *Construct*

072
Original
pre-FACT site

073 - 094
Construction
images
-
Austin-Smith:
Lord

080

084

087

091

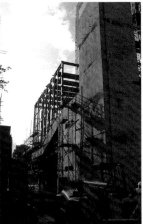

081

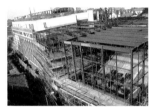

088

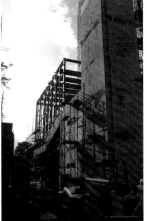

082

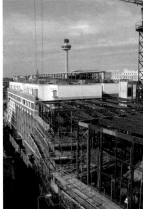

085

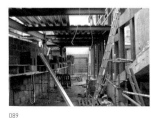

089

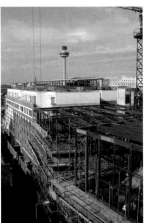

092

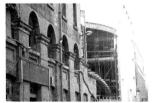

083

086

090

093

094

'02

D
Building
& Growing

–

A Finished
Building
2002

–

096

098

100

102

097

099

101

103

104

106

108

105

107

109

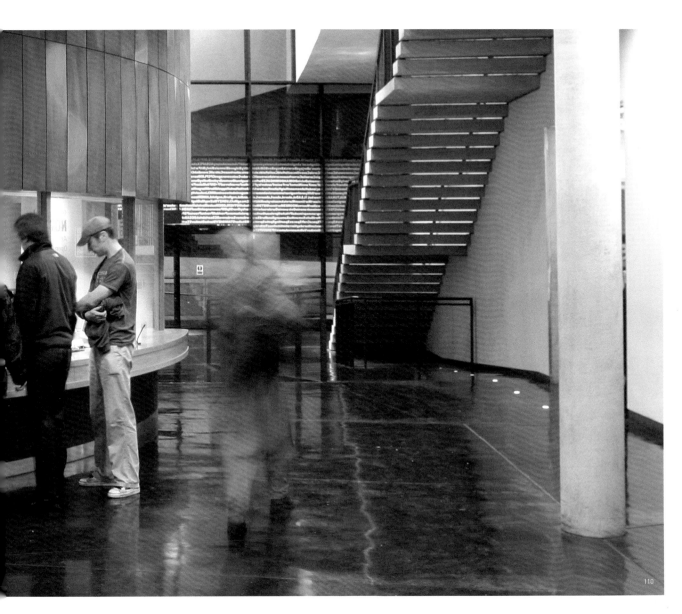

110

D
Building
& Growing
—
Permanent
Artworks
—

The design of FACT was the result of close collaboration between FACT's Lead Artist, Clive Gillman, and architect Austin-Smith:Lord. FACT wanted a building to reflect its aspirations – as much through images, sounds and texts as through architectural features. Clive Gillman worked with Austin-Smith:Lord to develop artworks or features that would form an integral part of the building. Some formed part of the building design itself – such as the zinc-panelled exterior and its interactive lighting system – while others were new commissions created in response to the building design process – such as the Singh Twins' beautiful lightbox portraits in the foyer. The work of the Lead Artist was also supported by the Royal Society of Artists through their Art for Architecture scheme.

111/112
Orientation Wall
-
Clive Gillman
-
Foyer

113
7 portraits
-
Amrit & Rabindra Singh
-
South Windows

114
External Lighting
-
Clive Gillman
-
FACT Building Exterior

115
Metroscopes
-
Clive Gillman
-
Ropewalks Square

Tune
greyworld

-

greyworld adapted some of the existing functional sounds within the building – such as those made by the lifts, tills and telephones – and 'tuned' them to create an audio palette, where each sound is part of a building-wide melodic composition.

External Lighting
Clive Gillman

-

LED light columns and graphic displays form an interactive lighting scheme that functions as a clock, building meter or web-based game.

Local Heroes
Graham Parker

-

A dictionary of unique words generated by FACT during the design and building process, applied to the glass wall at the back of the Centre, casting literal shadows into the café and foyer.

7 portraits
Amrit & Rabindra Singh

-

Seven miniature illuminated portraits of individuals who represent part of the development of the building, using the stylised and allegorical imagery of Seventeenth Century Mughal portraiture.

Metroscopes
Clive Gillman

-

Metroscopes is a constantly changing display that represents Liverpool's relationships with its four twin cities – Odessa, Dublin, Shanghai and Koln. By searching the Internet for live information about each city and displaying the results on five circular LED displays in Ropewalks square, it acts as a barometer for current thinking about these places.

115

—

2003–2009

—

Commissioning, Curating & Collaborating

—

« With the opening of the £10m FACT Centre, new media has finally gained its own academy »
–
Alfred Hickling, *The Guardian*, 28 February 2003

« A great deal of lip service is paid to the importance of new media art and the need to present it properly. But frankly, you are usually only talking about a paltry DVD projector in a plywood box. This is a gallery that allows digital artists to think like film-makers and have their ambitions realised in a professional environment. »

Isaac Julien, on the opening of the FACT Centre
–
The Guardian, 19 February 2003

'03

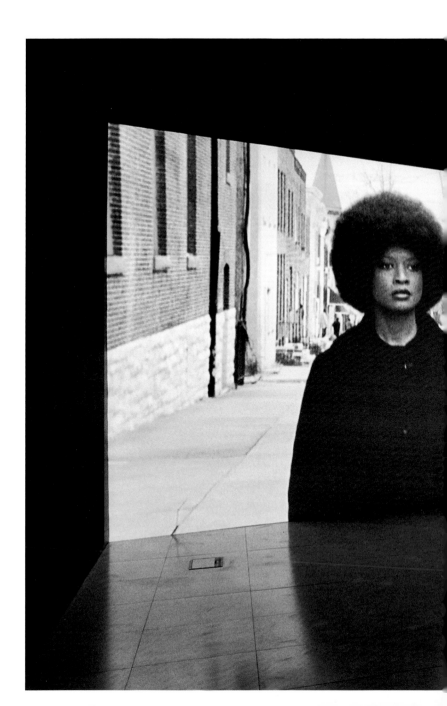

Baltimore
2003
—

Isaac Julien
—

Highlighted Projects:
Baltimore \ Film Programme \ MITES \
Vinyl Video \ Kingdom of Piracy \
Police Radio \ Culture Castles \
If I Am Not Here, I'm Over There \
Celebrations For Breaking Routine \
Deanimated \ Robot Films \
Calling the Shots \ Nothing Special:
Artists' Video, Media & Reality \
Superblock \ Factory

Baltimore was commissioned especially for the opening of FACT. This new three-screen DVD installation, produced by one of the world's leading artists working in film, uses the interiors of museum spaces in the city of *Baltimore* and the stylistic excesses of blaxploitation movies. In 2002, Julien made *BaadAsssss Cinema (Part 1)*, a documentary reappraising the blaxploitation genre. Made for American TV, it featured Pam Grier, Samuel L. Jackson and Quentin Tarantino. Featuring blaxploitation icon Melvin Van Peebles, and producing a contemporary reworking of the genre's gestures, stylings and attitudes, *Baltimore* is a funky yet meditative and richly poetic slice of cinematic art.

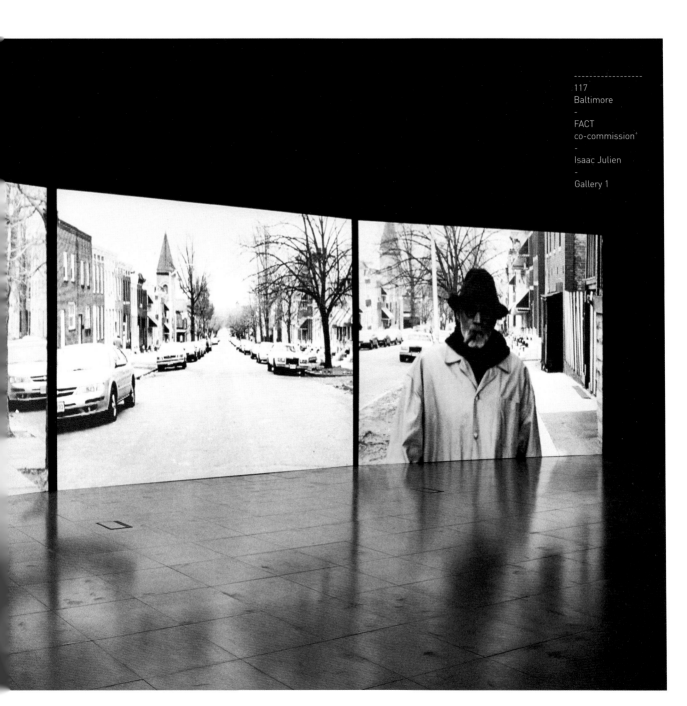

117
Baltimore
-
FACT
co-commission
-
Isaac Julien
-
Gallery 1

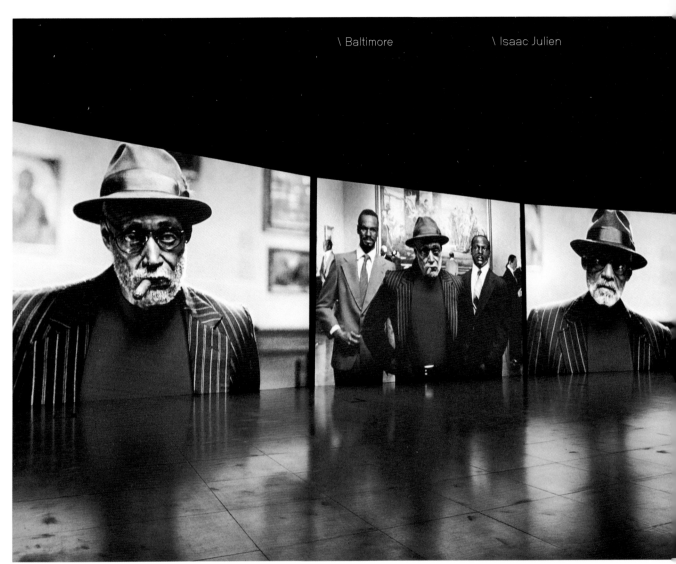

118

118
Baltimore
-
Isaac Julien
-
FACT
co-commission[+]
-
Gallery 1

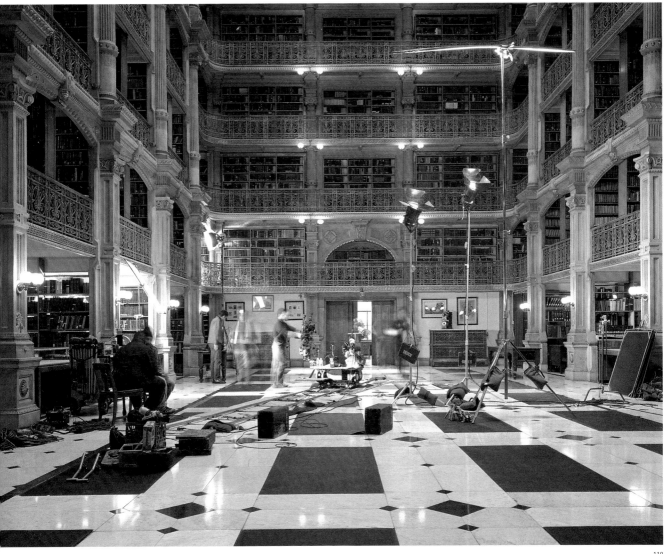

119
Baltimore Series⁺
-
(Filmset/Still Life)
-
FACT
co-commission⁺

FACT Film
Programme
2003 – Present
–
SEEN
–
Liverpool Film Night
and Young Liverpool
Film Night

120
Line Describing
A Cone[+]
-
Anthony McCall

121
Liverpool Film
Night Awards[+]
-
Left to Right:
Laura Sillars,
Terry Cheung,
Colin McKeown,
Paul Banner,
Scott Donovan,
Mike Forshaw,
Roger Phillips

120

Through a range of screenings and one-off events, FACT's film programme has championed the work of artists and filmmakers that explode boundaries between art and cinema. A complementary strand to the Picturehouse cinema programme, its ongoing partnership has brought guests ranging from Quentin Tarantino to Mark Aerial Waller to Liverpool, along with experimental masterpieces and shorts programmes.

SEEN was a provocative and eclectic mix of experimental film and artists' film and video rolled out in regular sessions between 2003 and 2007. The first SEEN featured Baadasssss Cinema by Isaac Julien and continued with highlights such as Anthony McCall's Line Describing a Cone, Jonas Mekas' Paradise Not Yet Lost and Armando Bo's tantalising Fuego. The film programme has since responded to FACT's wider programme ethos, in 2008 exploring its Human Futures theme, and in 2009 reflecting on the issues of sustainability considered in the exhibitions programme.

Launched in 2003, Liverpool Film Night continues today and is a quarterly screening of work by film-makers in the Merseyside region, selected through open submission, with special guest appearances.

In 2007 the programme expanded to include Young Liverpool Film Night, and in 2008 FACT joined forces with Atlantic Chambers, who sponsored a special awards ceremony in which three film-makers were awarded cash prizes and production support for future film projects.

121

MITES
(The Moving Image Touring and Exhibition Service)
—

122

MITES, the Moving Image Touring and Exhibition Service, was born in response to a number of questions arising from the *Video Positive* festival; beyond it, how were galleries going to exhibit new and emerging media without a technologically driven, responsive and artist-friendly support system? What galleries would be remotely interested in exhibiting new and challenging work if there was no infrastructure support in place? Who was facilitating the needs of this new breed of art graduates from the emerging video art and time-based media courses?

With Arts Council England funding, MITES started life with two LCD projectors, one CRT projector, a fleet of U-Matic Players, a dozen or so monitors, and an artist/tech-

nologist leadership that had drive, experience and, most important of all, vision. The funding of a technological support system for art brought an independence to the sector that meant investigative approaches were encouraged and supported across the developing group of interested organisations and artists. An active and dynamic trans-national team of affiliated collaborators pooled knowledge in a way that seems commonplace now but at the time was a relatively radical departure. In the process, they brought about such new technologies as the Corporal IV Sync Starter Units (1992) – built by Montevideo in Amsterdam – which enabled four low-band U-Matic players to be synchronised without having to loop video out

into the space of the gallery. This was a revolutionary asset, and in such demand across the country that FACT, who alone held the units in the UK, could barely keep up. When the *British Art Show 4* toured the UK in 1995 its curators turned to MITES for technological support. Organised by the Arts Council through the Hayward Gallery to showcase British art, this took place at the height of the YBA explosion and was a huge under-taking across multiple venues in multiple cities. It was also a catalyst for MITES to ramp up its services and assist in putting new technology at the heart of a burgeoning art scene. With the success of the shows, MITES became recognised as the de facto organisation in the UK for the technical management of

large-scale art events.

But more importantly, this success enabled a complete transformation of the equipment that MITES had at its disposal, increasing tenfold its ability to provide support to artists and galleries across the UK. This went some way to equalling demand in the short-term. In the long-term it was the first of MITES' successful lottery applications that indicated a continued, genuine and committed support from the Arts Council for long-term investment in a facility for artists and arts organisations that wanted to develop investigative, emerging and new media work.

ITEM was a research and develop-ment programme supported by NESTA (National Endowment

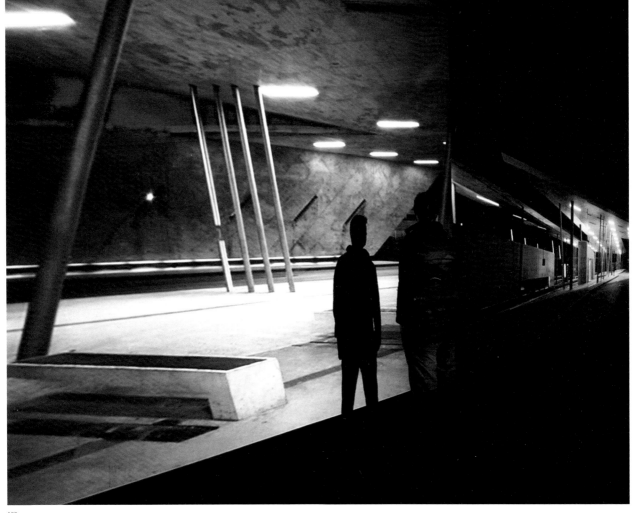

 123

for Science, Technology and the Arts) and Arts Council England. The programme supported a small cluster of artists and technologists interested in exploring the possible future directions of new media technologies. The projects it encompassed included research into RFID tagging for museums, interaction in relation to early computer science at the Manchester University, multiple narratives in online film production, self-powered outdoor video screens for permanent outdoor installation and illusion within 3D audio environments. All of these technologies have in some way gone on to become implemented into our everyday lives.

Both ITEM and New Tools are hands-on training and development schemes in which it is essential that participants can feel that they are part of the programme, rather than mere recipients of it. The things that they find out go back into the fields in which they practice, and encourage a developmental and experimental approach in all areas of engagement. This is serious play, where the outcome is uncertain, the rules are barely defined and the aim is as much to engage as it is to produce a 'result'. FACT's technological investment operates on the principle of sharing. With joined-up networks in the creative industries that include our status as a NorthernNET Access Bureau, participation in Liverpool's Culture Campus, the National Archive Group (known as Future Histories), the *Art of Digital* programme, the *AND* Festival and a desire to share information and knowledge with other organisations and individuals in one-to-one surgeries, in-house, online or by phone, FACT is heavily involved in trans-organisational boundary pushing. This is social, and it is computing; and it is based on Joy's Law – that the best people don't work in your organisation.

To retain this knowledge, FACT has been strategically building a public online resource of publications, presentations and exhibitions through its archive and through FACT TV. This is common knowledge, freely available, open to ideas and critique, and it is ongoing.

This approach has enabled us to rethink the notion of partnerships, share technology and develop supportive, knowledge-based economies.

This means breaching ingrained business practices and breaking down outmoded forms of behavioural economics such as the 'winner takes all' mentality. This perceptual shift extends to notions of audience too. The approach of 'local includes global' (the new business model) rather than 'local towards global' (the old business model) is the closest we have yet come to the business and art community realising Marshall McLuhan's global village. This is where dependence on a strong economy ends and a new economy begins.

Roger McKinley,
Production Manager, Digital Media

VinylVideo™
2003
–

Gebhard Sengmuller
Penny Hoberman
Julia Scher
–

VinylVideo™ presents new *Picture Discs* by Perry Hoberman and Julia Scher (2003).

VinylVideo™ is an analogue system enabling moving images to be played back from ordinary LP records. Using a turntable connected to a specially designed conversion box (the *VinylVideo™ Home Kit*), images are displayed on a TV screen or projected, and can be manipulated by changing the record speed.

23 *VinylVideo™* records have been produced, featuring artists such as Vuk Cosic, Alexei Shulgin, Kristin Lucas and JODI. For FACT's launch, two *VinylVideo™* picture discs were commissioned from American artists Perry Hoberman and Julia Scher and the gallery became a 'shop' where visitors played records and browsed through the *VinylVideo™* merchandise.

124/125
VinylVideo™
–

Gebhard
Sengmuller
Penny Hoberman
Julia Scher
–

Gallery 2

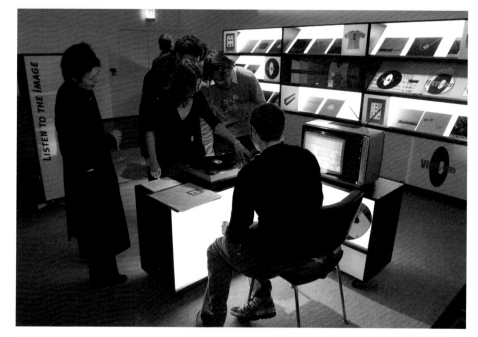

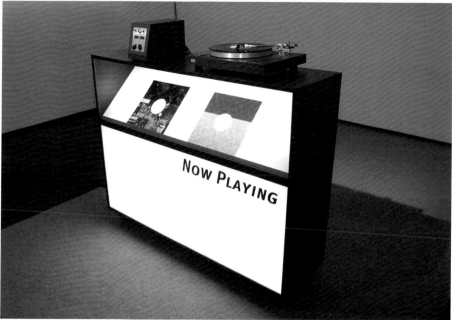

124/125

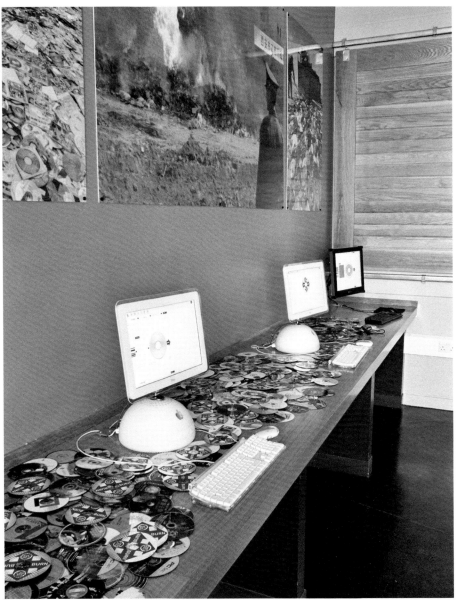

126

126
Burn
–
Kingdom
of Piracy
–
FACT
co-commission⁺
–
Media Lounge

The Media Lounge is a curated space for computer-based and video art. *Kingdom of Piracy (KOP)* was an online workshop exploring the free sharing of digital files – often condemned as piracy – as the Internet's ultimate art form. *KOP* featured 14 commissioned works and four new projects: *Last.FM* (2002), *NINE9* (2003), *Frequency Clock* (1998/2002) and *BURN* (2003).

Last.FM by Felix Miller, Martin Stiksel, Michael Breidenbruecker and Thomas Willomitzer is an adaptive music station that learns what you like to listen to (and what you don't) and connects you to other users with similar tastes. Mongrel / Graham Harwood's *NINE9* is a social software project that allows nine groups or individuals to map a text, image or sound archive for life-sharing and collaboration. *r a d i o q u a l i a* (Honor Harger and Adam Hyde) provides a solution to the problem of what to watch on TV – its Frequency

Clock allows you to set the broadcast schedule on Internet TV and radio yourself. *Kingdom of Piracy* also presented *BURN*, a new installation and filesharing interface that responds to an incident when the Chinese government burnt thousands of bootlegged CDs. The *BURN* webserver was transformed into an archive of public domain MP3s, made available to download and burn to CD.

www.policeradio.org.uk
2003
–
Nick Crowe
with South
Merseyside
Police
–

Police Radio is the world's first
web radio station with a playlist
selected entirely by police officers.
Their eclectic musical choices are
punctuated by sound recordings of
the officers on patrol: dealing with
juvenile delinquents and drunks.
By turns grave and humorous,
this 24-hour programme provides
an intriguing insight into life in an
urban police force.

www.policeradio.org.uk

127

Experiments
in Architecture
Education
2003
–
Culture Castles
–

Investigating art, architecture and
the built environment, www.culture
castles.co.uk showed the outcomes
of work with artists, architects,
engineers and filmmakers to
provide a resource to initiate new
activity and a place to play. It was
produced in collaboration with Ove
Arup Foundation, Dingle/Granby/
Toxteth Education Action Zone,
Speke/Garston Education Action
Zone, Liverpool Housing Action
Trust and The Hapold Trust.

127
Police Radio
-
FACT
Collaborations
commission
-
Nick Crowe
with South
Merseyside
Police
-
Media Lounge

128
Experiments
in Architecture
Education
-
FACT
Collaborations
commission⁺
-
Culture Castles
-
Animation
sequence for
the website

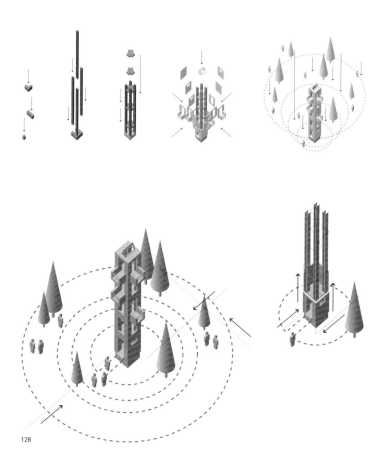

128

If I am Not Here,
I'm Over There
2003
—
Zilla Leutenegger
—

The first solo exhibition in the UK by Swiss video and animation artist Zilla Leutenegger. Her prolific output and body of work (she has produced over 50 projects during the past five years) ranges from topics of loneliness and alienation to playful narratives and delicate fantasies centred on the artist herself. The two video installations exhibited at FACT encapsulate the themes and ideas that underpin her entire artistic output. In *Zipcode*, Leutenegger talks to herself on a mobile phone in a non-existent language resembling Japanese. In *My First Car* we are invited to take a journey to the moon where a car and its mysterious passengers endlessly circle the barren landscape.

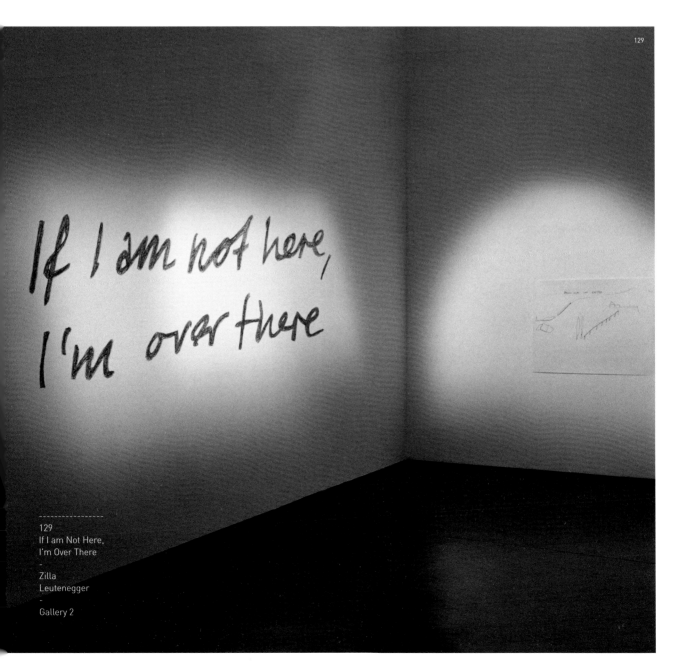

129
If I am Not Here,
I'm Over There
-
Zilla
Leutenegger
-
Gallery 2

Celebrations
for Breaking
Routine
2003
–

Kristin Lucas
–

In the Summer of 2002, three girl bands from Merseyside were invited by New York-based artist Kristin Lucas to write songs about their visions of the future. Sometimes wistful, sometimes defiant, the resulting songs – *Like a Lady*, *Right to Speak* and *Science and Nature* – reflect the young women's concerns with the environment and global politics as well as personal dreams and aspirations. Flamingo 50's *Science and Nature* was transposed for brass bands by composer Paul Mitchell Davidson and performed by Rainford Silver Brass Band in a unique open-air performance on Liverpool's Waterfront Walkway in September 2002.

The project culminated in three video works, which were shown in the exhibition *Celebrations for Breaking Routine* by Kristin Lucas in Gallery 1 at FACT. Collectively, the project presented a challenge to those visions of the future shaped by large corporations and their marketing strategies. Lucas works with video, installation, performance, and the World Wide Web to address and question the presence and effects of technology in a media-saturated world.

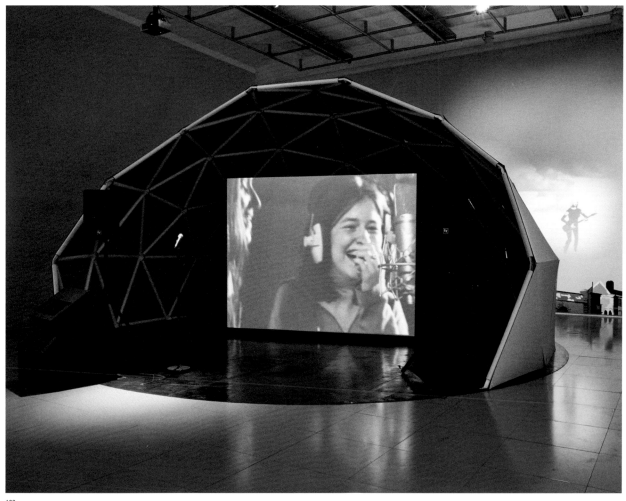

130/131
Celebrations
for Breaking
Routine⁺
-
FACT
Collaborations
commission⁺
-
Kristin Lucas
with Flamingo 50,
Venus and Exit 3
(three Merseyside
girl bands)
-
Gallery 1

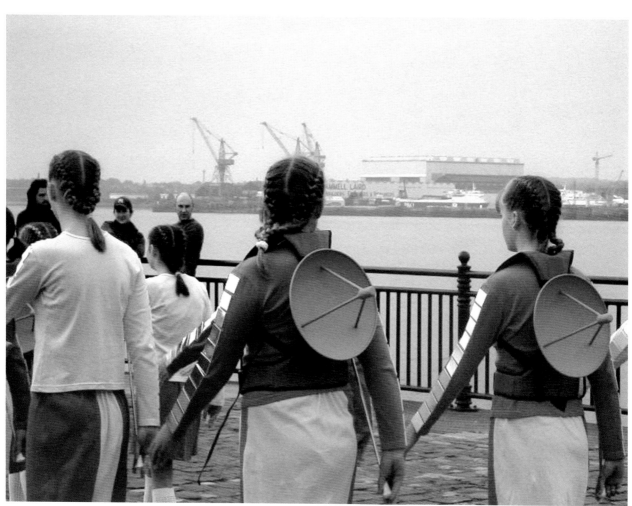

131

« FACT has always been an inspiration. From its ongoing work with the local community, such as the collaboration with tenantspin, to its remarkable history of commissioning and presenting extraordinary works, often with important

publications, FACT is one of the primary models that we all look to as an example of how to put together and sustain a focused and diverse cultural program that matters to local, national, and international audiences. >>

Steve Dietz
Artistic Director,
01SJ Biennial

Deanimated
2003
—

Martin Arnold
—

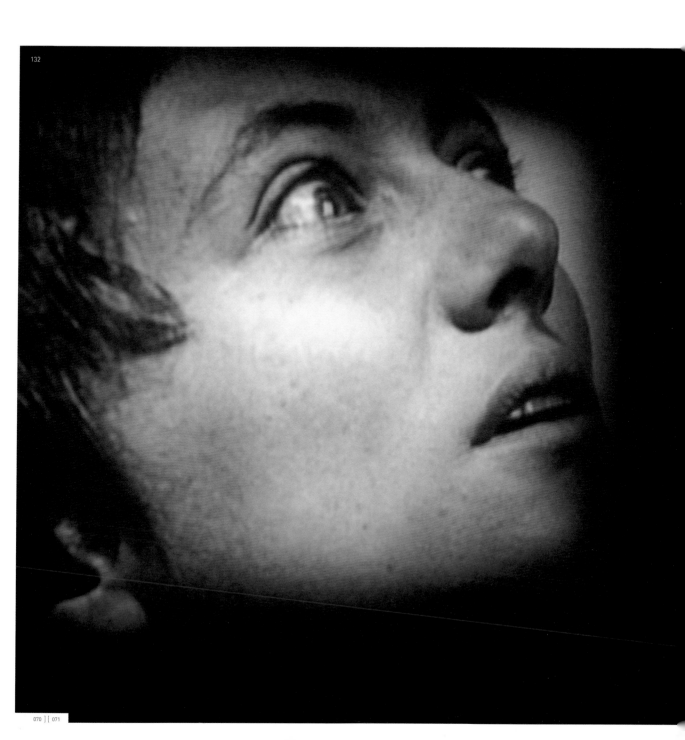

For Martin Arnold's first solo exhibition in Britain, FACT presented three new and recent film and video installations. With *Deanimated, The Invisible Ghost, 1941* screened in Gallery 1, Arnold literally deanimates the filmic material by digitally erasing one character at a time. The combination of disintegrating characters, re-recorded sound and the constructed cinema space reinforces the eerie, disorientating qualities of the piece.

Gallery 2 featured work which drew on the identities and myths of some of the key women inhabiting the history of film. In a new version of Arnold's *Jeanne Marie Renée* (*The Suffering of Joan of Arc*, 1928), based on Carl Theodor Dreyer's silent film, emphasis is on the repressed longings of Jeanne and her visually explicit inability to fulfil her desires. *Dissociated* (*All About Eve* 1950), locates the viewer in the middle of the fight scene between the two women in the film.

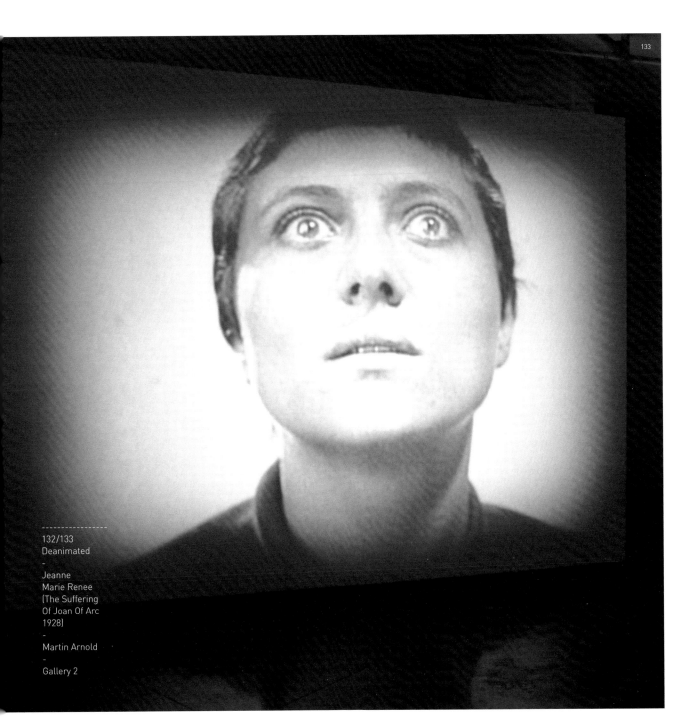

132/133
Deanimated
-
Jeanne
Marie Renee
(The Suffering
Of Joan Of Arc
1928)
-
Martin Arnold
-
Gallery 2

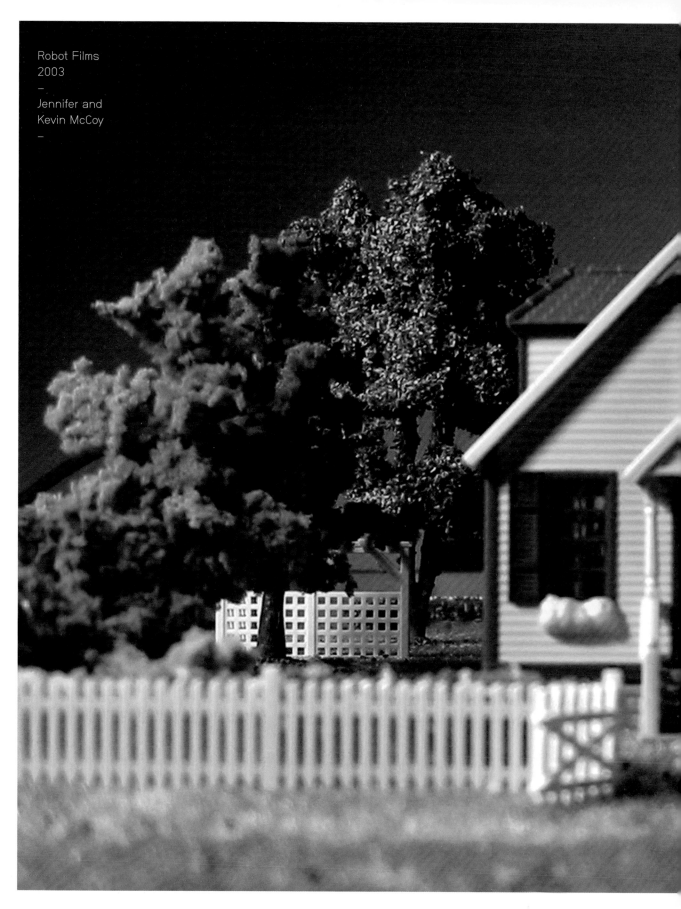

The first UK solo exhibition by the Brooklyn-based artists Jennifer and Kevin McCoy.

Robot Films refers to the role that automata and machines play in both the production and experience of the work, most visible in *Soft Rains* (2003) in Gallery 1.

It combines miniature movie sets, surveillance cameras and switching systems, allowing viewers to observe a film and its production in its entirety. The mini-stories are then projected onto a large screen in random sequences. The resulting miniature movies and sets highlight our culture's fascination with the

storytelling process, revealing the mechanisms and artifice behind the magic of cinema.

Two projected film works were presented in Gallery 2: *The Kiss* (2002) and *Horror Chase* (2002).

134
Soft Rains[*]
-
Jennifer and
Kevin McCoy
-
FACT
co-commission[*]
-
Gallery 1

Robot Films
2003
—

Jennifer and
Kevin McCoy
—

Recent history has seen a global explosion in image-making, resulting in miles of half-remembered footage, a vast body of raw material for a new generation of artists and filmmakers.

Every Shot Every Episode by Jennifer and Kevin McCoy is a video database of shots from the original *Starsky & Hutch*. Each shot was sorted by categories (*Every Stereotype*, *Every Blue*) and compiled onto video CDs.

For example, viewers can watch every animal that ever appeared on the show, edited together in quick succession.

Onewordmovie by artist Beat Brogle uses an online search engine to assemble a rapid sequence of images related to a keyword supplied by the viewer. The result is a stream-of-consciousness-style movie with often surprising results.

135
Every Shot
Every Episode
-
Jennifer and
Kevin McCoy

Nothing Special:
Artists' Video:
Media & Reality
–
Various Artists
–

Way before Cable and satellite
television were part of our everyday
lives, Andy Warhol wanted to stage
his own non-stop 24-hour-a-day TV
show. He never produced it but he
did give it a name: *Nothing Special*.

Independent curator Claire Doherty,
working with FACT, responded to
Warhol's great unfulfilled ambition by
creating the *Nothing Special* channel
as an exhibition that featured a series
of projects inspired and informed by
the conventions of TV by artists over

the last 30 years. By 1975, TV was 50
years old and artists such as Warhol,
Nam June Paik and Ant Farm were
recognising the medium's inherent
contradiction: as TV began to domi-
nate our experience of the world,
so mediated reality (however small)
became more desirable – more real
– than everyday life. The show traced
and examined the ways in which
artists have subsequently used
video to disrupt or reveal or weave
own versions of the mediated real.
This exhibition was not primarily

concerned with visual art on
television, rather, it presented
the subversion of the language
of television and asked: what is
the reality of this fiction?

Visitors to *Nothing Special* were
able to watch the *Nothing Special*
channel in four areas of the gallery
– Daytime, News, Primetime and
Night-time.

136
Nothing Special:
Artists' Video:
Media & Reality
2008
–
Various Artists

Superblock
2003
—

Superblock is based on the
experiences of Liverpool residents,
many of whom live in high-rise
accommodation across the city.
Liverpool-based writer Jeff Young
was commissioned by the BBC
Radio 3 New Writing Department
to author this experimental drama
in partnership with tenantspin.
Tenants Ronnie Ross, Jim Jones,
Freda Smith, Josie Crawford and
the late Peggy Appleby worked
with Young for twelve months on
the development of *Superblock*.
The play was broadcast on BBC
Radio 3 in 2003.

138

137

- - - - - - - - - - - - - - - -
137
Supermanual
Guide

- - - - - - - - - - - - - - - -
138
Superblock
-
Sunetra Sarker
and George
Costigan

Factory
2003
—

FACTORY involved a group of 12 young people aged 14 to 19 who worked with FACT over a year to programme and develop new activities and events for their peers. Their online initiative, www.factoryatfact.com, was developed collaboratively with Smiling Wolf which contained news, reviews and gossip for young people. As a group, they curated a young people's film festival, *Microwave*, held at FACT.

MICROWAVE

active minds, young works, moving images

A week of sizzling screenings and red hot experiments with the moving image – made by young people for young people

Tuesday 23 – Tuesday 30 March 2004

FACT Centre, 88 Wood Street, Liverpool, L1 4DQ

140

139
Factory
Pin Badge

140
Microwave
Event Flyer

139

'04

Highlighted Projects:
Primetime \ At The Still Point of
the Turning World \ Cave Trilogy \
Becoming \ Computing 101B \
Liverpool Biennial \
Welcome to the Infinite Fill Zone \
Darkly Comic \

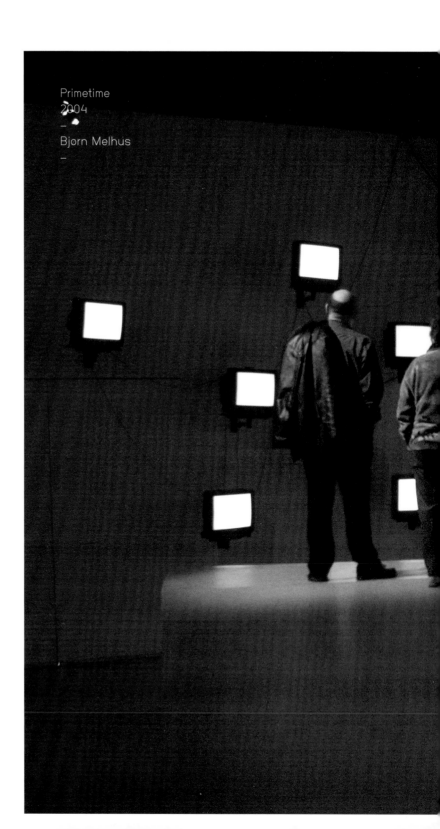

Primetime
2004
—
Bjørn Melhus
—

Continuing the focus on artists'
work informed by TV culture, FACT
presented *Primetime*, the first solo
exhibition in the UK by the pioneering
German video artist, Bjørn Melhus.

In *Primetime* (2001), the title work,
Melhus appropriated sounds, phrases
and content from the world's most
famous talk show, *The Jerry Springer
Show*. More than 30 TVs stretching
across the wall of Gallery 1 lent a
sculptural component to the work,
dominated by the presence of a
virtual talk show host soliciting
confessions from his guests.

Projects continued in Gallery 2 with
Weeping (2001). In *Weeping*, Melhus
studied the style of the anchormen in
religious TV and their manipulative
approach to selling the concept of
religion. Also in Gallery 2, *The Oral
Thing* (2001) featured a victim and
an aggressor overseen and manipu-
lated by a televangelist.

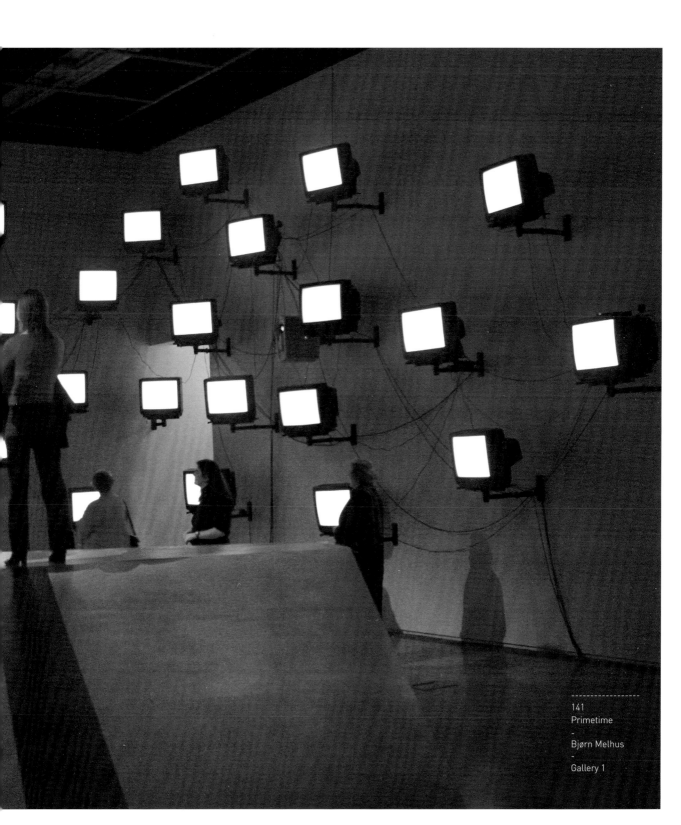

142
Towards the
Complex - For
the Courageous,
the Curious and
the Cowards
-
Jun Nguyen-
Hatsushiba
-
Gallery 1

143
Pulse
-
Stephen Dean
-
Gallery 2

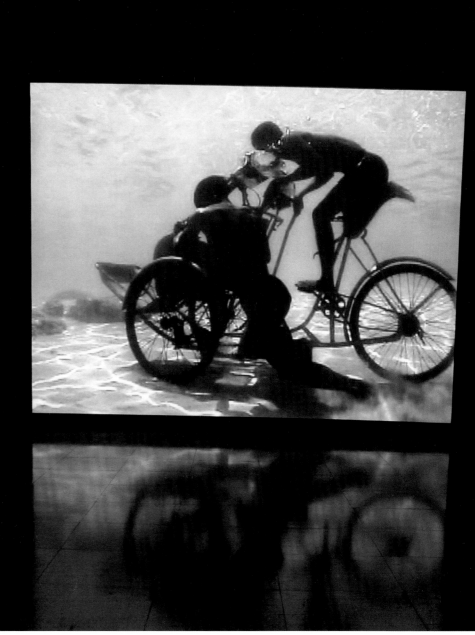

142

In this exhibition, FACT offered a moment of stillness in this ever-changing world by bringing together internationally acclaimed video works that offered intimate and thought-provoking encounters.

Towards the Complex – For the Courageous, the Curious and the Cowards (2001) by Jun Nguyen-Hatsushiba records an extraordinary underwater race by cyclos (bicycle taxis).

In his four-screen work True Colours (2002), Juan-Pedro Fabra Guemberena creates a mesmerising play between visibility and invisibility with his study of soldiers from a Swedish armoured unit on manoeuvres.

Pulse (2001) was shot in the north of India during the celebration of Holi and is an immersion in a painting in motion rather than a documentary.

Yang Zhenzhong's Let's Puff (2002), shown to acclaim at the Venice Biennale 2003, consists of face-to-face video walls, perfectly synchronised to depict a young

woman on one screen gulping for breath and then seeming to blow at the Shanghai street scene on the screen opposite.

« At the still point of the turning world. Neither flesh nor fleshless; Neither from nor towards; at the still point, there the dance is, But neither arrest nor movement. And do not call it fixity, Where past and future are gathered. Neither move-ment from nor towards, Neither ascent nor decline. Except for the point, the still point. There would be no dance, and there is only the dance. I can only say, *there* we have been; but I cannot say where. And I cannot say, how long, for that is to place it in time. »

—
T.S. Eliot,
Burnt Norton from *Four Quartets*

Cave Trilogy
2004
–
Salla Tykkä
–

144/145

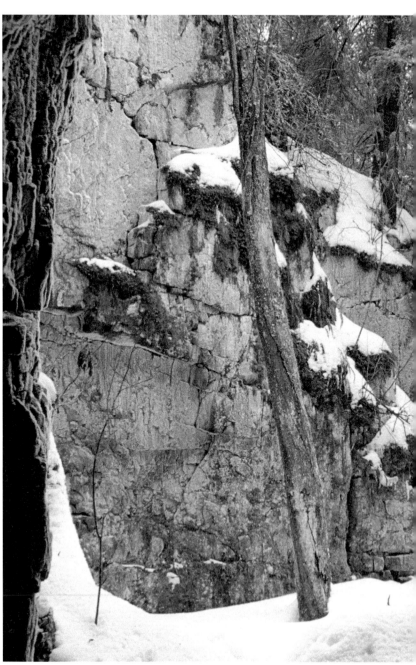

Lasso, Thriller and *Cave*, the critically acclaimed trilogy of short 35mm films, made between 2000 and 2003, by the young artist Salla Tykkä.

In this large-scale installation, a female protagonist features in all three films that reference classic film genres. *Lasso* (2000), a highlight of the 2001 Venice Biennale and the most celebrated of the films, provides an introduction to the main character's life. The girl's earlier life is explored in *Thriller* and *Cave* concludes the trilogy, projecting us into the future.

Through exploring the dynamics of these genres, Tykkä exploits the effects of ambiguity, memory and fantasy, and subverts thresholds of desire, power and violence.

Becoming
2004
—
Candice Breitz
—

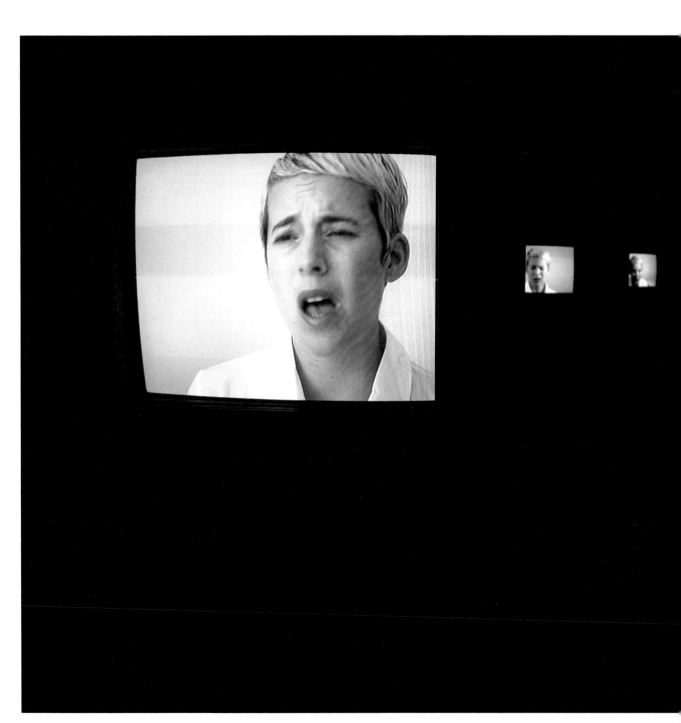

147
Becoming
-
Candice Breitz
-
Gallery 2

Candice Breitz slips awkwardly into the roles of actresses (Cameron Diaz, Julia Roberts, Jennifer Lopez, Meg Ryan, Neve Campbell, Reese Witherspoon and Drew Barrymore). Having cut-and-pasted short sequences of these actresses from various films, and isolated the actresses by eliminating the actors who originally appeared opposite them, Breitz re-enacts their performances.

In the resulting fourteen-channel video installation in Gallery 2, Breitz's diligent mimicry of the actresses results in disturbingly earnest renditions of their performances.

Becoming raises complex questions facing contemporary subjectivity, focusing in particular on the way in which identity increasingly takes its cues from media-produced prototypes. Alternatively, the work might be read to suggest that screen icons achieve stardom precisely because – beyond the clichés that they perpetuate – we ultimately imagine these stars as real people.

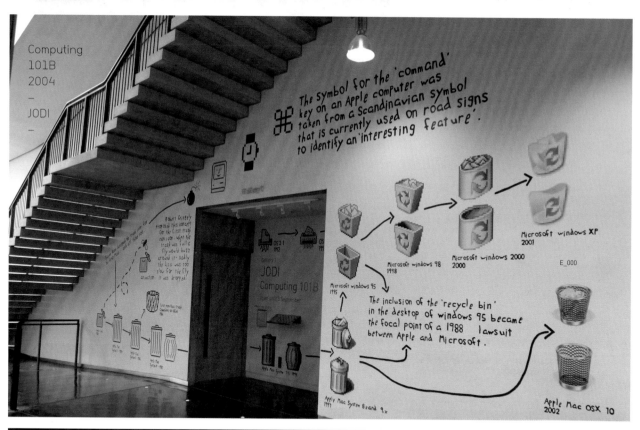

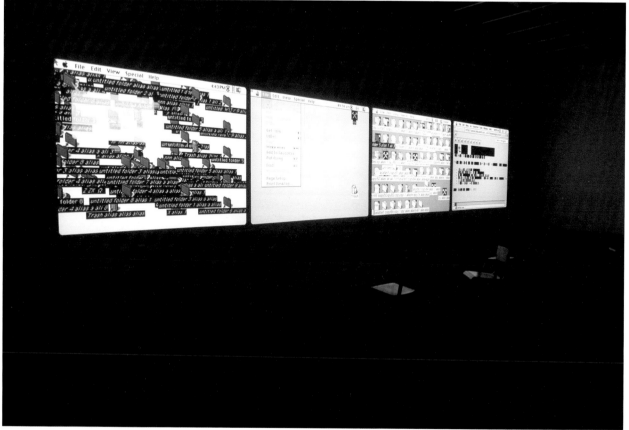

In their first UK solo exhibition, the Netherlands-based artist duo JODI poked fun at the mistakes made by computers and their human users. JODI's work is inspired by the very things we hate most about technology.

The exhibition featured the UK premiere of *My%Desktop*, a video artwork that shows large-scale computer screens violently erupting, windows opening and closing as if controlled by some mad unseen force, creating hypnotising sound and visuals.

In video installation *Max Payne Cheats Only*, Max, the main character from a video game popular for its shoot-'em-up violence, explores the whimsical side of his personality. He wanders film noir-style sets without regard for his mission, searching for the spaces where the logic of the game breaks down.

148
Computing 101B
-
Joan Heemskerk
(JODI)
Dirk Paesmans
(JODI)
-
Public Spaces

149
My%Desktop
-
Joan Heemskerk
(JODI)
Dirk Paesmans
(JODI)
-
Gallery 1

150/151
Computing 101B
Flyers

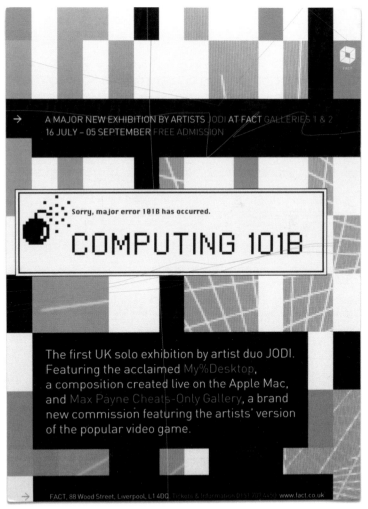

150/151

Liverpool
Biennial
2004
–
Various Artists
–

Retrieval
Room
–
Jill Magid
–

Jill Magid has been using cameras to explore hidden spaces, whether they be those of her own body or those of authority, Since 1998, she combines these lines of investigation in the diaries, videos and installation that make up *Retrieval Room*.

Over a period of 31 days spent in Liverpool, the artist developed a close relationship with CityWatch (Merseyside Police and Liverpool City Council), whose function is city-wide video surveillance – the largest of its kind in England.

Wearing a bright red trench coat and knee-length boots, ensuring she was easily identifiable throughout the city, Magid would call the police on duty with details of where she was and ask them to film her in particular

poses and even guide her through the city with her eyes closed – all using the public surveillance cameras in Liverpool city centre.

For access to this footage taken by the CityWatch system, Magid completed 31 Subject Access Request Forms, writing them as though they were letters to a lover. In addition to detailing the facts of where she was and what she was doing, she expressed her thoughts and feelings. These letters form an intimate portrait of the relationship between herself and the city and were exhibited alongside her video work.

The exhibition comprised two chapters, one at FACT and the other at Tate Liverpool.

152
Retrieval Room⁺
-
Jill Magid
-
FACT
co-commission⁺
-
Gallery 2

Close
to the Sea
—
Yang Fudong
—

Yang Fudong lives and works in Shanghai, a coastal city renowned as a filmmaking centre in the 1920s and 1930s.

In his ten-screen installation in Gallery 1 Fudong addressed themes of alienation and perception through the relationship of a young couple in love and their life by the sea. The seaside setting connects Shanghai and Liverpool, conveying beauty and generosity. Threatened by death, the pair talk about their ideals, beliefs and expectations of life.

The original musical score adds to a strange, dreamlike, disturbing quality. This is particularly relevant to Liverpool, where the transformation and regeneration of the city brings with it tension and the contradictions of reality and desire.

Whilst Fudong's work has a strong cinematic narrative component, the stories he unfolds are never explicit or conclusive, but characterised instead by change; from the over-whelming changes of personal life, urban environment and society, to the distancing of urban youth.

153
Close To The Sea
-
Yang Fudong
-
FACT
co-commission⁺
-
Gallery 1

Welcome to the
Infinite Fill Zone
2004
—

Cory Arcangel
& Interchill
—

The Infinite Fill Zone was a green
screen studio situated in FACT's
Media Lounge, where members
of the public could come and make
their own music video. The studio
was produced by Cory Arcangel in
collaboration with young people
from Interchill based in Speke,
Liverpool. Presented as part of
Liverpool Biennial 2004.

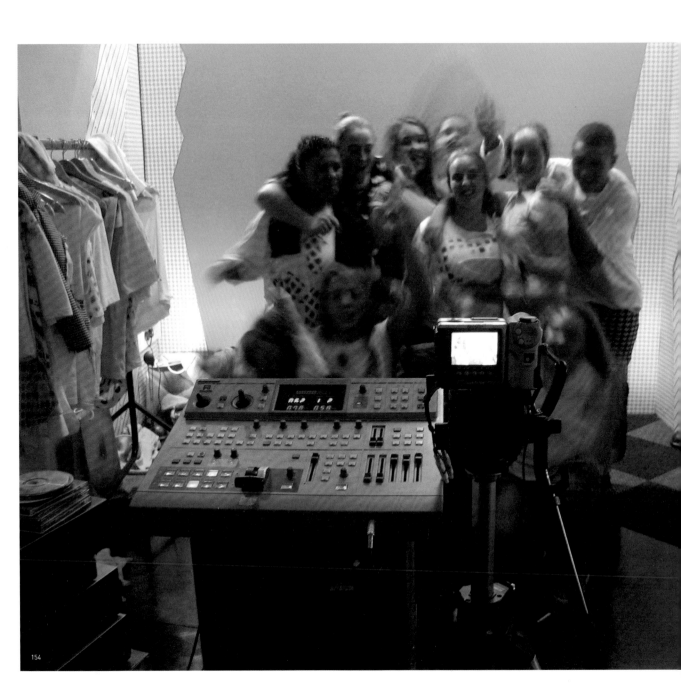

154/155
Infinite Fill Zone
-
Cory Arcangel
& Interchill
-
FACT
Collaboration
commission
-
Media Lounge

155

Darkly Comic
2004
—
Marina Zurkow
and Eddo Stern
—

Can a videogame be considered art? How about a cartoon? If the answer for you is 'no', then let the work of acclaimed international artists Eddo Stern and Marina Zurkow convince you otherwise. Using forms of popular culture most often found in kids' bedrooms, Zurkow and Stern make art that ranges from sinister and haunting to outrageously amusing. Zurkow translates the dark side of human nature into eye-popping, colourfully lush cartoons, while Stern makes videos that show how realworld politics are re-created in the video-game playground.

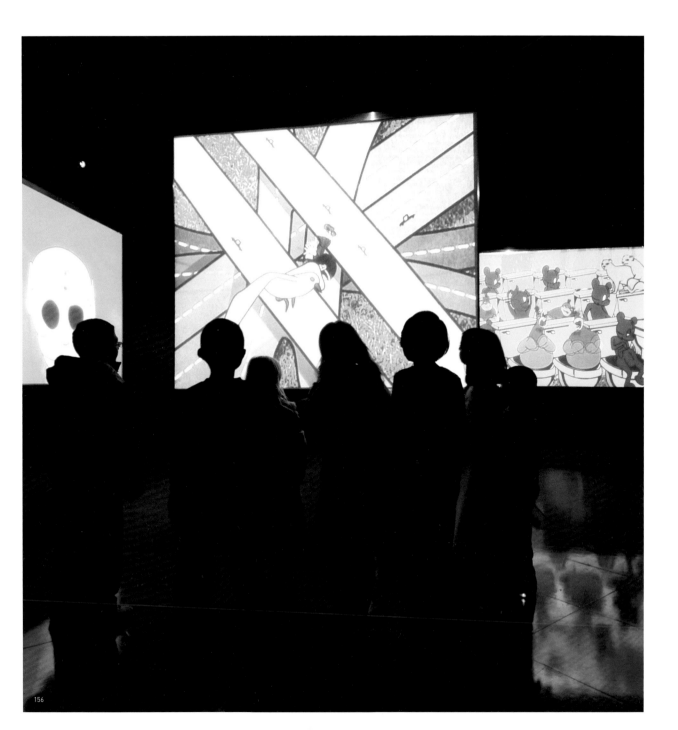

157

162

167

172

158

163

168

173

159

164

169

174

160

165

170

175

161

166

171

176

156 - 176
Nicking the Never
-
Marina Zurkow
-
Gallery 1

«Stern elevates videogames above the status of gallery novelty act, making viable sculpture out of bulky main-frames and combining the (still) surprisingly stilted imagery of Playstation bestsellers with

music that is evocative and
laughably low-tech. >>

—

Martha
Schwendener,
Artforum

177
USS Dragon
–
Eddo Stern
–
Media Lounge

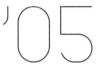

Critic's Choice
2005
–
Various Artists

178
Critics Choice
Panel Discussion
-
FACT

Highlighted Projects:
Critic's Choice \ Self/Sound/City \
The Agony & The Ecstasy \
FACT FM: The Secret Lives of Liverpool \
Rock The Future \ Skate Films \
Funny, How Thin The Line Is

178

179
Beyond Words
-
Fiona Banner
-
Gallery 1

Purveyors of what's hot and what's not, critics are often the gatekeepers of our access to the contemporary art world and their opinions can launch artists' careers or even close shows.

Critic's Choice was curated by established commentators and practitioners from the field of contemporary art including Patricia Bickers, Editor of Art Monthly; Sarah Kent, Arts Editor of Time Out; Mark Lawson, Radio 4 Front Row Presenter and Presenter/Chair of BBC's Late Review and Tim Marlow, Chanel 5 Arts presenter and Director of Exhibitions at the White Cube Gallery.

« My contribution to Critic's Choice consists of two parts - work by artists whom I have only recently discovered and a retrospective of personal favourites that goes back to the mid-1960s. »
–
Sarah Kent

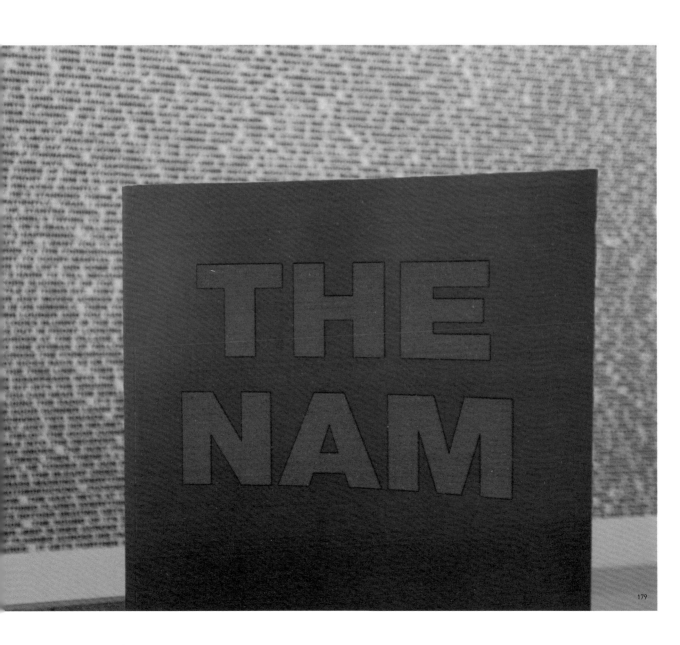

Self/Sound/City
2005
–
Vito Acconci
–

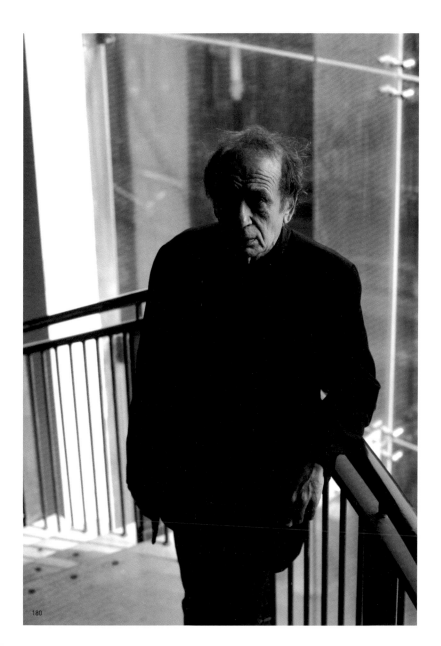

« His view of the self, as constructed in the world rather than natural, has influenced a generation of artists - the so–called 'picture' generation - who have attended to the force of representation. »
–
Kate Linker, *Vito Acconci*, Rizzoli International Publications, 1994

Vito Acconci, pioneering film and video artist, poet, performer and architect, has spent over 35 years exploring the relationship between the body and public space. In close partnership with Acconci himself and Acconci Studios, FACT presented a unique exhibition that explored the relationship between his early and current practice, through a collection of films, videos, project notes and related materials, including documents from his 1969 -1973 archive and a database consisting of over 13 hours of audio works.

Featuring some of his notorious body works such as *Trade Marks*, *Seed Bed* and *Following Piece*, and including work never seen in the UK before, this personal selection for FACT gave a direct insight into the thought processes and motivation behind this remarkable artist and his working methods.

181

186

191

196

182

187

192

197

183

188

193

198

184

189

194

199

185

190

195

200

181 - 185
Self/Sound/City
-
Vito Acconci
-
Gallery 1

186 - 190
Self/Sound/City
-
Vito Acconci
-
Gallery 2

191 - 195
Self/Sound/City
-
Vito Acconci
-
Public Spaces

196 - 198
Breakfast with the Artist
-
Vito Acconci
-
FACT

199 - 200
Self/Sound/City
-
Vito Acconci
-
Media Lounge

The Agony &
The Ecstasy
2005
–
Various Artists
–

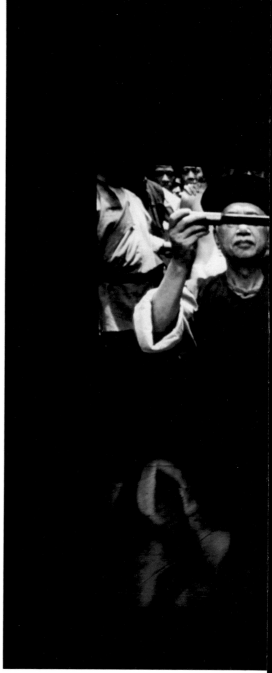

201
-
Barbed Hula
-
Sigalit Landau
-
Gallery 2

202
-
Pitfall
-
Marzia Migliora
& Elisa Sighicelli
-
Gallery 2

203/204
-
Lingchi - Echoes
of a Historical
Photograph
-
Chen Chieh-jen
-
Gallery 1

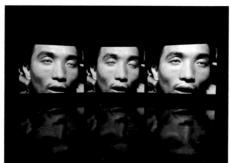

201/202/203 204

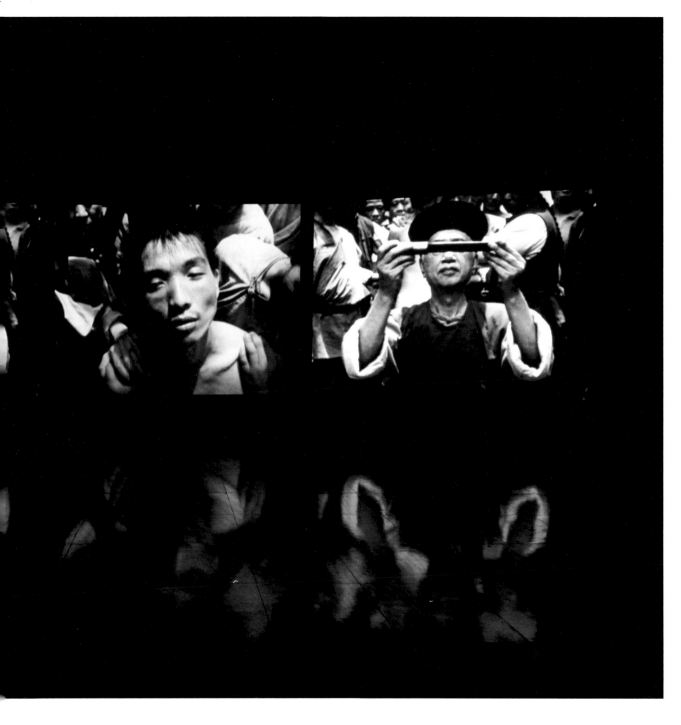

Inspired by legends and artefacts from the past, four artists use the moving image to explore history, religion, pain/pleasure, life/death, fear and power.

Using intense and sometimes disturbing imagery, all four artists explore the impact of the image, watching and being watched –

seducing the viewer into an uncomfortable, but transfixing, relationship with the subject of their work.

It is human nature to find a way of anaesthetising ourselves to the fears we all face in life – we've all turned over when a famine documentary starts on TV or a report on the latest bomb attack, opting instead for a

Hollywood blockbuster designed to transport us into a safe world, where we can predict the ending. With a squidge of the remote control or click of the mouse we indicate that we want to be connected, but simultaneously separate ourselves from 'them', opting out of seeing ourselves in the darker side of life. The artists in this show attempted

to produce work to stop us in our tracks and make us reassess these 'shadowy areas', (as Marzia Migliora puts it), and our role as an individual within community and society.

FACT FM:
The Secret Lives
of Liverpool
2005
—

FACT FM was a digital online radio station with round-the-clock broadcast and a large collection of audio recordings composed, recorded, uploaded and mixed by the people of Liverpool. The project aimed to highlight the many people who make the city unique, perhaps outside the city centre or out of the limelight. *FACT FM* brought together the alternative histories of Liverpool, the voices of the city's many cultures, the music, poetry and sound art by artists both renowned and unknown. The project featured a recording booth in FACT's Media Lounge and computer stations where people could upload content onto the *FACT FM* website, which was accessed and mixed by people around the world.

205
FACT FM:
The Secret Lives
of Liverpool
-
FACT
Collaborations
commission
-
Media Lounge

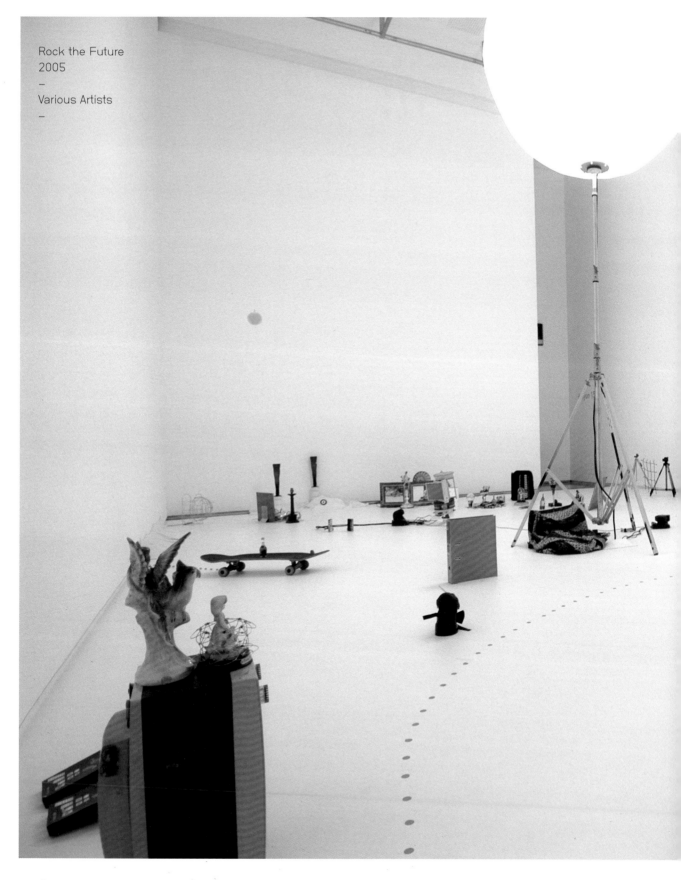

Rock the Future
2005
—

Various Artists
—

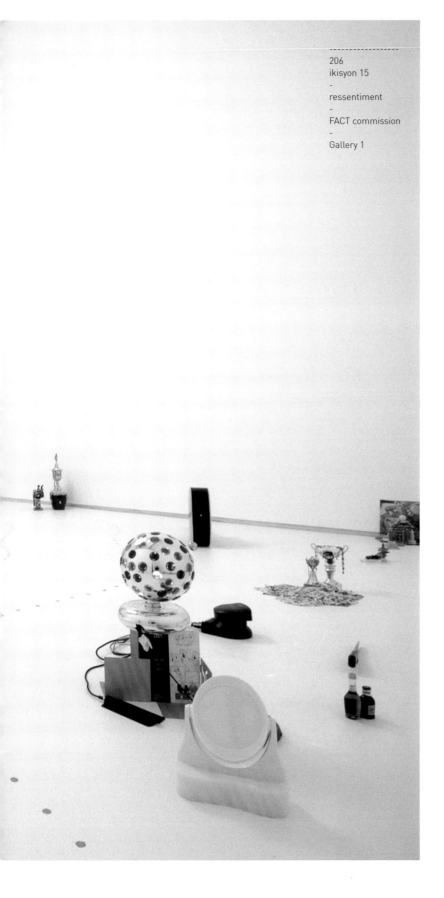

206
ikisyon 15
-
ressentiment
-
FACT commission
-
Gallery 1

Rock the Future featured new work by contemporary Japanese artist Ryota Kuwakubo and artist collectives ressentiment and exonemo.

ikisyon 15
-

In Gallery 1 ressentiment took a wild assortment of donated items from the people of Liverpool and created a walk-through installation monitored by robot cameras to produce an ever-changing film perspective on contemporary culture and life in the city. From strange gorilla heads, skateboards and guitars, to statues of local sporting icons, the cameras construct their own mini-dramas and create mythical creatures, involving the audience as simultaneous makers and consumers of the work.

Shikakunomukou
-

exonemo invited visitors to Gallery 2 to make their own digital drawings in a new interactive web-based installation. Each individual mark made by the visitor influenced the light and sound in the space, providing a highly sensory environment. Moving into the adjoining room, visitors witnessed their drawings as part of an impressive three-screen projection, and on the exonemo website.

extra!
-

The Media Lounge at FACT was transformed by Ryota Kuwakubo into a stunning blue room where information appeared to fall from the sky. His ingenious till receipt printer swept the web's news agencies to churn out snippets of the latest headlines; fluttering to earth for the visitor to read, take away or simply leave to decorate the space.

207
8bit
-
Paper engineered
robot used in
marketing

208
extra!
-
Ryota Kuwakubo
-
FACT commission
-
Media Lounge

Visitor Comment:
« Enjoyed it . Quirky and fun. I really
liked the ideas and it was refreshing
to see something that you can be a
part of and has links with the city. »
–
Anonymous
30/09/05

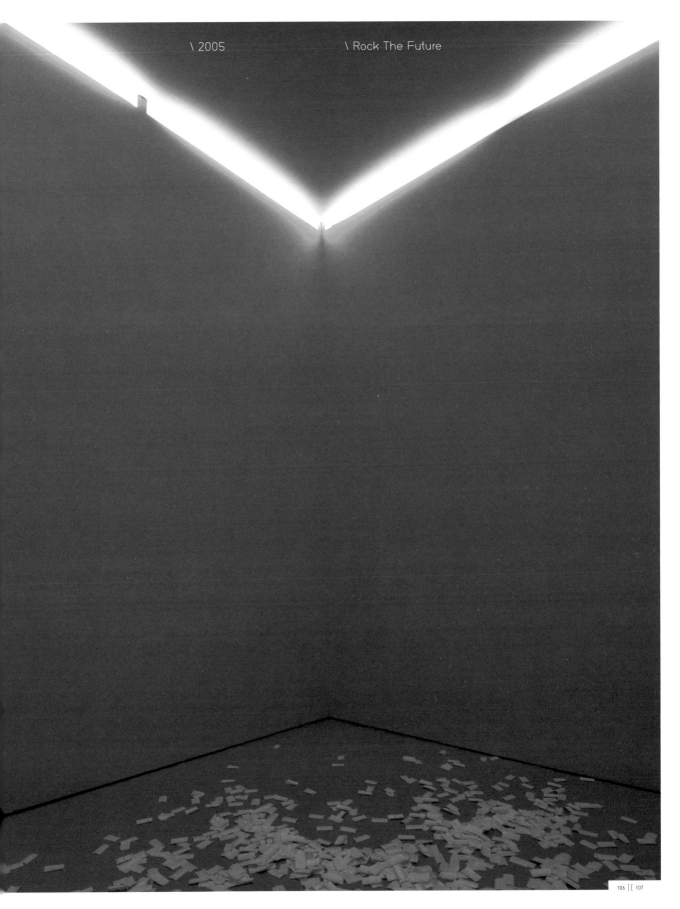

Footage
Skate Films
2005
–

FACT's Collaboration Programme developed new audiences with the local skateboarding community through a weekend-long celebration of skateboarding culture, *Footage*, culminating in two short films and a long-term film project with independent skateboarders and filmmaker Stu Bentley. This project was funded by the Paul Hamlyn Foundation

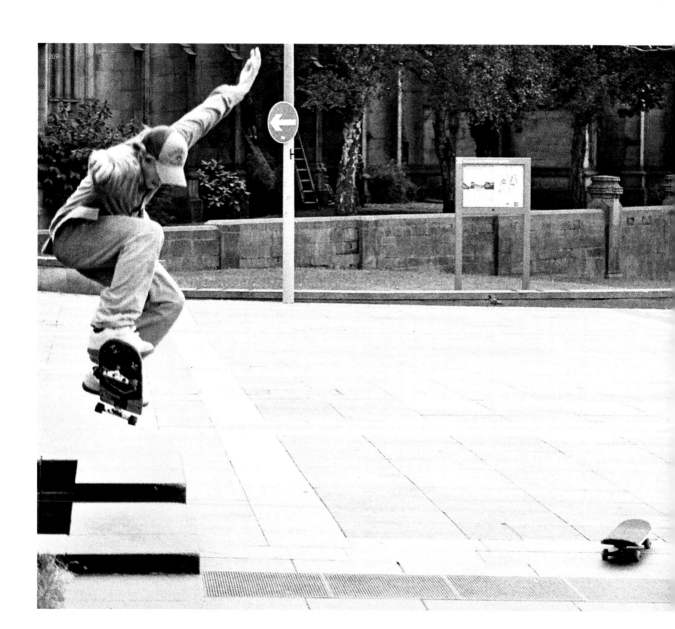

« FACT is always interested in the new and innovative, and the first place to look is youth subcultures. Nine times out of ten they're going to be doing something that pushes broader culture forward, or reflects an element of culture that we've not seen or understood before. While FACT continues to show the best mid-career and established artists who set the scene for the art practices we're embedded in, I'd like to think we'll always be tapped into what young people are up to – it's bound to be interesting. »
–
Heather Corcoran,
Curator, FACT

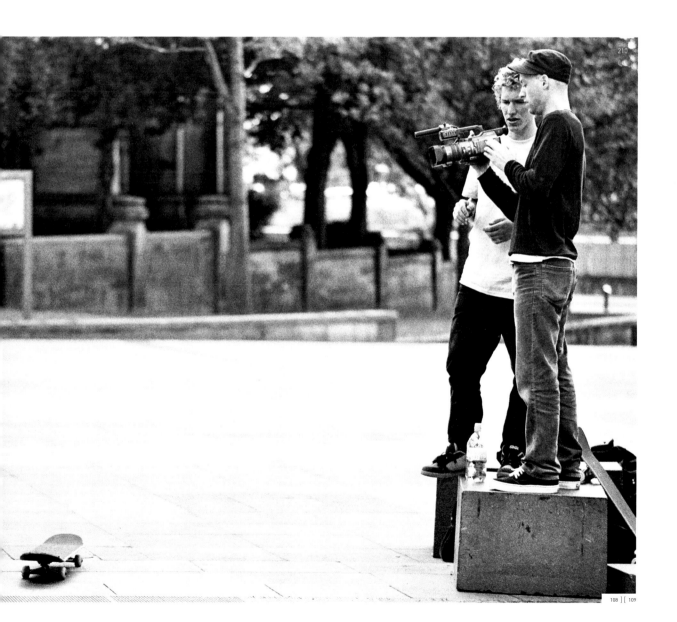

210

Funny, How Thin
The Line Is
2005
—
Walid Raad /
The Atlas Group
—

211
My Neck is
Thinner Than
a Hair
-
Walid Raad /
The Atlas Group
-
Gallery 1

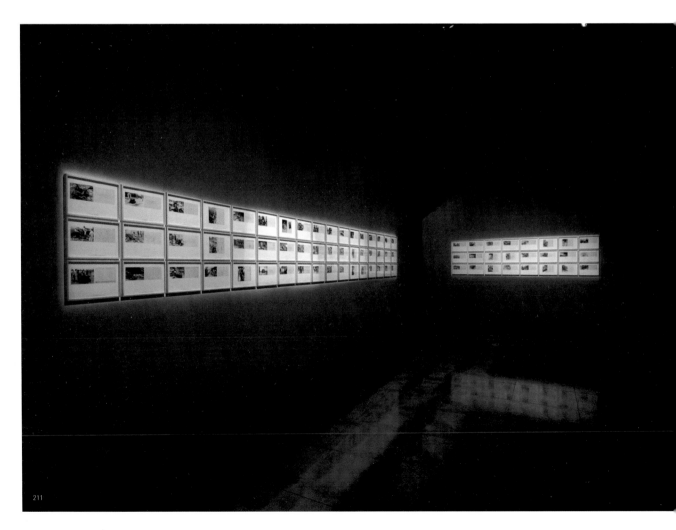

211

I Was Overcome
With a Momentary
Panic at the
Thought That They
Might be Right

-

Walid Raad /
The Atlas Group

-

FACT commission

-

Gallery 1

This exhibition explored the meanings, experiences and feelings produced by the impact of war, the nature of 'evidence' and individual and collective memories in their role in the formation of history.

The Atlas Group do not set out to record what actually happened, but provide us with the opportunity to think about what can be imagined, said, or taken for granted about Lebanon's wars, enabling us to reflect on events in other parts of the world, such as London, Baghdad, New York and Madrid.

In *Funny, How Thin the Line Is*, Walid Raad invited the Visible Collective to present part of their project, *Disappeared in America*. Visible Collective question and challenge ideas, theory and images in the post 9/11 'war on terror'. They use film, soundscape, images, installations and lectures to explore the faces of made-to-disappear émigrés, exiles, visitors and other suspects after 9/11, occupying an "uneasy space between documentary and political theatre."*

'06

Highlighted Projects:
Everything Fell Together \ Howlin' Wolf
Human Computer Interaction (HCI) \
Under the Radar \ Liverpool Biennial \
Jungle Jam \ The Black Moss

Everything
Fell Together
2006

—

Christian
Jankowski

—

First major UK exhibition of Christian
Jankowski featuring 14 film and
video installations.

In *16mm Mystery*, Jankowski collabo-
rates with the Brothers Strause,
leaving the decision on the film's
location, the special effect and the
fate of his art in their hands.

The Day We Met is an interactive karaoke booth which FACT visitors were invited to use; selecting the movie of their choice to join in, as the artist acted out scripted love stories for their karaoke pleasure.

This I Played Tomorrow has Jankowski interviewing the hopeful actors he meets at the gates of the legendary studio Cinecittà in Rome, where epic films including *Ben-Hur*, *Quo Vadis* and *Cleopatra* were made. He enquires about their dreams and ambitions with regard to cinema, then transforms their answers into a script, inviting the participants to act out their dreams in a real movie, shot on the actual set of the 1966 film, *Francesco d'Assisi*.

In *Matrix Effect*, Jankowski pokes gentle fun at the art establishment casting children as both artists and curators.[+]

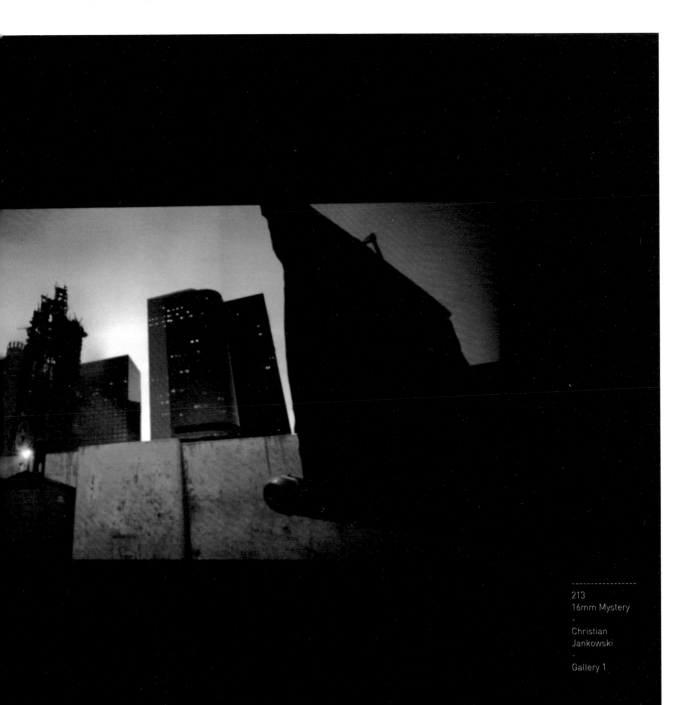

213
16mm Mystery
–
Christian
Jankowski
–
Gallery 1

Howlin' Wolf
2006
—

Mark Lewis
—

FACT presented the world premiere of the new commission *Rear Projection (Molly Parker)* (2006) as well as a rich selection of work never seen before in the UK. Lewis uses 35mm film, professional actors and production crew to make stunning films that subtly undermine the characteristics that define mainstream and avant-garde cinema. *Rear Projection (Molly Parker)* (2006) recalls the traditional combination of landscape and portraiture in film, photography and painting, through an early film effect that Lewis believes revisited the composition technique of painters such as Jan van Eyck and Edouard Manet.

In *Northumberland* (2005) a starkly beautiful English rural landscape is revealed, while in *Jay's Garden, Malibu* (2001), we experience the constant meandering of a camera through a lush, tropical garden. On closer inspection, this location is also a porn movie set, with suggestively costumed actors providing a distraction to the camera's progress through the garden.

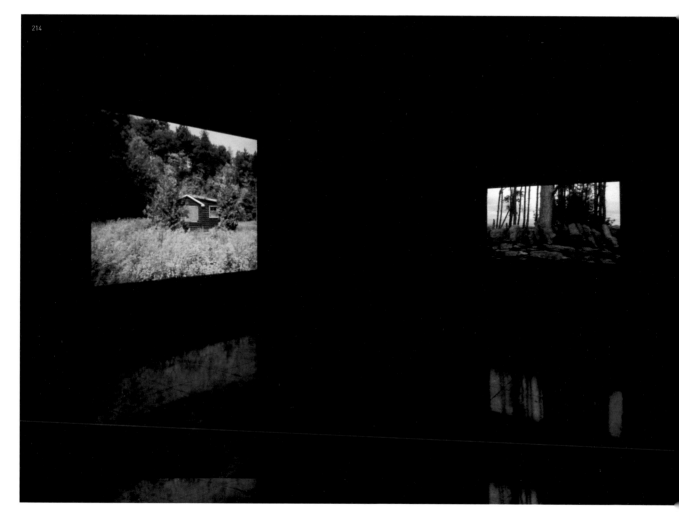

214

214
Rear Projection
(Golden Rod)
-
FACT
co-commission[+]
-
Mark Lewis
-
Gallery 1

215
Rear Projection
(Molly Parker)
-
Mark Lewis
-
FACT
co-commission[+]
-
Gallery 1

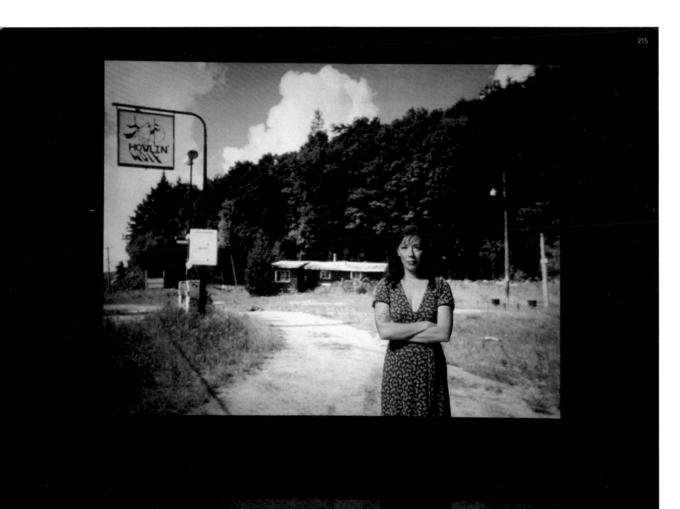

215

Human Computer
Interaction (HCI)
2006

–

Various Artists

–

An unforgettable experience of
interactivity and usability, proving
that direct communication with
a computer, without a keyboard,
mouse or joystick, is both possible
and lots of fun.

Three international artists, Simon
Poulter, Josh Nimoy and Caen Botto,
were commissioned to create work
based on *HCI* research by Liverpool

John Moores University's School
of Computing and Mathematical
Sciences. They responded by creating
projections that react to the viewer's
shadow, an ATM that offers ideas
instead of money, musical toys and
low-tech movement sensors.

216
Icon==Function
-
Josh Nimoy
-
Media Lounge
and Public
Spaces

Under
the Radar
2006
—
Experimenta
—

FACT was the first UK venue to host *Experimenta: Under the Radar*. An exhibition of innovative new media and video artworks transformed the galleries into an arcade of interactive fun – with an invitation round every corner to play, participate and explore.

Since its inception in 1986, Experimenta has developed a worldwide reputation for groundbreaking work and its exhibitions have been the launching pad for many Australian contemporary artists.

In Liverpool, the wild imaginings of these talented artists manifested as a sofa that purred and growled to the touch, a virtual shop where visitors' voices and screams caused chaos and even a digital rocking horse.

217
Op Shop
–
Stephen Barras
–
Gallery 2

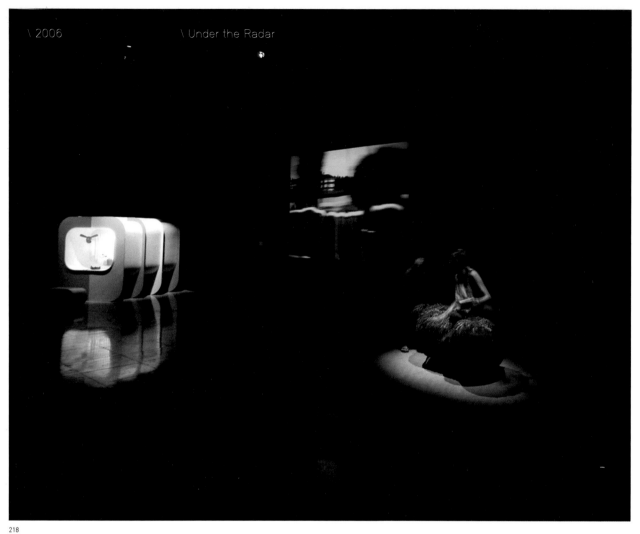

218
Under
the Radar
-
Various Artists
-
Gallery 1

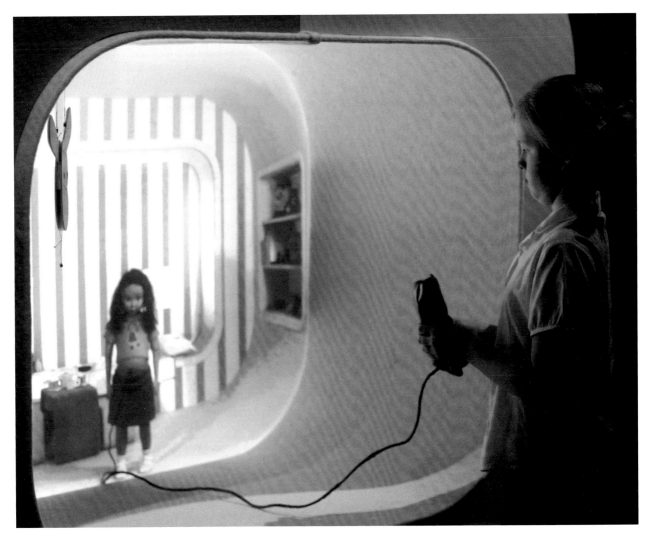

219

219
Expecting
-
Van Sowerwine
& Isobel Knowles
Liam Fennessy
-
Gallery 1

Liverpool Biennial 2006

–

Various Artists

Gerardo Mosquera's thoughts on 'reverse colonialism' tie in neatly with Manray Hsu's idea of the city as a 'hypertext'. Hsu refers to the city as a site for the flow of different energies; he pictures the city as a body and envisages that artists and their projects could act as 'archipuncture' – a way of revitalising or energising areas and aspects of the city that may have been overlooked or neglected, or that have a special function in the life of the city.

Consultant curators, Mosquera and Hsu, were invited to suggest international artists who might respond in an interesting way to the city and to the different contexts of the arts institutions participating in the Liverpool Biennial *International 06* – FACT, Open Eye Gallery, Tate and the Bluecoat.

At FACT, six international artists explored, to a greater or lesser degree, the public and private facets and histories of Liverpool – the fabric of the city itself and its people.

Artwork included *Obscure Moorings*, a new film by Matthew Buckingham filmed in and around Liverpool featuring local actors; Norwegian artist Sissel Tolaas' sensory, scentual

installation *OUTSIDEIN*; Shilpa Gupta's interactive *Untitled* bridging Liverpool and Mumbai; *Faith*, an ambitious installation from the acclaimed Thai filmmaker Apichatpong Weerasethakul; Kelly Mark's *Liverpool A–Z* and *A Day in the Office*, Anu Pennanen's window on the working life of Liverpool and the architecture that influences our everyday lives.

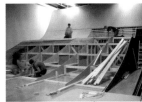

221 - 224

220
Obscure
Moorings
-
Matthew
Buckingham
-
FACT
co-commission⁺
-
Gallery 1

221 - 224
Making of the
ramp for Obscure
Moorings
-
FACT
co-commission⁺
-
Gallery 1

225

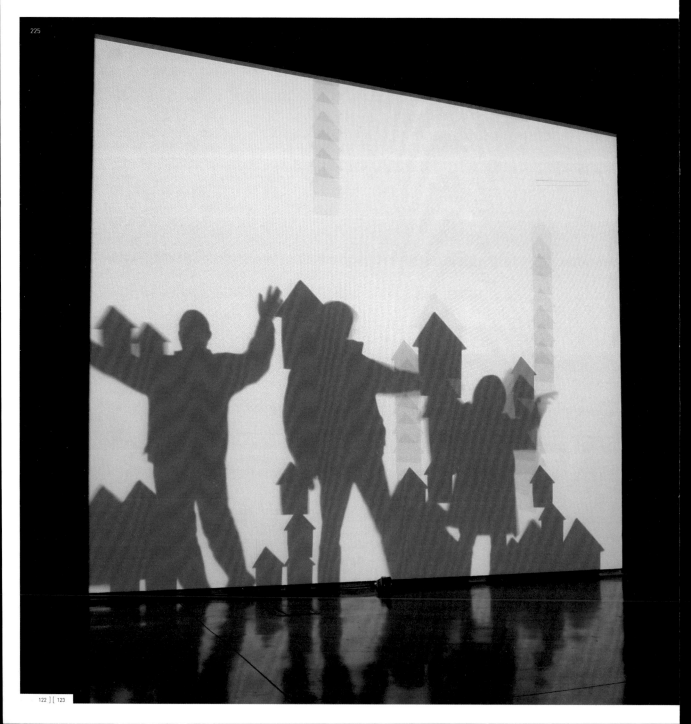

225/226
Untitled
-
Shilpa Gupta
-
FACT
co-commission[+]
-
Gallery 2

227
Faith[+]
-
Apichatpong
Weerasethakul
-
FACT
co-commission[+]
-
Gallery 2

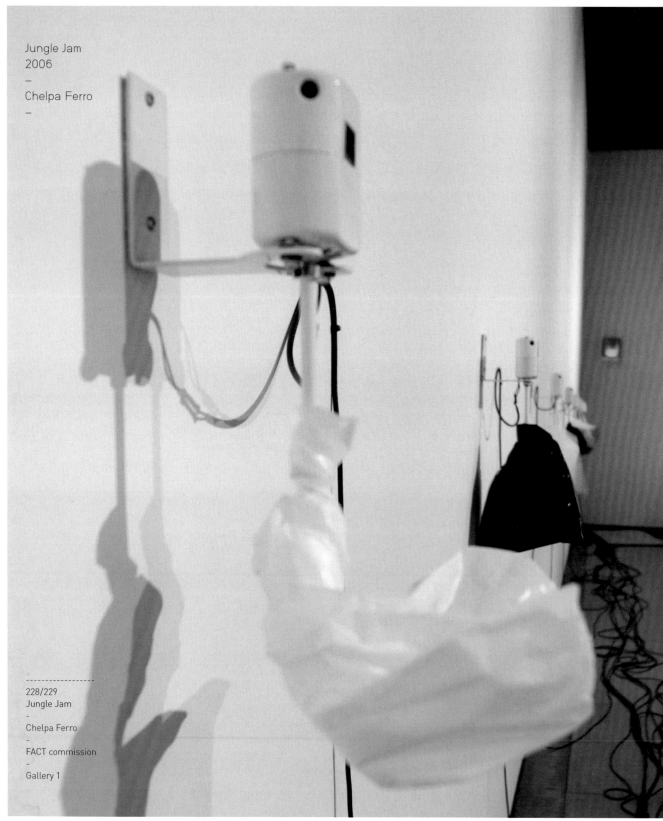

Jungle Jam
2006
–
Chelpa Ferro
–

228/229
Jungle Jam
–
Chelpa Ferro
–
FACT commission
–
Gallery 1

Jungle Jam, a musical experiment by Brazilian sound artists Chelpa Ferro. Impressed by Liverpool's street and experimental music scene, for this FACT commission the group created a rhythmical composition that speaks of the imagination and creativity present in contemporary Brazil, and invited visitors to reflect on the meaning and purpose of art and music in our modern technology-driven society. The unexpected musical qualities of plastic bags are also 'sampled' to create a startling sound environment.

Chelpa Ferro's projects refer to traditional Brazilian rhythms, as well as to the early musical experiments of the 50s that developed into characteristic Brazilian jazz of the 60s and 70s. They are in a direct line with the *Tropicalismo* movement, born out of the extreme modernisation of Brazil at the end of the 60s.

229

The Black Moss
2006
—
juneau/projects/
—

FACT presented new work by juneau/ projects/ commissioned specially for this exhibition, alongside a selection of other recent pieces.

For this exhibition the artists paid homage to British wildlife through a digital animation and installation that literally took over the building, spilling through the public spaces and fuelling the nature vs. technology debate. The Media Lounge was transformed into a mystical shrine dedicated to wildlife featuring digital animation and an array of handmade creatures, where visitors were invited to contribute to a continually evolving installation.

In Gallery 2, visitors entred the imaginary world of an interactive text-based computer game, while the public spaces were invaded by crows and pigeons (a common juneau/projects/ emblem). This cheeky intrusion into a modern building challenged the dominant role of technology in our lives, suggesting that nature is setting out to restore its place in our environment.[+]

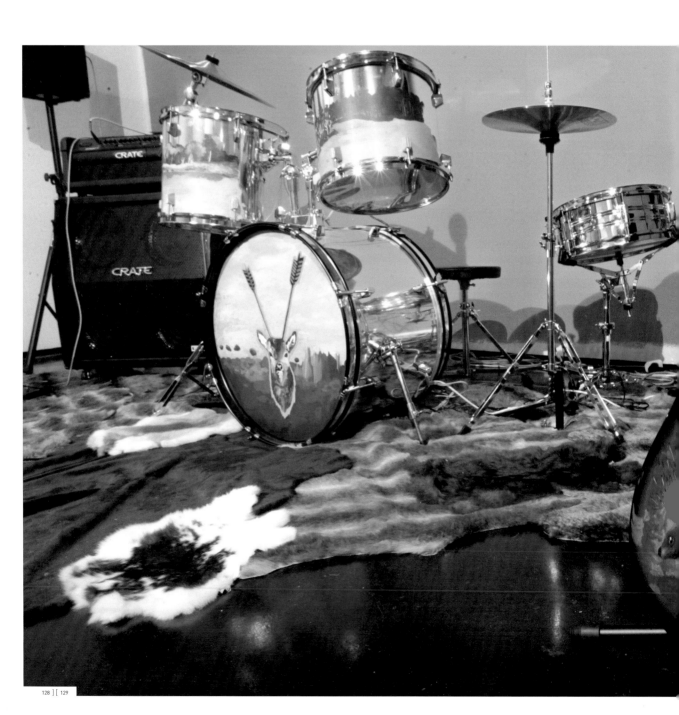

« Eddie Berg performing as part
of the staff band at the FACT
Christmas party represents the
spirit of FACT for me – hungry for
it, enormous fun and prepared
to always go one step further
in the name of creativity. »
–
Ceri Hand, Director,
Ceri Hand Gallery

230/231/232

230
I'm going to
antler you
-
juneau/projects/
-
Gallery 2

231
The Black Moss
-
juneau/projects/
-
Gallery 2

232
juneau/projects/
-
Live Performance
-
The Bar

233/234
Instincts are
misleading (you
shouldn't think
what you're
feeling)
-
juneau/projects/
-
FACT commission
-
Media Lounge

233

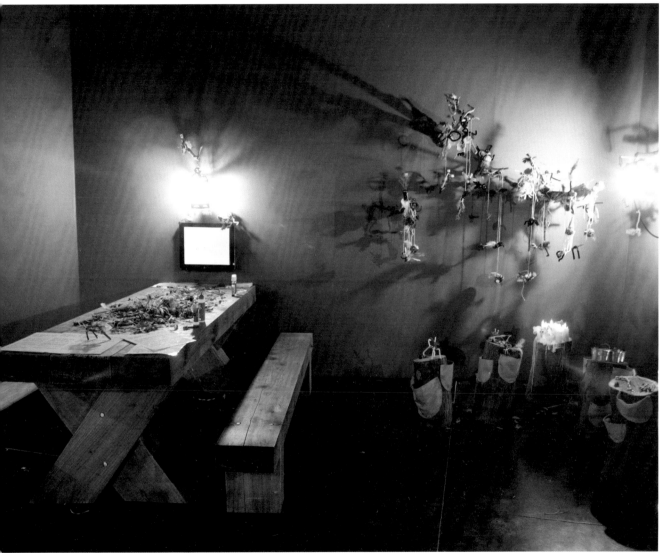

One M

Visitor

llionth

« Working at FACT has always been a mixture of the sublime and the ridiculous, and that's what I've always liked about it. In my three years here I've met interesting people ranging from Simon Reynolds and Deborah Curtis to Orlan and Terence Davies. I've seen the same piece of artwork inspire awe, derision and disgust in different people. I've asked visitors to 'swim through trash' with David Rokeby, kept foot odor at bay with Pipilotti Rist and encouraged people to take home old Daniel O'Donnell cassettes with *Climate for Change*. I've been in debates about everything from the nature of art to whether Jesus was a spaceman, and talked with the public about subjects ranging from Everton's recent form to stray dogs and the Iraq War. I've discussed why local girls don't tend to wear many clothes with an international artist and talked about the films of Shane Meadows with a group of homeless alcoholics. I've looked after visitors from New York, Rome, São Paulo and Bootle. I've programmed large events, led VIP tours and made imaginary animals out of pipe cleaners with small children. I've also unblocked toilets, smashed up furniture and cleaned dried blood off the back of the building. Like I say, sublime and ridiculous. Bit like art itself I suppose. »

—

Kenn Taylor, Gallery Supervisor

'07

Highlighted Projects and Events:
Sonic Streams \ Virtual Lives \ The Ghosts
Of Songs \ Silicon Remembers Carbon \
Here And Your Here \ The Bold Street
Project \ Re: [Video Positive] Archiving
Video Positively \ At 25 Metres \
Tarantino Visits

Sonic Streams /
Virtual Lives

—

Virtual Lives

—

Virtual Lives forms part of the *enquire*
national programme of projects that
engage children and young people
with galleries, contemporary visual
arts and artists. *Virtual Lives* comes
out of a set of shared agendas and
concerns between FACT, Corner-
house, folly, ICDC and Liverpool
John Moores University's Education
Department. All of the organisations
develop work with new technologies
and with young people. In different

235
Sonic Streams
Website
-
FACT
Collaborations
commission

236
Virtual Lives
Workshop
-
FACT
Collaborations
commission

235

ways, we are all involved in the dissemination of contemporary art that uses new media and we are all engaged in educational activity in our venues as well as off-site.

Virtual Lives aims to develop a deeper understanding of young people's technological lives. It aims to develop working practices that use the language of the young people we work with as a starting point (as opposed to us 'teaching' them).

It aims to develop shared working and the sharing of good practice across a digitally rich and experimental region.

Sonic Streams
-
Sonic Streams is a creative collaboration between Alder Hey Children's Hospital and FACT, exploring the impact of sound on the human body. Working with an established team of new media artists, medical professionals, education experts and

young people, FACT and Alder Hey set out to explore the impact of one of the few sensory factors that can be changed within a healthcare environment: sound.

We invited artists Chris Watson, Josh Nimoy and Sam Jones to be artist-researchers and creative collaborators on the *Sonic Streams* project. Each artist was invited to spend time in Alder Hey and to explore the space, meeting medical professionals including

paediatric doctors, nurses and play specialists along with the lead scientific researcher, surgeon and pediatrician, Andrew Curran, patients and the education team. Each artist was invited to make a proposal for a work of art that explored the impact of sound upon the human body and the health environment. The artists were encouraged to think about their works both as artworks and as therapeutic tools.

The Ghosts
of Songs
2007
—

Black Audio
Film Collective
—

World premiere retrospective
exhibition of the work of the Black
Audio Film Collective curated by
Anjalika Sagar and Kodwo Eshun.

Founded in 1982 and dissolved
in 1998, the seven-person Black
Audio Film Collective is widely
acknowledged as one of the most
influential artist groups to emerge
from Britain in recent years.

John Akomfrah, Lina Gopaul, Avril
Johnson, Reece Auguiste, Trevor
Mathison, David Lawson and Edward
George produced award-winning
film, photography, slide-tape,

video, installation, posters and
interventions, much of which had
never been exhibited in Britain.

The Ghosts of Songs is the first
retrospective to explore this impor-
tant group's entire body of work.
The exhibition and accompanying
monograph presented films such
as *Handsworth Songs*, *Who Needs A
Heart* and *Seven Songs for Malcolm
X*, alongside archival works and
documents that situate the group's
practice in the social, historical,
economic and geographical context
of a changing Britain.

237
Vitrine
Detail
-
Gallery 2

238
The Black Audio
Film Collective
-
Left to right:
David Lawson,
John Akomfrah,
Lina Gopaul,
Reece Auguiste
and Trevor
Mathison

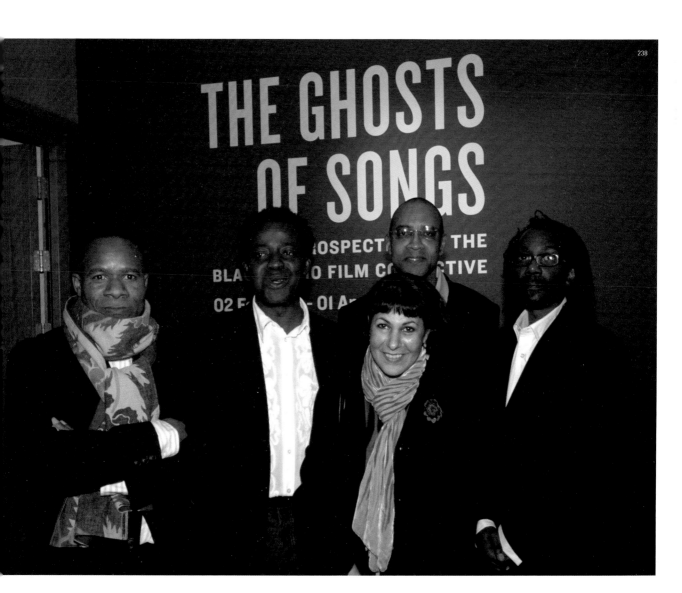

Silicon
Remembers
Carbon
2007
–

David Rokeby
–

I am fascinated by the way we transform the raw impressions streaming in through
our senses into a coherent mental picture of reality. So I create artworks that look and
listen, and try to make sense of what they see and hear. I am caught in the daily clash
between the loo orld of the computer and the embodied e ⬦ nce of living. So I
bring these tw s into closer dialogue to see what fails a t resolves.

David Roke▸

FACT, in collaboration with DA2
(Digital Arts Development Agency),
has re-staged works that signify
key moments in the development
of Rokeby's career. Interactive
installations that see, hear, talk
and make decisions invite us into
the mysterious, magical and lonely
realm of the computer.

In *Watch* (1995) and *Taken* (2002)
surveillance images are broken
down into different components
such as movement and stillness
to present us with another way of
seeing our same reality. *The Giver
of Names* (1991) and *n-Cha(n)t* (2001)
are systems that have learnt to talk
in their own computer language from
a database of associated words.

The work of David Rokeby explores
human psychology, language, vision,
memory, learning, and how tech-
nology defines the way we see the
world around us.

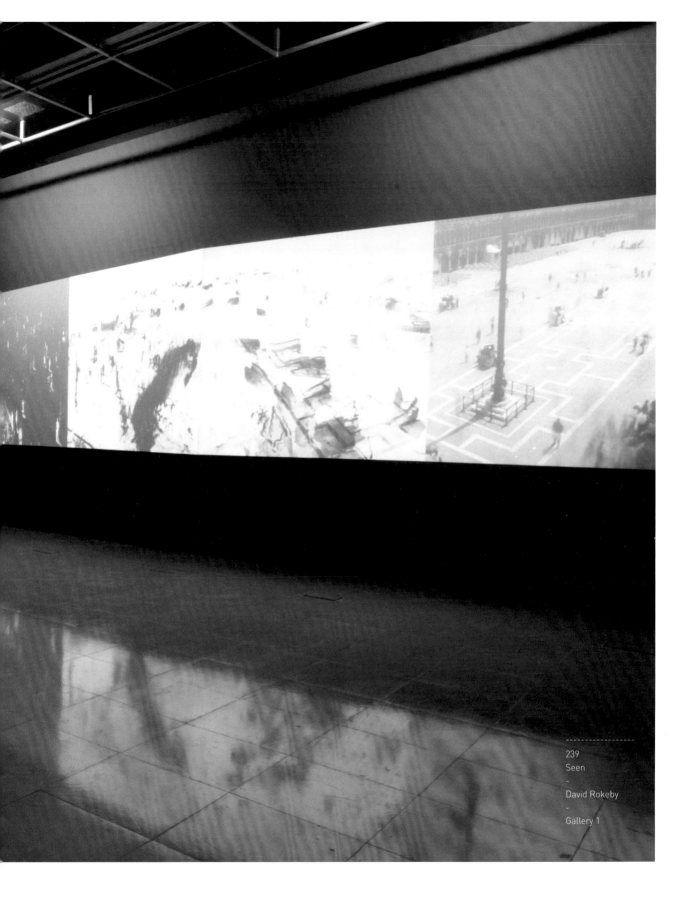

239
Seen
-
David Rokeby
-
Gallery 1

Here And
Your Here
2007

–

Anna Lucas

–

This exhibition featured three new
commissions by Anna Lucas, filmed
in London, the Middle East and Peru.
These works explore the social,
scientific and spiritual subcultures
surrounding a number of exotic
plants. Set against a backdrop of
political uncertainty and environ-
mental concern, they extend Lucas'
interest in local and global situations
and investigate the promise of nature
and new technologies.

Atlantic Botanic reflects on two
institutions, London's Brixton

Markets and the South London
Botanical Institute, and explores
notions of cultural history
and exchange.

Kaff Mariam and *Uña de Gato*,
document Lucas' pilgrimage over-
seas to find the homes of two rare
plants. Sold in Brixton Markets,
both plants are associated with
numerous medicinal, spiritual and
superstitious beliefs.

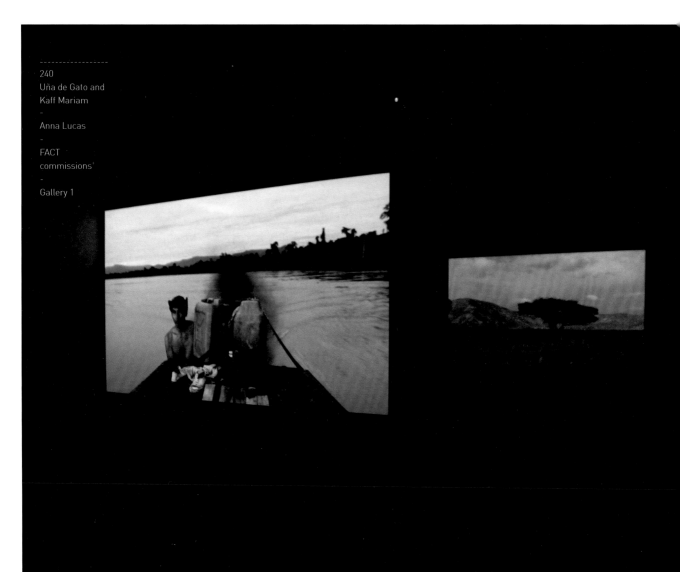

240
Uña de Gato and
Kaff Mariam

-

Anna Lucas

-

FACT
commissions

-

Gallery 1

The Bold
Street Project
2007
—
Katie Lips and
Michelle Wren
with tenantspin
—

241

243

245

242

244

246

241/242
The Bold Street
Project
-
Exhibition
Preview
Street Market
-
Ropewalks
Square

243 - 247
The Bold Street
Project
-
FACT
Collaborations
commission
-
Katie Lips and
Michelle Wren
with tenantspin
-
Media Lounge

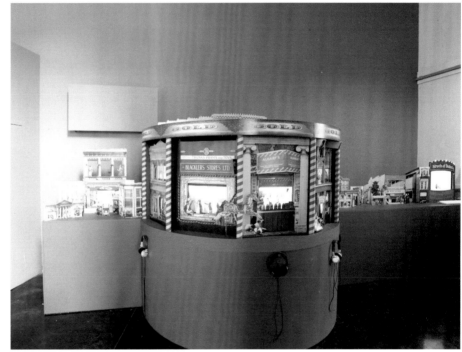
247

In the context of a dramatically changing city, FACT developed a programme of work that explored its immediate location. In a globalised world, trade and social networks are mapped out on our local environment. Collaborating with local residents, traders, buskers and shoppers, FACT worked with artists to investigate subjects ranging from shopping and smoking to global politics and economics. From hosting artist residencies and projects to new commissions, screening films and putting on exhibitions, *The Bold Street Project* used where and how we live as a starting point.

Collaborating with tenantspin, Liverpool artists Michelle Wren and Katie Lips of Kisky Netmedia used Liverpool's Bold Street as inspiration, subject and metaphor, to create an intricate old-style architect's model of the street filled with new media content. Like a carnival, the model brought together stories from different moments in time, from cutting-edge contemporary artwork to early activism, from footage from the 80's club Café Berlin to portraits of Bold Street-born innovator, Sebastian Ziani de Ferranti.

Artists and filmmakers Kim Ryan, Alex Cox, Chris Bernard, Pete Wylie and Jeff Young all have a passion for the street, and contributed new films. Broadcaster Roger Hill produced a unique series of audio tours, and filmmaker Emily Voelker, in collaboration with tenantspin, made a new Bold Street short film.

www.boldstreet.org.uk/blog

Re:
[Video Positive]
Archiving Video
Positively
2007
–

Various Artists

–

To coincide with the launch of FACT's Online Archive archive.fact.co.uk this exhibition re-staged and re-contextualised a selection of work from the groundbreaking *Video Positive* festivals.

Works on view included David Hall's *A Situation Envisaged: The Rite II (Cultural Eclipse)* (1989), Judith Goddard's *The Garden of Earthly Delights* (1991), Lynn Hershman Leeson's *America's Finest* (1994), Lei Cox's *Skies Over Flower Field* (1995), Keith Piper's *Reckless Eye-balling* (1995), Imogen Stidworthy and Michael Curran's *Closing/Close By* (2000) and a new commission by artists Thomson & Craighead, *BEACON* (2007).

The Media Lounge hosted a video jukebox with a selection of significant moving image works screened during *Video Positive*, as well as original documentation from the festivals and access to FACT's new online resource.

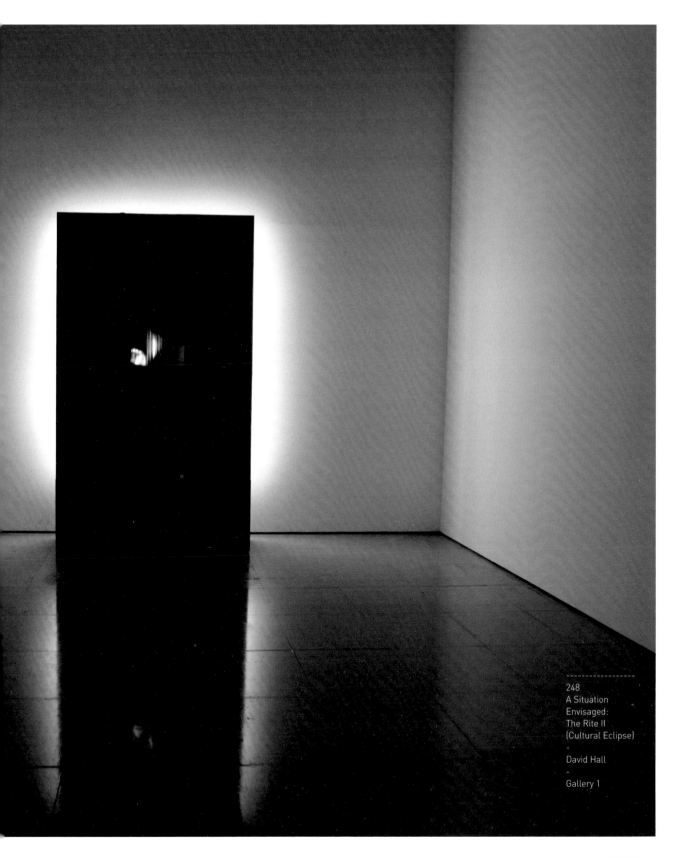

248
A Situation
Envisaged:
The Rite II
(Cultural Eclipse)
-
David Hall
-
Gallery 1

249

249
BEACON
-
Jon Thomas &
Alison Craighead
-
Public Spaces

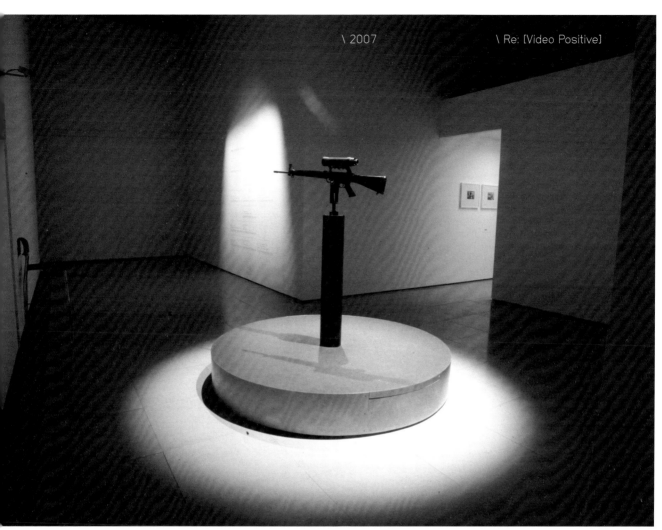

250
America's Finest
-
Lynn Hershman
Leeson
-
Gallery 1

251
Re:
[Video Positive]
Archiving Video
Positively
-
Various Artists
-
Stills from
Promotional
Animation

252
Re:
[Video Positive]
Archiving Video
Positively
-
Various Artists
-
Public Spaces

251

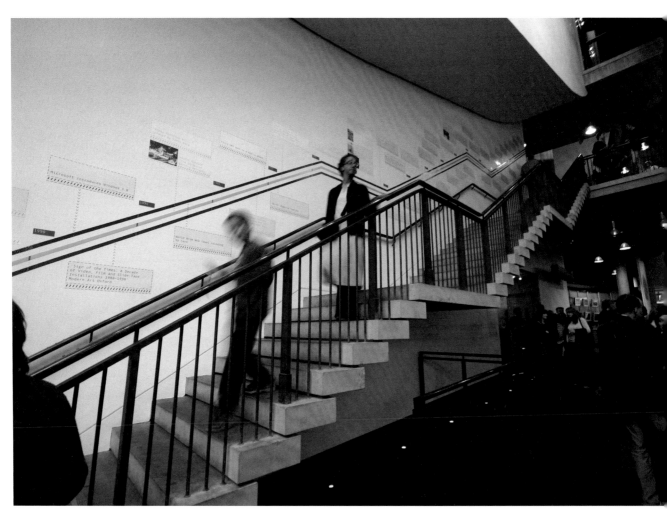

253
Evolution of
Media Formats

254
Re:
[Video Positive]
Archiving Video
Positively
-
Preview Invitation

253

YOU ARE INVITED
TO THE PREVIEW OF

RE: [VIDEO POSITIVE]
ARCHIVING VIDEO POSITIVELY

THURSDAY 30 AUGUST 2007 6.00PM - 8.00PM
BY INVITATION ONLY - ADMITS TWO

GALLERY 1, 2, THE MEDIA LOUNGE AND PUBLIC SPACES
OPEN TO THE PUBLIC 31 AUGUST - 04 NOVEMBER

To celebrate the launch of our new online archive, FACT
presents a selection of work from the grounds of long
Video Positive festival (1989 - 2000). The artworks on
view will invite audiences to reflect on the preserva-
tion, communication and re-presentation of old media
art. Also on display will be a new commission by artist
Thomson & Craighead.

An exciting programme of screenings, workshops and
artists talks will complement the exhibition. For full
details visit www.fact.co.uk

254

At 25 Metres
2007
—

Nick Crowe and
Ian Rawlinson
—

Nick Crowe and Ian Rawlinson have
worked collaboratively since 1994,
investigating and revealing human
behaviour, ideologies and belief
systems. For this major exhibition
they developed a body of work that
focused on issues around faith in
contemporary society, its hold
on the individual and its continuing
ability to define communities.

FACT commissioned three
new works: *The Fireworks*, *The*

Name of God and *Two Leprechauns*,
shown alongside *The Carriers'
Prayer*, commissioned by Film
and Video Umbrella. The works
combined intelligent critique with
irreverent humour and a rich and
exciting visual sensibility. Works
ranged from the subtle and contem-
plative to the humorous and the
highly spectacular.

255
The Making of
The Carriers'
Prayer

256
The Carriers'
Prayer
-
Commissioned
for At 25 Metres⁺
-
Nick Crowe and
Ian Rawlinson
-
Gallery 2

255

« My personal FACT highlights... the opening party being so busy that it was literally impossible to move in the galleries; installing *Baltimore* in the midst of a building site; The Melvins turning up with a backline bigger than the PA we had provided and proceeding to blow the doors off with a 10-minute gong solo; trying to build a geodesic dome out of cardboard; Jodi performing *My Desktop* live in the cinemas with a follow spot; green screen with Cory Arcangel; Christian Jankowski singing 'We are the World' in his karaoke booth; working nights with Vito Acconci; interactive furry sofa; painting carpet with a spraygun to make it match the wave in Gallery 1; drunk guy staggering out of the smoke from the *Fireworks* shoot on Wood Street at 3am, asking if he was in *Batman*; trying to grow live cells in Gallery 1; load-testing the sculpture rig by hanging the Genie lift off it for an hour... »

–

Nick Lawrenson
Programme Delivery Manager

257/258/259
The making of
The Fireworks

260
The Fireworks⁺
-
Nick Crowe and
Ian Rawlinson
-
Gallery 1

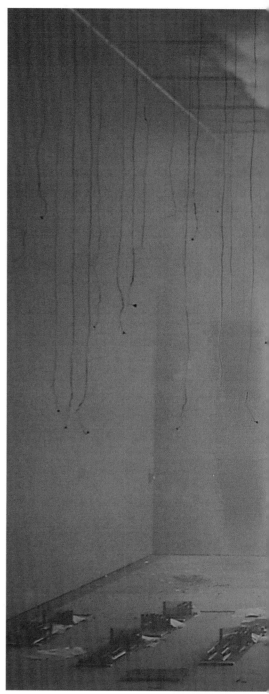

257/258/259 260

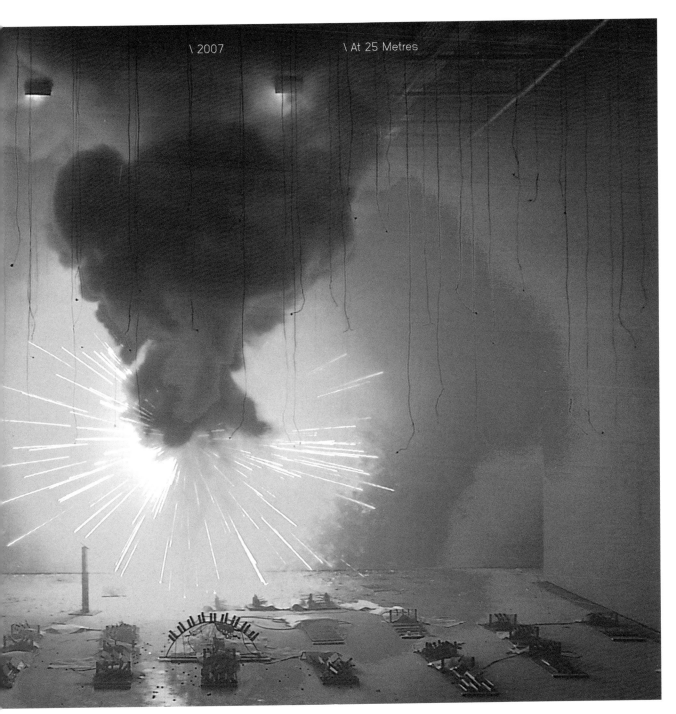

Tarantino Visits
2007

Quentin Tarantino treated film fans to a lengthy Q&A after an exclusive screening of his movie Death Proof at FACT. Tickets for the event had sold out in under 20 minutes, as fans queued around the building. After watching the movie from the audience, Tarantino came to the front of the screen to respond to questions. He thanked the audience for their "warm welcome", adding that it was "much appreciated", and then got down to the business of talking about the film.

One film fan got the surprise of her life when she turned up to watch Death Proof and found out the director would be watching it sitting next to her. Tarantino wanted to watch the film from the audience "to stick a thermometer up the bum of Liverpool". But 19-year-old Becky Johnson didn't expect that would mean sitting next to her.

She says he was very charming, shaking her hand as he sat down and took in the audience's reaction while bobbing his head along to the music.

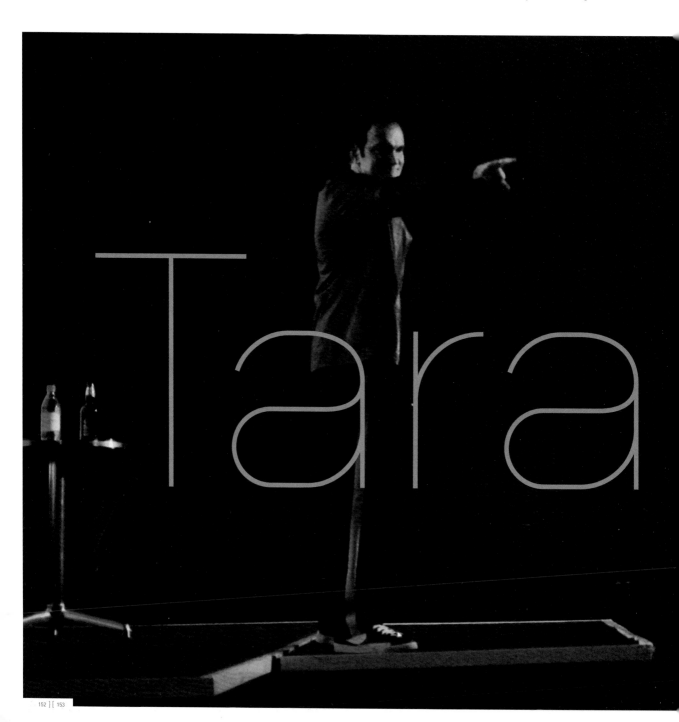

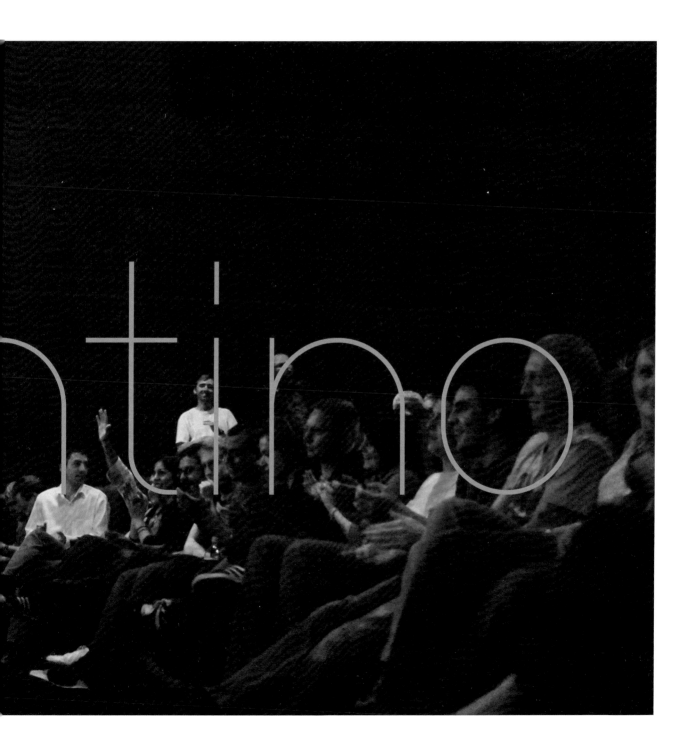

J'08

Highlighted Projects:
New Year's Revolution \ Freehand \
Human Futures \ sk–interfaces \
Eternal Youth \ Pipilotti Rist \
Liverpool Biennial \ DING>>DONG \
First Light Movie Awards \
The Waiting Rooms

08
Liverpool
EUROPEAN
CAPITAL OF CULTURE

261

261
New Year's
Revolution
-
Workshop

262
New Year's
Revolution
-
Exterior
Projection

« The biggest change in Liverpool
since our last visit is the opening of
the FACT centre. It's very impressive. »
–
Sir Jeremy Isaacs,
Chair of the European Capital
of Culture 2008 judges

Freehand
2008

–

Freehand is FACT's Young People's Programme, which offers something for anyone interested in getting involved with art/film/sound/technology projects taking place at FACT. All *Freehand* projects are led by young people and encourage young people to take control and decide what kind of projects they want to do.

Freehand is also a website for people aged 13–19 who are interested in art, music, film, technology and design and who want to share their ideas and work with other young people. Since November 2007, a dedicated team of Freehanders has been working with artist Sally Olding

to develop FACT's young people's site. After researching both on and offline, they then wrote a brief and interviewed design companies, choosing Smiling Wolf as the company they wanted to collaborate with. Smiling Wolf worked with them to create a 3D viral animation, and created the site according to their specifications. The group continue to work on the site, moderating content uploaded by new members, and creating great new projects for the online *Freehand* community.

www.freehand.fact.co.uk

263

263
Freehand
-
Stills from 3D
Viral Animation

264
Freehand ID kit

Human Futures
Programme 2008
—

In 2008 FACT devoted its programme
to *Human Futures* with exhibitions,
events and debates designed to
inspire new ways of thinking about
life and art – now and in the future.
Advancing technology is accelerating
the evolutionary process and chang-
ing collective notions of who we are
and how we live, work and play.
We are moving towards being able
to increase longevity, prevent disease,
improve intelligence and spread
beyond the confines of Earth. Yet it is
human nature that will dictate how
this technology is harnessed and
applied. The future is ours to shape.

humanfutures

Where are humans headed? What
does the future have in store for our
children's children? What *choices*
could we make? What *futures* do
we want to create?

Throughout 2008 *Human Futures* pre-
sented innovative works by interna-
tionally renowned artists that
transcend the borders between
the physical, virtual, biological

and digital. Their focus on conver-
gence reflects the unfolding of a
conceptual frontier in which art
informs the world of technological,
scientific and social research.

The works by artists featured in
Human Futures can be seen as
a clue to what art or life may look
like in the future. Whether they
reveal new ways of exploring and

understanding our human biology
or our ability to create and exist in
virtual, digital or physical worlds,
they comment on and extend
current thinking.

The *Human Futures* programme
was structured around three main
areas: *My Body*, *My Mind* and *My
World*. The interconnection between
these areas unites us, and through

Human Futures, FACT aimed to
activate us all to think about the
fundamental changes coming our
way in our mental capacities and
relationship to the body and the
environments we inhabit.

Linked to each area was a major
exhibition, special screenings, public
talks and practical workshops which
encouraged discussion and debate

265
Human Futures
Logo

266 - 269
Human Futures:
Art in an Age
of Uncertainty
-
Book Cover and
Selected Spreads

266 - 269

on the social, psychological and emotional consequences of living in a digitally and technologically networked society.

A publication and symposium drew together the whole year of events and community involvement to engage public and professionals in discussion and debate around the *Human Futures* research questions of: *How will technology affect human experience and awareness? What is the role of art and creative technology in shaping human futures?* The year closed with a focus on young people, the hope and guardians of our human futures; their games and creations may be virtual today – but could be our reality tomorrow.
-
Mike Stubbs, Director / CEO

sk-interfaces
2008
—
Various Artists
—

A groundbreaking exhibition on the uncertain limits between art and science, *sk-interfaces* explored, materially and metaphorically, the concept of skin as a technological interface.

The exhibition featured designer hymens by medical artist Julia Reodica, a coat made of blended skin cultures by legendary French artist ORLAN, Jun Takita's model brain infused with glowing moss,

and biotechnological 'leather' growing in the galleries by the Tissue Culture & Art Project.

Oron Catts and Ionat Zurr (Tissue Culture & Art Project) are behind SymbioticA, the art and science collaborative research laboratory in Perth (Golden Nica, Prix Ars Electronica, 2007). Their *Victimless Leather* investigates the idea of producing leather without killing

an animal. Zbigniew Oksiuta (Award of Distinction, Prix Ars Electronica, 2007) designs biological structures that can serve as new habitats; he grew a new gelatine sphere in FACT's Media Lounge as a statement in favour of a new form of spatial coexistence between man and nature.

Other artists featured in the exhibition and related events included French duo Art Orienté objet, Swiss performer

Yann Marussich, situational art and technology innovator Neal White, Wim Delvoye (Award of Distinction, Hybrid Art, Prix Ars Electronica, 2007), Stelarc, Critical Art Ensemble and the French designer Olivier Goulet. The exhibition was guest curated by Jens Hauser.

sk-interfaces

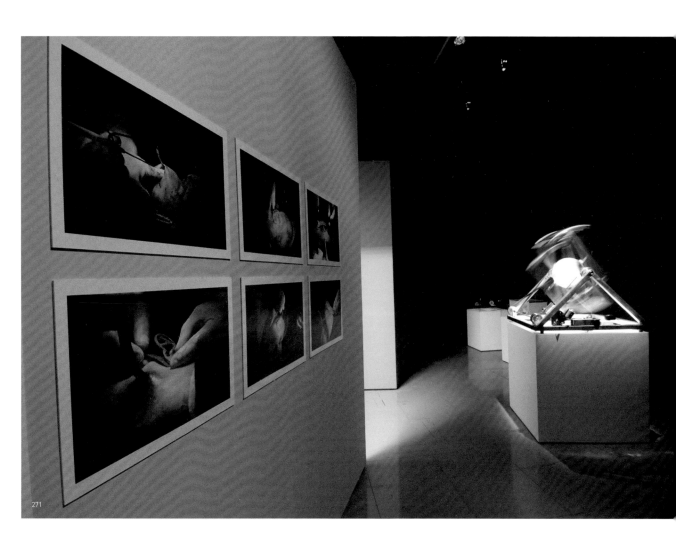

271

271
sk-interfaces
-
Left to Right:
Ear on Arm,
Stelarc, Hymen
Project, Julia
Reodica & Cosmic
Garden Spatium
Gelatum 191202a,
Zbigniew Oksiuta
-
Gallery 1

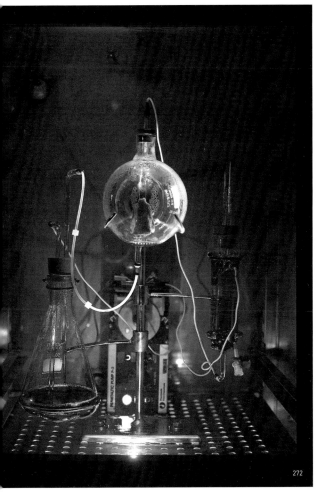

272

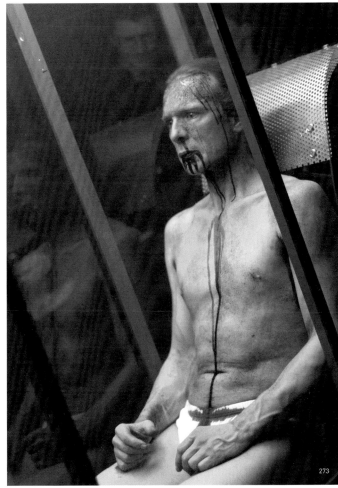

273

272
Victimless Leather
-
The Tissue Culture
& Art Project:
Oron Catts and
Ionat Zurr
-
Gallery 1

273
sk-interfaces
Exhibition Preview
Performance
-
Blue Remix
-
Yann Marussich
-
The Box

Eternal Youth
2008
—
Al and Al
—

274

274
Al and Al

The first solo presentation in the UK of work by artist duo Al and Al, the exhibition featured a new video installation, *Eternal Youth* (2008), commissioned by FACT, which was shown alongside two existing works and a blue-screen interactive studio.

The works in this exhibition all investigated the power of mediation and popular culture. *Interstellar*

Stella (2006) features a child model who embarks on a journey inside a labyrinth formed by her own advertising pictures. The film considers the origins of 'paparazzi' in a study of Fellini's *La Dolce Vita*.

Perpetual Motion in the Land of Milk and Honey (2004) refabricates the artists' grandfather's lifelong dream to create a perpetual motion device

that produces free power.

Al and Al's latest work *Eternal Youth* is laden with references to the killing and legacy of Liverpool's famous cultural icon, John Lennon. The work refers to a city undergoing its own rebirth while grappling with the dominant legacies of its past. *Eternal Youth* is also a story of anonymous youth and the technology of mediation.

Pipilotti Rist
2008
–
Pipilotti Rist
–

One of the world's most celebrated artists, Pipilotti Rist drew together a body of work that explored what it is to be human. In her trademark heady mix of bright light, lush colours and zany feminine energy, the work in this exhibition explored the loss of innocence. It challenged viewers to look at art differently: whether lying on the floor, peering into a small dark crack in the floor or perched on over-sized furniture, Rist's work creates an 'Alice in Wonderland' feel to the exhibition.

Opening the show, Pipilotti turned FACT into a screen, playing on the building's purpose and natural environment. A previously unused still from one of her most famous works, *Open My Glade* (2000) – originally commissioned to be shown in New York's Times Square was is presented on the front window of FACT. Pipilotti Rist's first public art project in New York, *Open My Glade* was composed of 16 one-minute video segments shown at a quarter past every hour. Transported to the UK for the first time, the work also appeared on the BBC Big Screen in Clayton Square, Liverpool bringing a new dimension to the piece.

In Gallery 1, the UK premiere of *Gravity Be My Friend* (2007) saw a re-working of the site-specific installation originally designed for Magasin 3 Stockholm Konsthall

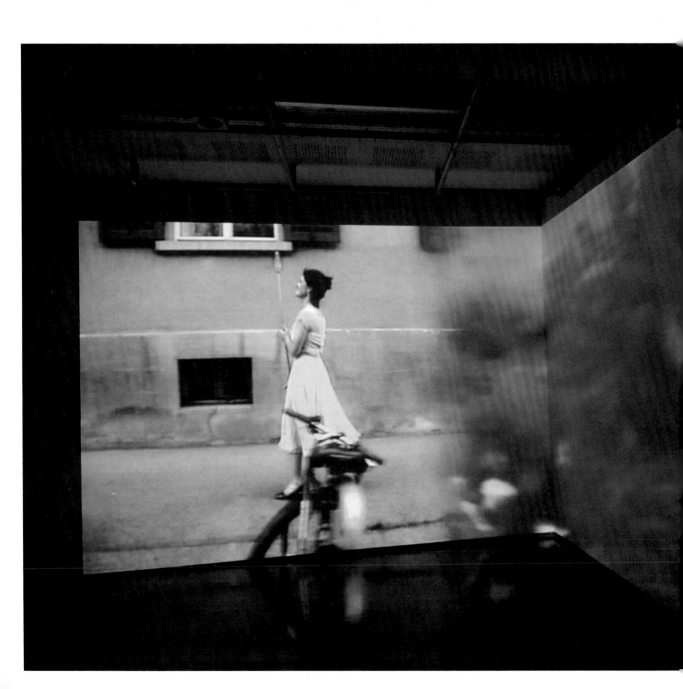

in 2007. In a visual and sensorial experience, the visitor lies on a 'carpet landscape' to watch the work projected above.

In Gallery 2, FACT presented a selection of Pipilotti Rist's finest work from the last 15 years, including *Apple Tree Innocent on Diamond Hill* (2003), *Ever is Over All* (1997), *Blood Room* (1993/98) and *Your Space-Capsule* (2006). These works show the artist's progression and her

ongoing fascination with viewing spaces, moving image sculpture and ideas around femininity, artistic production and creativity.

In FACT's interactive space, the Media Lounge, the installation *The Room* (1994/2000) made the viewer feel childlike as they sat on oversized furniture watching TV.

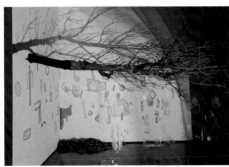

276/277/278

276
Ever is Over All
-
Pipilotti Rist
-
Gallery 2

277
The Room
(Das Zimmer)
-
Left to right:
Laura Sillars,
Pipilotti Rist and
Mike Stubbs
-
Media Lounge

278
Apple Tree
Innocent on
Diamond Hill
-
Pipilotti Rist
-
Gallery 2

37,96

visits

05

279
Gravity Be
My Friend
-
Pipilotti Rist
-
Gallery 1

Record Breaking Attendance

Liverpool Biennial
2008

—

Various Artists

—

MADE UP at FACT focused on the power of the mind to make up meaning when faced with complete abstraction and extreme sensory deprivation. Outside the gallery and in the public realm, MADE UP allowed fiction to rub up against the everyday, inviting artists to carve out space for the imagination, whether in imaginary models made manifest, or in playful reworkings of our life world.

From the ceiling, suspended above the main public space on the ground floor, we presened an awe-inspiring automated creature created by U-Ram Choe, and in Gallery 1 we had Ulf Langheinrich's fully immersive, sensory environment. *Stranger than Fiction* brought together a selection of artists – Terrence Handscomb, Lisa Reihana, Stella Brennan and Michael Bell-Smith – in Gallery 2, alongside work by Muchen featured in the FACT Café.

280

280
LAND
-
Ulf Langheinrich
-
FACT
co-commission[*]
-
Gallery 1

281
Opertus Lunula
Umbra (Hidden
Shadow of Moon)
-
U-Ram Choe
-
FACT
co-commission[*]
-
Atrium

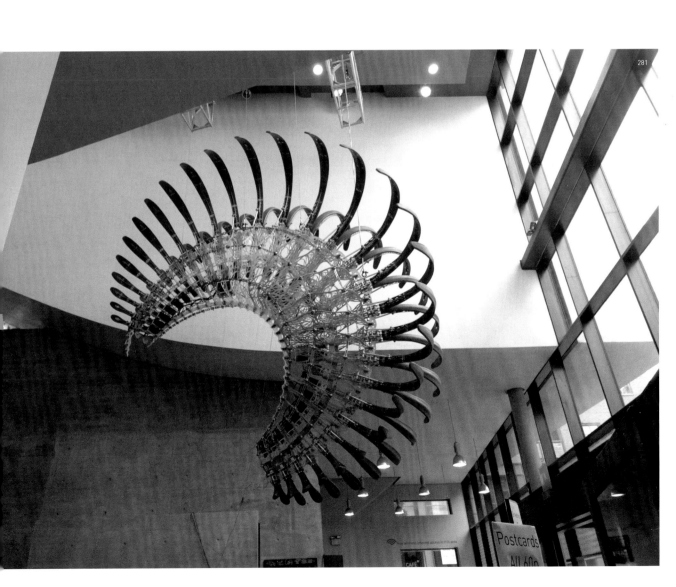

281

DING»DONG
2008
—

Various Artists
—

DING»DONG exhibited new ways
of exploring sound for both novices
and experts alike, encouraging par-
ticipants to expand, distribute and
share performance - to make music
with anything.

FACT's atrium was transformed with
Ray Lee's *Swarm*. These hanging,
spinning, interactive speakers
generated an interplay of sound to
play with the building itself. As the
listener moved in the space, aural

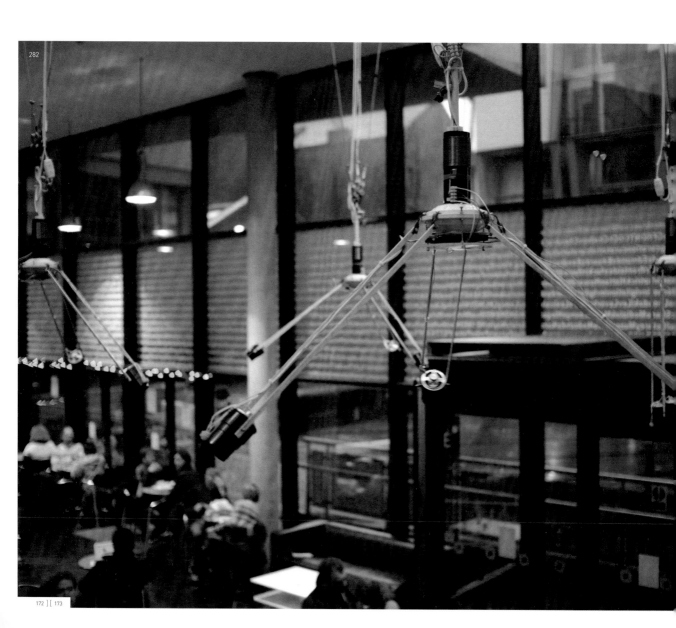

282

details were revealed among the rich wash of sound. In Gallery 1 we presented the world premiere of *The Fragmented Orchestra*, winner of the PRS Foundation's prestigious New Music Award 2008. Jane Grant, John Matthias and Nick Ryan created a work that mimics the rhythm of neuron activity in the human brain. 24 neuron 'units' were placed across the UK in locations chosen for their inherent sonic rhythms. A microphone picked up sounds at each

location, continuously transmitting to 24 corresponding speakers at FACT to create a neural network in the gallery.

Gallery 2 featured a new audio-visual installation, the result of collaboration between two legends in popular music. OMD's Andy McCluskey and Peter Saville, in collaboration with video artist Hambi Haralambous, returned to the iconic images of their youth

in the Northwest – the industrial landscape of five power stations embedded in pastoral beauty. The Media Lounge was a musical playground letting your body become a drum with Tetsuaki Baba's *The Freqtric Project*; control virtual instruments with gamepads with *fijuu* by Julian Oliver & Pix; while The Owl Project (Anthony Hall, Simon Blackmore and Steve Symons) encouraged you to make electronic music with the wooden *m-Log*.

282
Swarm
-
Ray Lee
-
Atrium

283
The Fragmented Orchestra
-
Left to Right: Nick Ryan, John Matthias, Jane Grant
-
Gallery 1

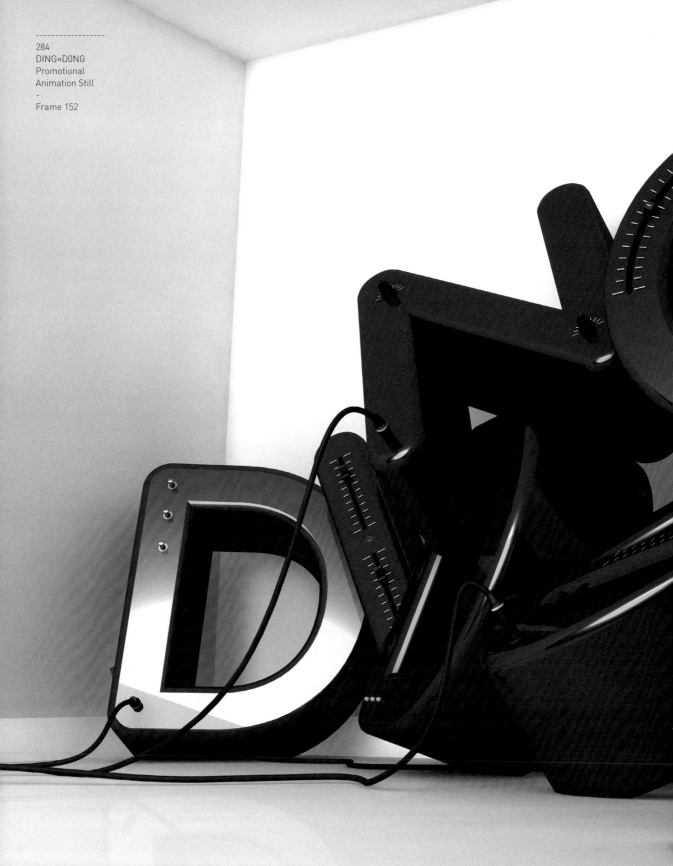

Young People's
Film Commissions
—
First Light Movie
Awards 2008
—

285
The Making
of W.I.L.D
-
FACT
Collaborations
commission*

Two teams of young filmmakers
were awarded production support
and bursaries to produce new
short films under the mentorship
of artists Al and Al. The films were
premiered in a special screening
in the cinemas at FACT as part of
a special effects weekender in April
2008. The project was funded by
First Light Movie Awards.

W.I.L.D.
2008
—

Terry Cheung

This sci-fi adventure chronicles the
results of a scientist's attempts to
beat a deadly virus with the power
of lucid dreams. With amazing

special effects and acrobatic fight
scenes, this is an action-packed
and uncompromising work of
the imagination.

Pinnacle Man
2008
—

Mike Donaghy, Frances
Mitchell, Joseph Oliveira

Pinnacle Man is a futuristic drama
set in a world in which the sterile
apartments of the rich are set high
above the grim realities of the world
on ground level. The two worlds have
become entirely separated, until
chance intervenes to force Lennon,
a property mogul, into an encounter
with Kaolin, a ground-level girl.

Waiting Rooms
2008
—

Waiting Rooms consists of four
new artworks in Liverpool and
Sefton healthcare buildings.
Commissioned by Liverpool and
Sefton Health Partnership (LSHP)
and managed by FACT, the artworks
are installed in the waiting areas
of the buildings and are accessible
to the whole community.

The commissions are part of LSHP's
Healthy Building programme, which
looks at the potential of waiting rooms
as settings for interactive artwork.
The purpose of the artworks is
to create engaging social spaces.
They invite interaction and distraction
in an environment in which people
often feel nervous or unwell.

286
Three Drops
-
Scott Snibbe
-
Earle Road
Health Centre

286

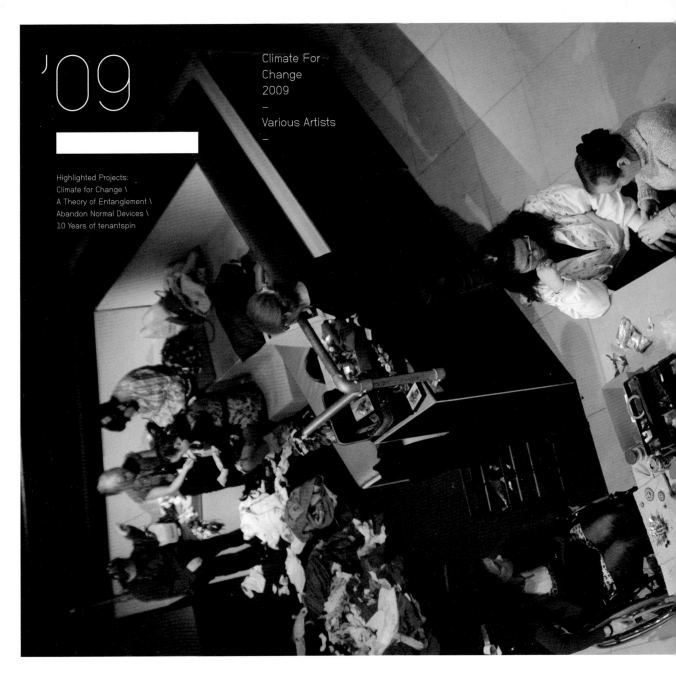

'09

Climate For
Change
2009
–
Various Artists
–

Highlighted Projects:
Climate for Change \
A Theory of Entanglement \
Abandon Normal Devices \
10 Years of tenantspin

UNSUSTAINABLE 2009

In 2008 FACT asked "What is the future of our world?" In 2009, as the world faces an increasingly uncertain future in the wake of credit, oil, food, water and housing crises, this question is even more pertinent. Liverpool City Council's *Year of the Environment* is timely. As we celebrate 20 years of producing art, FACT asks is the world as we know it *UNsustainable*? Through a series of artist residencies, debates, films, exhibitions and events we examine the idea of un-sustainability and what that might mean for how society develops in the future.
-
Laura Sillars,
Programmes Director

Climate for Change speculated that the local, self-organising, distributed networks are the most important tools we have for creating sustainability; providing confidence and feeding imaginations that could form the foundation for real change.

In Gallery 1 FACT handed over the keys to the door and the gallery became a social hub for meetings, discussions and workshops, allowing Merseyside grassroots networks

to practise and imagine new models of governance and organising – live in the gallery space.

New York's Eyebeam Art and Technology Center staged its *Sustainability Road Show*. Artists in residence included Steve Lambert, Jeff Crouse and Hans-Christoph Steiner, while artist Stefan Szczelkun presented his *Survival Scrapbooks*. In addition, Gallery 1 hosted a loose and rotating line-up of artists working in Liverpool and beyond, including British-born Chinese artist Kao-Oi Jay Yung, underground nightclub The Kazimier, DIY craft group C.U.T.S., artist-led environmental group The Gaia Project in partnership with L@tE, and more.

In Gallery 2, FACT presented Melanie Gilligan's film, *Crisis in the Credit System*. Nik Kosmas and Daniel Keller (AIDS 3D) unveiled *Forever*, a new installation alluding to a post-apocalyptic future where our machines remain as beautiful relics of our former glory.

Copies of a spoofed *New York Times* newspaper, created by thousands of volunteers and originally distributed in November 2008 –but dated July 4, 2009 – received a further outing at FACT.

In the Media Lounge, Copenhagen-based art and architecture collective N55 set up *SHOP*, a unique exchange area.

The Ghana Think Tank, a collaboration between artists Christopher Robbins, John Ewing and Matey Odonkor, and in partnership with FACT's own tenantspin network, asked visitors to submit their problems, which were given to a network of think-tanks established in Ghana, Cuba, El Salvador, Mexico, Ethiopia and Serbia to propose solutions.

288

291

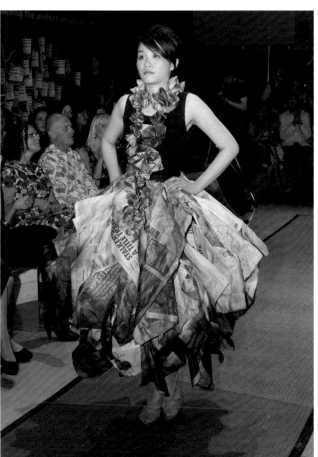

289

290

292

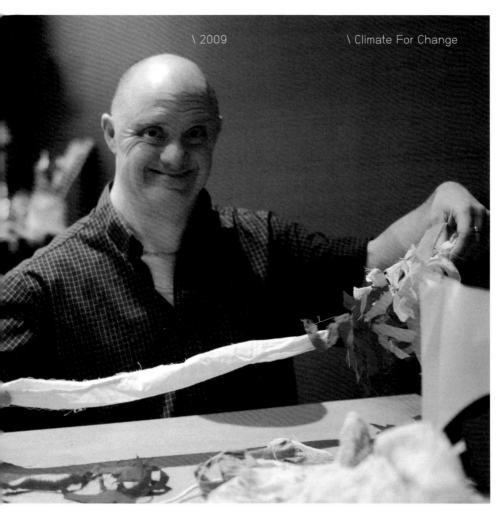

288
Climate
for Change
Exhibition
Preview
-
Gallery 1

289/290
Sustainable
Fashion Show⁺
-
Skirt by Alison
Little (The Fabric
Reclaimer)
-
Gallery 1

291
Red Dot Workshop
-
Gallery 1

292/293
On/Off Button
Research during
Exhibition
Preview
-
Glen Davidson
-
Gallery 1

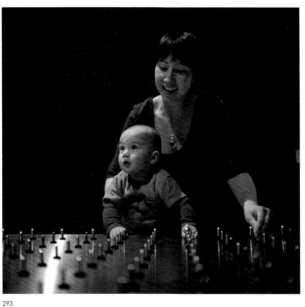

293

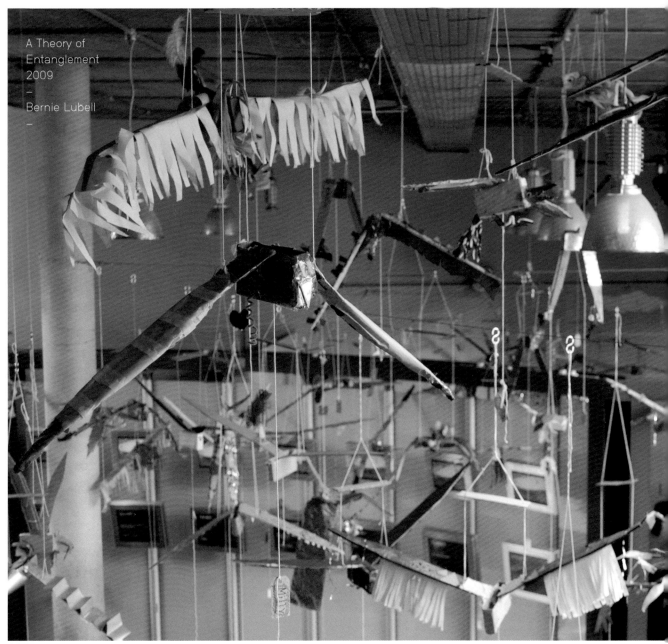

A Theory of
Entanglement
2009
—
Bernie Lubell
—

San Francisco-based artist Bernie
Lubell presented a stunning new
12-metre high sculpture that took
over FACT's atrium and an exhibition
of his adamantly low-tech artworks.
His work includes a stone-age digital
computer, a rainstorm of chaos and
nostalgia, a phone booth/confessional
communications network and
simulations of the human heart and
brain. This was the first exhibition
in the UK by the artist, who has
exhibited internationally, including

Ars Electronica in 2007, where he
received the Award of Distinction
for Interactive Art.

Lubell's whimsical machines look
like three-dimensional medieval
diagrams. All of the sculptures call
for the participation and collabora-
tion of others to make them work,
suggesting that only by working
together can we create solutions
to our everyday problems. Constr-
ucted from soft, sustainable woods

that are ill-suited for machines, they
hover between functioning and not.
The artist takes inspiration from
the work of French scientist and
chronophotographer Étienne-Jules
Marey, who studied the movements
of the body, from the limbs to the
heartbeat. Marey's work was funda-
mental to developments in cardiology,
aviation and cinematography.

Lubell adopts this body of work to
examine the human as a machine,

an area he became interested in
when he suffered from cardiac
problems in 1999.

The new commission A Theory of
Entanglement (2009) activated the
FACT atrium and ensured visitors
became participants in the work.
By pedalling bicycles connected to
a large wooden machine overhead,
the audience cooperated to weave
a large knotted web that gradually
descended from the ceiling towards

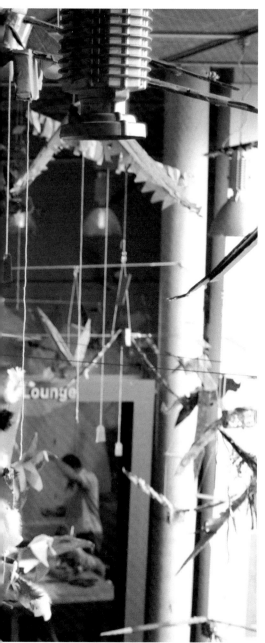

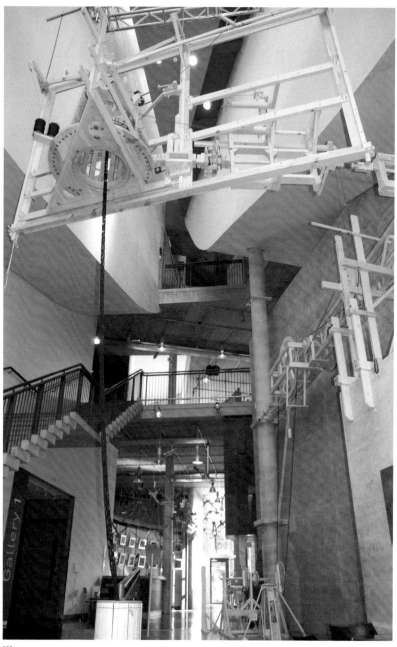

the floor. In Gallery 1 and Gallery 2,
a selection of Lubell's previous works
were exhibited, including *Conservation
of Intimacy* (2005), *...and the Synapse
Sweetly Singing* (2003) and *Etiology
of Innocence* (1999).

The Media Lounge was transformed
into a workshop where visitors
created *Flying Flappers*, their own
miniature Lubell-esque sculptures.[*]

294
Flying Flappers[*]
-
Public Spaces

295
A Theory of
Entanglement[*]
-
Bernie Lubell
-
Public Spaces

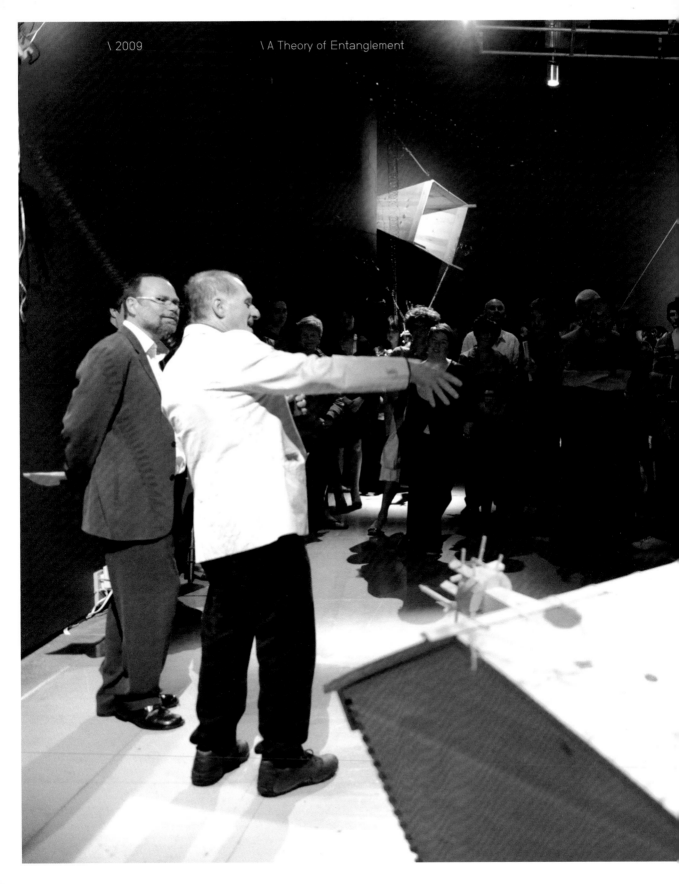

296
A Theory of
Entanglement
Exhibition
Preview
-
Mike Stubbs
and Bernie Lubell
-
Gallery 1

Abandon Normal
Devices (AND)
2009
—

Various Artists
—

Abandon Normal Devices (AND) is
a festival of new cinema and digital
culture, debuting in Liverpool then
continuing across the Northwest
in the run up to 2012 and beyond

With screenings, exhibitions, online
projects, public realm interventions,
debates, workshops and live events,
AND has a distinctive emphasis on
critique and ideas. At the heart of
this festival lies a fascination with
ideas about social, physical and
technological norms with artistic
approaches from the playful to the
downright provocative.

2009 highlights include Apichat-
pong Weerasethakul, The Yes Men,
Krzysztof Wodiczko, Nic Roeg,
Carolee Schneemann, Jamie King,
Duane Hopkins, DJ Spooky, and
more. AND is presented by FACT,

Cornerhouse (Manchester) and
folly (Lancaster).

The debut festival provides a legacy
in the region after the success
of Liverpool's year as European
Capital of Culture.

Participating 2009 venues include:
A Foundation, BBC Big Screen,
the Bluecoat, City Screen, DaDa
Fest, Kazimier, The Art and Design
Academy at Liverpool John Moores
University, Open Eye Gallery, The
Royal Liverpool Philharmonic and
Tate Liverpool.

The festival forms part of WE PLAY,
the Northwest cultural legacy
programme for the 2012 Olympic
and Paralympic Games.

297
AND Logo

298
AND Brand
Images

Primitive
2009
–

Apichatpong
Weerasethakul
–

The UK premiere of Apichatpong Weerasethakul's new multi-platform media artwork *Primitive* commissioned by FACT in partnership with Haus der Kunst, Munich and Animate Projects, London. *Primitive* is a multiple-screen video installation, a music video, a short film for cinema, an online film and an artist's book.

This is the first solo exhibition in the UK by the Thai artist, which forms part of the AND Festival. *Primitive* is set in Nabua in the Renu Nakhon district of Thailand, which suffered violent clashes between communist communities and the Thai military in the 1960s. Communist suspects

were brutally tortured during attacks and those who managed to escape fled to the jungle where they disappeared forever.

Nabua's story undeniably has echoes with the current political turmoil in Thailand, as freedom of expression is still restricted and Thai security forces continue to engage in extrajudicial killings, torture and arbitrary arrests, with new cases of 'enforced disappearances' emerging during 2008.

The *Primitive* project is about re-imagining Nabua, a place where memories and ideologies have

been extinguished. The video installation features the teenage male descendants of the communist farmers who were invited by Apichatpong to fabricate new memories in building a spaceship together in the rice fields. Used as a place to hang out, sleep and dream, the spaceship also takes on its own life in the landscape as young men are seen playfully attacking one another, instilling an atmosphere of both pleasure and violence. By giving us time and space to re-dream the past, Apichatpong asks what can be learned to create a better future for the next generation.

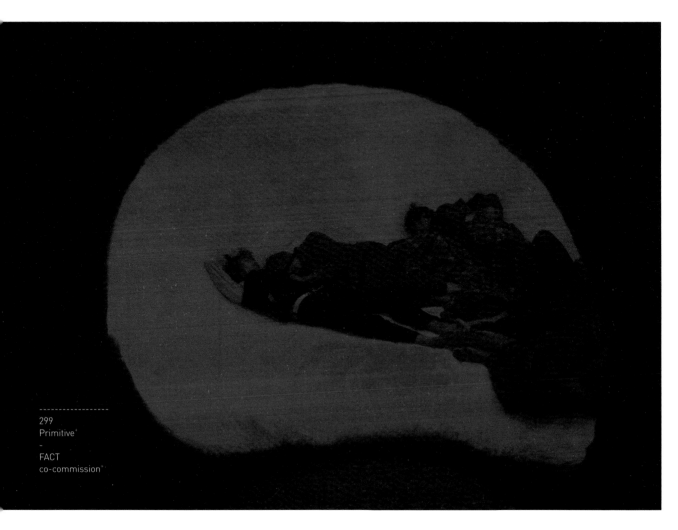

299
Primitive⁺
–
FACT
co-commission⁺⁺

Ten Years
of tenantspin
–

Top Ten
tenantspin
Moments
–

www.tenantspin.org

In 1999 FACT piloted an Internet TV project with social housing tenants and Government agency the Liverpool Housing Action Trust (HAT). Danish artists' collective Superflex provided the technical infrastructure and theoretical possibilities of a new DIY broadcasting technology – putting the social into media long before YouTube and Facebook became ubiquitous features of modern life. It all began humbly, in a shared room in Coronation Court, Liverpool's oldest tower block – since demolished. It had some successes and failures and crucially inspired a group of tenants to explore sustaining it. The project, tenantspin, continues today as a collaboration between FACT, Arena Housing Association and some of the original tenants plus a host of new ones.

The project has been much celebrated and continues to develop. tenantspin has had its fair share of surreal, moving and zeitgest capturing moments, largely due to the dynamic vivaciousness of the volunteers involved.

300
Beans on Toast
-
Olga Bayley
-
Copenhagen

10
Together In Electric Spoons

-

In the Autumn of 2006, tenantspin contributed a one-hour webcast as part of Grizedale Arts' *Virtual Grizedale* exhibition in collaboration with A Foundation and Liverpool Biennial. Guests and visitors included Jesse Rae and Richard Demarco.

Following the webcast, tenantspin's own John "Spoons" McGuirk, joined an illustrious list including Living Colour, The Rolling Stones, Depeche Mode, Mick Jagger, Madonna and Jeff Beck, by jamming with leading dub guitarist Doug Wimbish.

07
The Final Hand

-

In 2006, the late and much missed Mark Hobson produced a film called *The Final Hand*, which tackled the serious issue of male depression and was shot over several months.

04
Bon Voyage!

-

Everyone loves a good trip, and no-one more so than tenantspin. tenantspin has been welcomed into the hearts of many communities over the years and passport stamps include New York, Dresden, Rotterdam, Copenhagen, Cologne, Dublin and Cardiff.

01
Beans on Toast

-

One of tenantspin's most iconic images remains the *Beans on Toast* image. When tenantspin founder, the late Olga Bayley visited our Superflex collaborators in Copenhagen, she dazzled the group with a local recipe and spread the much loved delicacy to Scandanavia.

09
Eastern Promises

-

In 2005, tenantspin was invited by renowned artist and activist Gustav Metzger to take part in *EAST05 International* exhibition in Norwich. tenantspin presented three webcasts from the gallery.

06
Gardens of Stone

-

In 2005, tenantspin premiered the film *Gardens of Stone* by local film-maker Paul Sudbury. The film was an intimate portrait of the Gerard Gardens area of Liverpool. Such was the popularity of the film, FACT had to put on four screenings of the film welcoming over 400 people to the cinemas where former neighbours were tearfully reunited whilst others reminisced of times past.

03
The Bold Street Project

-

In the summer of 2007, tenantspin launched an exhibition titled, *The Bold Street Project*, a mass collaborative project dissecting Liverpool's Bold Street. Record figures flocked to FACT to visit and take part in this unique project which looked at everything from secret tunnels to hidden histories.

08
The King is Alive

-

One of the most viewed clips in the tenantspin archive is an interview from Liverpool's legendary Cunard Building in 2002, featuring none other that an Elvis look-a-like.

05
Loaded

-

Never one to shy away from difficult topics, tenantspin hosted a discussion about gun crime following some much publicised gun-related crimes. With guest host Liam Fogerty and a diverse panel, the discussion was one of tenantspin's most emotive and topical webcasts ever.

02
Richard & Judy

-

In late 2008/early 2009, tenantspin de-camped to Tate Liverpool to set up a fully equipped interactive TV Studio where they hosted daily discussions, readings and performances from a host of guests. Over 70,000 tuned into the tenantspin live broadcasts over a six week period.

—

Futures

—

Essays by Laura Sillars & Andy Miah

—

Depending on where we are at in our lives we rewrite and rethink our individual and collective histories differently. For some of us, the difference between being twenty and being twenty-five may be very slight; for others this five years may between existing and not existing. Institutions are different from individuals, not least in that they absorb so many human hours and lives in their making and running, but they too have their own life journeys. At twenty, FACT is a mass of relational networks old and new. As in a house that has been rewired, some of the electrical links are no longer in use while others are part of the central energy network on a twenty-four-hour basis. Some power points are switched on only on special occasions and others are in frequent use. All of them are part of the fabric of the organisation, and as cultural caretakers it is part of our responsibility to make sure that the complexity of this framework is valued and understood.

As FACT reached twenty, the current team made the assessment that while some of the history of the institution could be traced through anecdote, friendships that still exist and the documentation that we have kept safe (contracts, programmes, moving image footage), there is a body of work that needs to take place before FACT hits twenty-five to understand this history in a wider context. We need to be able

to track the history of the organisation through the developments in the multiple fields in which it has operated, from Liverpool as a city to the international media art world within which FACT has played a key role. We need to develop a better understanding of the organisation's role inside an ecology of cultural production both of art and of art institutions from the 1980s onwards, as well as in relation to the sporadic history of archiving and collecting media art work. The word 'need' is used here advisedly: in order to understand where you are going it is important to understand where you have come from and how you got there.

In order to start this work, FACT has developed a research programme under the umbrella of the FACT Atelier. This includes a range of partnerships with higher education institutions, arts organisations and funders. Over the next five years we will host a series of artist-led research projects, alongside PhDs and ongoing action-research led by the FACT team, FACT's Research Fellows and Associates. With our twentieth anniversary in mind, FACT is working in partnership with the University of Liverpool and LJMU to set up a series of collaborative PhD student-ships researching a set of questions around FACT's institutional history, the history and the future of new media. By 2014, when FACT reaches

twenty-five years old, the institution will be better able to present and understand the history of art in which it has played a key role.

The proposed programme seeks to produce a series of interlinked critical case study-based accounts of the role of FACT, the artistic and local communities of Liverpool and the development of new media art in the UK in an international context. Divided into three areas of focus – past, present and future – this programme begins by charting FACT's history of production of art and 'incubation' of artists over the last twenty years within a growing field of contemporary practice and investigating the challenges and opportunities that face artists of the future as technologies become ubiquitous and ever more complex. This leads to a second study providing a historical analysis and evaluation of the development of new media arts over the past twenty years using the archives developed by partners across the UK and the wider world. This research will explore the collection strategies of major international museums, galleries and private collectors and the ways in which these media art histories are being preserved. As we approach 2014, the third piece of research will draw on the first pieces of work to consider how we should use this knowledge, what individual and institutional interventions could, and perhaps

should, be made with a view towards the future of collecting, preserving and maintaining media art histories.

At twenty, FACT feels both old and young. Twenty years of commissioning, collaborating and presenting is a real achievement, of which FACT's founders can be proud; yet twenty is also relatively youthful – a coming of age almost. Within this time frame, as can be seen from the timeline in this book, an enormous amount of social and technological change has taken place in the world. While institutionally we can trace a history, we are perhaps less able to trace trends through our work more objectively. This research process will also, we hope, stimulate a level of collective self-awareness of some of the processes, models and practices that have been used over the last twenty years as both pragmatic and idealistic strategies for making art. As new media arts have emerged in volume through the late 1980s to the early 1990s, how has FACT selected, displayed, sought to 'curate' and make sense of this production within its exhibition, collaboration, education and outreach activities? Similarly, how has the art impacted upon the organisation? How has FACT as an organisation itself been transformed in its activities, identity and sense of purpose through its engagement with new media arts and their antecedents (such as film and video)? With a set of parallel histories across a range of areas of

« At twenty, we ar
lot of questions.
should have a fe
but undoubtedly
even more quest

able to ask a
twenty-five we
more answers;
e will also have
ns. »

work in arts, culture and society, how has FACT reviewed and reconstructed its vision and mission? What range of factors have influenced and shaped this transformation in FACT's current activities and definition of its purpose? Without delving into the imprecise art of futurology, what forms of social and cultural change can we prepare for, and how can this impact upon the decisions we make today (from what we keep, and how we keep it, to how we work with artists and audiences as we move forwards)? Crucially, we want to get to a place where we are exploring not only how organisations such as FACT should respond to developments but also how they should lead them.

The relationships between individuals, culture and society have mutated since the onset of post-industrial, or postmodern, conditions. We know that technologies alter the ways in which we think about the world, and media art has often positioned itself in opposition to a market economy of technology-driven obsolescence. As this environment shifts and develops, what are the consequences for media art practice? These developments seem to lead to an arguably freer and yet less private society. How should artists navigate these increasingly contested systems of web-based environments. How can artists operate in an environment in which technologies – e.g. biotechnology – are becoming increasingly specialised and in which they are developed within highly commercialised or militarised environments? As artists begin to use materials and technologies for which there is little developed legal or ethical framework in place, what is the role of the art centre as a policy-maker, or, more to the point, a policy provocateur? Does the use of these technologies imply an ethical complicity? FACT works as a research hub and supports informal networks that tie an ecology of artists and curators to the institution. What are we learning from these networks about the values and roles of a twenty-first-century art agency?

Innovative, engaging and collaborative, the history of FACT is the history of a complex web of supportive creative relationships. The festival element of FACT's output concluded in 2000 as the organisation – housed at this point in the Bluecoat arts centre – focused on building the first ground- up capital development in Liverpool for 60 years as part of a millennium regeneration push in the city. At the same time Liverpool Biennial took up the challenge of producing the UK's only visual arts biennial. Some of FACT's earliest communities of interest still exist (with some individuals aged 85 and above); as its earliest artist contributors reach the end of their careers, this is an important moment to consider the history of the organisation.

At twenty, we are able to ask a lot of questions. By twenty-five we should have a few more answers; but undoubtedly we will also have even more questions.

In the summer of 2006, I moved from Glasgow to a flat in Toxteth, Liverpool, which did not have internet access. At the time, social media was quickly becoming popular, I was blogging regularly and FACT's wireless internet access was free. It still is. As a result, my time in Liverpool began as a client of FACT, one of its many nomadic notebook-bearing cafégoers. We sat in the corner, by the window – ideally with a plug socket within reach – looking out into the atrium. This seems as good a starting point as any to explain part of what FACT means to its community or to those who pass through Liverpool. It also explains why FACT is necessary and what it might accomplish in the future, which is what I want to consider in this concluding essay.

Even in 2009, after half a decade of free public wireless capability, the United Kingdom, along with many other developed countries, still expects to charge the public for internet access. Yet free wireless internet access should be regarded as a public good in the Twenty-First Century, a public space even, like a park or a bridleway. Internet access is something we should be able to take for granted everywhere we go, without having to pay a fee. Indeed, over the last five years, cities around the world have begun to treat wireless internet

access in this way, making it free to all, but in the UK the realisation of this notion remains elusive.

In London, Mayor Boris Johnson expressed the view that London should have wifi throughout the city by the 2012 Olympic Games. These are valuable sentiments, but the crucial word – *free* – is not particularly evident in the campaign. Even the sole restaurant to have free wireless at Euston station has now been swept into another fee-paying ISP circuit. Moreover, internet dongles are now appearing in the high street, each one charging us far too much for far too little. The aspirations of digital culture have yet to be met, yet so much more could be freely available already. Audio should be free. Video should be free. FACT understands this and its cafégoers are loyal because of its persistence in delivering open access.

A vigilance around new media culture – advocating its promise and bemoaning its limitations – permeates FACT's work. Indeed, my three years in Liverpool have shown me that these dual discourses of promise and scepticism pervade many spheres of work in the city. I think this is why the history of FACT is such a contested space. FACT is clearly an organisation that arose from collaboration, sharing and opportunism on behalf of upcoming cultural leaders in the city at the time. In 2008, the Chair

of the European Capital of Culture, Phil Redmond, described the year as something like a Scouse wedding, an analogy that pervaded the year's media. He described how the process began with disagreements over how best to deliver an exciting cultural programme, but when the time came, everyone enjoyed themselves and it all went very well. This analogy might work for explaining queries into FACT's origins – whether it was indeed a 'Liverpool invention', as Lewis Biggs interrogates here. Biggs' 'regionalism' narrative of FACT's birth, which demonstrates how it took place amidst considerable political unrest within the UK, reveals even further how FACT might best be thought of as a Liverpool artwork, rather than an invention.

Liverpool's port city and slavery heritage, along with its contemporary ghettoisation, requires its institutions to make community a central part of their work, which also explains how the birth of FACT fits here. These are endearing qualities of the city and they shape my own experience of it, living now in the 1960's bohemian district, sandwiched between the Asian, African and Chinese communities, with the two cathedrals, a synagogue and a mosque all a short sprint away.

As I began to consider FACT's history, I was struck by thoughts about the immediate past, Liver-

pool's year as European Capital of Culture in 2008, which was my major reason for coming to the city. How has FACT's past contributed to Liverpool's contemporary art and cultural environment? During 2008, FACT consolidated its past by entering into the Liverpool Arts Regeneration Consortium (LARC) collaboration, itself a product of necessity in times of difficulty leading up to 2008. As one of the eight major cultural institutions in the city, FACT inevitably became – for some – more of an institution than a grassroots organisation, though with the arrival of its newly appointed CEO Mike Stubbs it remains artist-led. As such, 2008 consolidated FACT's role as a key venue for major cultural events in the city, while it also became an organisation that could have the Secretary of State for Culture wandering around its atrium just as easily as it might have the prizewinner of Ars Electronica. This speaks volumes about how FACT has adapted over twenty years, defining its trajectory while also stopping at each juncture to consider its choices.

For any successful organisation, a rise in status implies a danger of losing the intimate connection with core membership, due to the imposition of other obligations that emerge from major funding opportunities. Concern about such prospective loss, but more broadly about the change that surrounded

« FACT is beginning to play a more central role in shaping government policy, particularly on digital culture, and, in the future, this will surely be a stronger component of its work. »

Liverpool during 2008, seemed integral to all of FACT's works throughout the year. In 2008, I was fortunate enough to be part of FACT's conversations on its future. I recall one of the first artists' workshops in the *Human Futures* programme, which brought together such artists as Stelarc and Orlan, though not just to talk about bioethics and bioart. Instead, a significant part of our debates focused more on what arts organisations – and artists – should be doing at the beginning of the Twenty-First Century.[1]

Present

In 2009, the labour of these discussions bore fruit in the form of *Climate for Change*, FACT's first exhibition for its *UNsustainable* year. Inviting local communities into the gallery space, FACT placed its creative vision in their hands, opening up a dialogue about its future and providing a space in which the concerns of its peers could be heard. As an exhibition, its major artworks were thus the people who inhabited the space, which brought new communities together and welcomed new publics into their fold. Yet this was not just an exercise in public engagement or outreach. Rather, the exhibition's thematic focus on 'economics and sustainability' issues, as Mike Stubbs explains in this volume, also demonstrates FACT's

desire to interrogate the conditions of contemporary mediatised and politicised debates about climate change, by linking them with broader issues of social and political unsustainability.

Throughout *Climate for Change*, I wondered what would be next for FACT. After all, what more can an arts organisation do to support local communities than to hand over the gallery space for a period? Perhaps handing over the space permanently would be a more powerful gesture, but FACT's communities are numerous, its audiences multiple – cinema goers, art lovers, café visitors, bookshop browsers, bar quiz buffs, conference delegates, and so on (and even within each of these categories there is substantial variance). This composite audience is not unique to FACT. Actually, it may describe the conditions of being a Twenty-First-Century arts and cultural institution, the kind of multipurpose media space that is arising in venues such as King's Place London, which opened in 2008. This is not to say that art is merely one of the things that FACT does. Rather, art – along with the two senses of creative technology mentioned by Sean Cubitt in this volume – pervades each of these other works. This is beautifully demonstrated in Bernie Lubell's bicycle-powered collaborative artworks that take FACT towards its next major intervention, a festival of new cinema and digital culture

called *Abandon Normal Devices* or *AND* with aspirations of Olympic proportions.

Like FACT's birth, *AND* is also the product of collaboration in the arts and new media sector, driven by FACT in Liverpool, folly in Lancaster, and Cornerhouse in Manchester. Moreover, it arises partly from funds related to the Legacy Trust's UK investment in *WE PLAY*, the cultural legacy programme of England's Northwest for the London 2012 Olympic and Paralympic Games. The producers of the festival are working to ensure the investment extends well beyond 2012, hoping *AND* will become a key item in the national calendar. Here again we see at work the duality of FACT's identity – new cinema and digital culture – as an organisation that champions new work and invites local communities to scrutinise it, as it does with its long-standing online community broadcast platform tenantspin.

Abandon Normal Devices also lends itself to multiple, rich interpretations. It is an inquiry into the consequences of normalising processes – both physical and social – while also functioning as a conjunction, inviting the participants to invent associations: body *AND* economy, art *AND* health, sport *AND* culture. This cross-fertilisation of ideas offers a much needed opportunity to critically interrogate the Olympic period

within the United Kingdom, as London prepares to host the Games for the third time (the first city to have had this opportunity in the era of the modern Olympics). After all, the idea of normality and our critique of it is implicit in the Olympic philosophy, which pivots on notions of individualism, nationhood, excellence and perfection. Indeed, this is prominent when observing how an athlete's physique is being altered by technology, especially within disability sport. Very soon, it is likely that prosthetic devices will overtake the capabilities of their biological counterparts, thus transforming what it means to be the fastest or strongest person in the world.[2] Indeed, in 2012 we might even see the first 100m sprint of the Olympics won by an athlete with prosthetic legs, signalling the beginning of the end of able-bodiedness as a privileged condition.[3]

The Olympic Movement is also wrestling with its future, as citizen journalists threaten the financial base of the Games by syndicating Olympic intellectual property and as the youth of the world – the Olympic Movement's core community – shift their attention to video games and alternative sports, which have quite different values to their traditional counterparts. Already, there are major competitions around digital gaming with the first professional gamer, Fatal1ty, occupying centre stage. Cybersports are a part of this

and many of the largest sports rely on digital technologies to constitute the training environment, taking sports into the digital arena. These circumstances locate FACT within another new set of relationships. Through *AND*, it will play a major role in constituting the legacy of the London 2012 Olympics for the Northwest of England. This work will create new associations for the Olympics, by bringing together new media art with research into body economies (biotechnology, synthetic biology, AI, energy, etc.). Yet, perhaps also for this reason, FACT is in a position to critically interrogate the meaning of the Olympics in contemporary culture. These discursive processes can have far-reaching implications and might call for the abandonment of traditional sports practices and the reinterpretation of the Olympics for a new generation, whereby arts and culture become as central to the Olympics as they were in the early Twentieth Century. After all, the Olympic infrastructure should be construed first as a social movement and second as a sports event. Artists can help here, and their design of new technological encounters is demonstrative of this. Indeed, such design is constitutive of the Olympic enterprise, which has always pushed the boundaries of technological excellence, from taking an Olympic torch underwater at the Sydney games in 2000 to using slow-motion for the first time in broadcasting.

Future

FACT's birth coincided with that of the Internet, which Tim Berners-Lee conceived on 12 November 1990. One might even say that FACT's birth occurred at the moment of the Internet's conception. As the Internet reached maturity around the mid-2000's, the Web 2.0 era transformed it into a prolific offspring machine, with new nodes arising daily and data-based societies emerging in which content production and creativity reached pandemic levels. The next twenty years of both FACT and the internet will be very different from their first twenty, but it is clear that they will be intimately connected. We already see a glimpse of their promise in Mike Stubbs' appeal in this volume to establish the Collective Intelligence Agency (CIA), which urges us towards better-networked intelligence, rather than just better-networked stupidity. Information now moves in different ways, both offline and online. Google is beginning to look like an outdated model of information distribution, as new modes of semantic or real-time searching arise through such platforms as Twitter Search.

The implications of this are profound and require organisations to understand that they are no longer the sole proprietors of their intellectual property, which includes their public relations and marketing. Consider the fake Twitter hashtag that was used around the South by South West (SXSW) festival in 2009, created by people who did not have access to the festival.[4] The prominence of this ambush medium allowed the fringe community to create their own alternative experience. Unlike URLs, nobody owns hashtags and, by implication, nobody can restrict their use (yet). Coming to terms with the reality of distributed IP will be a central part of allowing an organisation to move from a Microsoft model to an open source model. The rise of Web 2.0 platforms such as Facebook and Flickr demonstrate this, as communities take ownership of their institutions.

Understanding how best to deal with these challenges requires a restatement of what FACT does. FACT is not driven by technology, but by the desire to make technology 'invisible'. It is an organisation that endeavours to put people together and provide them with the means to realise the potential of new technologies. Such work also involves subverting the parameters of new technology, as demonstrated by Hans-Christoph Steiner's iPod hacking session, which took place during his recent FACT residency as part of *Climate for Change*. These aspirations to democratise technology speak to both enduring and emerging dimensions of our post-human future. Around the world today research programmes are exploring the link between biology and computing, which also describes the intersection of new media art and bioart, a key focus of FACT's recent work. The prospect of Artificial General Intelligence (AGI) and the *singularity* have pervaded philosophical inquiries into cognition and neuroscience over the last decade.[5]

It is, thus, highly appropriate that we consider, finally, what FACT might be doing precisely twenty years from now in the year 2029. According to Wikipedia – yes, it is also an encyclopaedia for the future – this will be the year when machine intelligence passes the Turing Test and will have reached the equivalent of one human brain.[6] What we cannot know yet is how this will come about. How much of this achievement will be brought about by collaboration between artists and scientists within mixed media laboratories such as FACT?

Our consideration of FACT's future must also take into account Liverpool's future. What will Liverpool look like in 2029? FACT's first twenty years began during a recession. Its next twenty years begin in similar times and it is notable that, as Liverpool's renaissance takes shape and it finds a way of emerging from twenty years of economic neglect, the largest global recession of the last ninety years hits the world. Nevertheless, Liverpool is a much

more competitive place now for the visual arts. With new arts and cultural centres such as the Novas Contemporary Urban Centre, A-Foundation, an expanded Bluecoat centre and ever-growing independent galleries, Liverpool's artistic renaissance is clearly underway.

Despite its name, the truth about what FACT was, is or will become remains elusive. It is still an artist-led organisation, but its art is not empty of responsibility, since it is also an institution that needs to have concern for such things as accessibility. There are additional opportunities that arise from this. FACT is beginning to play a more central role in shaping government policy, particularly on digital culture, and, in the future, this will surely be a stronger component of its work. It is also building a research capacity and a growing empirical base to align with this role. In so doing, it is also establishing a research atelier – not a laboratory – proposing new models of undertaking practice-based research and complementing this with more traditional forms. This work will help to reset the boundaries of research in the twenty-first century, back towards a stronger emphasis on arts-based knowledge. As a city, Liverpool is also well placed to support this process, having built legacy research into its year as European Capital of Culture – the first city to ringfence such funds around this programme.[7] Indeed,

it is perhaps one of the best-placed cities within the UK and possibly Europe to build a model for cultural regeneration, and it is apparent that London has similar aspirations for evaluating the impact of the London 2012 period.

From my position as a FACT Fellow, I occupy a space somewhere between the organisation and my starting point in Liverpool, as its client. To this end, I perceive a tremendous self-induced pressure on FACT's programme team to achieve broad, dramatic societal and creative impact through its work, expectations that are praiseworthy and highly ambitious. If they get even eighty per cent of the way towards those goals, they will have excelled themselves. I conclude with a pitch for what I would like to see next: a curatorial team established for an exhibition in 2029 or, better yet, 2049. I wonder if that has been done before.

1: See J. Hauser, ed., *sk-interfaces*, (2008). Liverpool University Press, Liverpool.

2: For example Aimee Mullins presence in fashion, film and sport has become iconic of the new enabled paralympian.

3: Oscar Pistorius fought for his legal entitlement to compete in Beijing 2008 and has competed alongside so called able-bodied athletes. It is likely that his trajectory towards London 2012 will be even stronger.

4: The hashtag attracted such established media as LA Times *Latest Twitter + SXSW Trend #Fakexsxw*, (2009). latimesblogs.latimes .com/technology/2009/03/ latest-twitte-1.html

5: We can also consider the relationship between biology and computing as prominent, competing discourses. See Janicaud, D. (Ed.) *On the Human Condition*, (2005). Routledge Press, London and New York.

6: This is based on Ray Kurzweil's prediction, which derives partly from Moore's Law. See Kurzweil, R. *The Singularity is Near: When Humans Transcend Biology*. (2005). Viking Press, New York.

7: Liverpool City Council and Arts and Humanities Research Council programme *Impact08* draws on many local research collaborations and encompasses the *City in Film* project at Liverpool University and any number of community research projects that FACT and other organisations have implemented.

Appendix

—

FACT Exhibitions Group Artist Names:

—

2003

Vinyl Video, Gebhard Sengmüller, Penny Hoberman & Julia Scher

Kingdom of Piracy, KOP (Armin Medosch, Shu-Lea Cheang, Yukiko Shikata), Felix Miller, Martin Stiksel, Michael Breidenbrueker, Thomas Willomitzer, Mongrel, Graham Harwood, radioqualia (Honor Harger & Adam Hyde)

Round World Flat Map, Amit Pitaru, Simon Biggs, Ted Nelson & MC Paul Barman

Total Information Awareness, Guerilla News Network, Indymedia Liverpool, Indymedia Argentina & Samizdata.net

Dive Launch, Armin Medosch, Yukiko Shikata & Shu Lea Cheang

Nothing Special, Ant Farm, T.R.Uthco, David Blandy, Mel Chin, Gala Committee, Christoph Draeger, Reynold Reynolds, Gary Breslin, Gorilla Tapes, Leon Grodski, David Hall, Christian Jankowski, Anne Magnusson, Tim Rubnitz, Dorit Margreiter, Chris Morris, Armando Iannucci, Antonio Muntadas, Nam June Paik, Ilene Segalove, Brian Springer & William Wegman

typ0 writing with style, Xu Bing, Olaf Nicolai & Claude Closky

2004

At the Still Point of the Turning World, Yang Zhen-zhong, Jun Nguyen-Hatsushiba, Stephen Dean & Juan-Pedro Fabra Guemberena

Computing 101B, JODI is Joan Heemskerk & Dirk Paesmans

2005

Critic's Choice, Fiona Banner, Xu Bing, Joonho Jeon, Marina Abramovic, Ulay, Yael Bartana, Richard Billingham, Mohamed Camara, Alan Currell, Jake & Dinos Chapman, Tracey Emin, Mike Kelley, Paul McCarthy, Sarah Lucas, Mike Marshall, Bruce Nauman, Yoko Ono, Dennis Oppenheim, Carolee Schneemann, Richard Serra, Mark Wallinger, William Wegman, Julian Schnabel, Derek Jarman, Peter Watkins, Julie Taymor, Henri-Georges Clouzot, John Maybury, Vincente Minnelli, Ed Harris, Alexander Korda, James Ivory, Carol Reed, Philip Haas, Paul Cox & Sarah Morris *The Agony & The Ecstasy*, Chen

Chieh-Jen, Sigalit Landau, Marzia Migliora & Elisa Sighicelli *Rock the Future*, ressentiment, exonemo (Kensuke Sembo & Yae Akaiwa) & Ryota Kuwakubo

2006

Human Computer Interaction (HCI), Simon Poulter, Josh Nimoy & Caen Botto

Under the Radar, Van Sowerwine, Isobel Knowles, Liam Fennessy, Craig Walsh, Narinda Reeders, David MacLeod, Daniel Crooks, Stephen Barras, Linda Davy, Kerry Richens, Shaun Gladwell, Alex Davies, David Haines, Joyce Hinterding, ENESS (Steven Mieszelewicz, Nimrod Weis, Asaf Weis) & Tan Teck Weng

Liverpool Biennial 2006, Matthew Buckingham, Shilpa Gupta, Apichatpong Weerasethakul, Kelly Mark, Anu Pennanen & Sissel Tolaas

Jungle Jam, Chelpa Ferro is Barrão Zerbini, Luiz Zerbini & Sergio Mekler

The Black Moss, juneau/projects/ is Phil Duckworth & Ben Sadler

2007

The Ghosts of Songs, Black Audio Film Collective is John Akomfrah, Lina Gopaul, Avril Johnson, Reece Auguiste, Trevor Mathison, Edward George, Claire Johnson & David Lawson

Bold Street Project, tenantspin, Michelle Wren & Katie Lips

Re: [Video Positive] Archiving Video Positively, David Hall, Judith Goddard, Lynn Hershman Leeson, Lei Cox, Keith Piper, Imogen Stidworthy, Michael Curran, Jon Thomson & Alison Craighead

2008

sk-interfaces, ORLAN, Stelarc, Julia Reodica, Art Oriente Objet (Marion Laval Jeantet, Benoit Mangin), The Tissue Culture & Art Project (Oron Catts, Ionat Zurr), Jun Takita, Zbigniew Oksiuta, Maurice Benayoun, Critical Art Ensemble (Steve Kurtz & Lucia Sommer), The Office of Experiments (Neal White), Zane Berzina, Olivier Goulet, Jill Scott & Wim Delvoye

Liverpool Biennial 2008, Ulf Langheinrich, Terrence Handscomb, Michael Bell-Smith, Stella Brennan, U-Ram Choe, Lisa Reihana & Muchen

DING»DONG, The Fragmented Orchestra (John Matthias, Jane Grant, Nick Ryan), Andy McCluskey, Peter Saville, Hambi Haralambous,

Julian Oliver, Pix, Tetsuaki Baba, The Owl Project & Steve Symons, Ray Lee

Climate for Change, Eyebeam Art & Technology Center, Stefan Szczelkun, Anthony Iles, The Gaia Project, L@tE, The Kazimier, Beccy Williams, Kai-Oi Jay Yung, tenantspin, Joshua Tennant, Melanie Gilligan, AIDS 3D (Nik Kosmas, Daniel Keller), N55, Christopher Robbins, Matey Odonkor, John Ewing and all of the groups and individuals who contributed

Additional Image Credit Information:

—

119
Baltimore Series
> page 057
Image still courtesy of the artist and Victoria Miro Gallery, London

120
Line Describing a Cone
> page 060
16mm film
Image courtesy of the artist

Installation view at the Whitney Museum of American Art exhibition *Into the Light: the Projected Image in American Art 1964-1977* (2002). Photograph by Hank Graber. Courtesy Sean Kelly Gallery, New York, Galerie Thomas Zander, Cologne, Galerie Martine Aboucaya, Paris

121
Liverpool Film Night Awards
> page 059
Photograph by Ant Clausen

123
Installation image of Zaha Hadid, Architecture and Design exhibition
> page 061
Image courtesy of The Design Museum and Luke Hayes

131
Celebrations for Breaking Routine
> page 067
Image still courtesy the artist

134
Soft Rains
> pages 072-073
Image still courtesy of the artist

144/145/146
Cave Trilogy
> pages 082-083
Image still courtesy of the artist

152
Retrieval Room
> page 088
Image still courtesy of the artist

210
Skate Films
> page 109
Photograph by Stephen King

227
Faith
> pages 124-125
Image still courtesy of Kick the Machine Films

260
The Fireworks
> pages 150-151
Image still courtesy of the artists

289/290
Sustainable Fashion Show
> page 180
Photographs by Anton Rodriguez

294
Flying Flappers
> page 182
Photograph by Lucie Davies

295
A Theory of Entanglement
> page 183
Photograph by Lucie Davies

299
Primitive
> page 187
Image still courtesy of Kick the Machine Films

Commissions and Co-commissions

—

Algonquin Park, September 2002
> pages 040-041
Commissioned by FACT and Liverpool Biennial. Presented at Tate Liverpool

Baltimore
> pages 054-057
Co-commissioned by the Contemporary Museum,

Baltimore, the Walters Art Museum and FACT, in association with The Great Blacks in Wax Museum, Baltimore and Eyebeam Atelier, New York. The project has been funded by Artadia, FACT, Toby Lewis, the National Endowment for the Arts, Peter Norton Family Foundation and Linda Pace. Presented in association with the Victoria Miro Gallery

Liverpool Film Night Awards
> page 059
Liverpool Film Night Awards ceremony, sponsored by Atlantic Chambers, 2008

BURN
> page 063
Commissioned by FACT and the VirtualCentreMedia .net, with the support of the Culture 2000 programme

Culture Castles
> page 064
Funded by LHAT, Ove Arup Foundation and Speke Garston Education Action Zone

Celebrations for Breaking Routine
> pages 066-067
FACT Collaboration Programme Commission. The project was realised in partnership with Venus Working Creatively with Young Women, Bootle, Rainford Silver Brass Band and The Merseyside Majorettes, and was funded by Arts Council England, BT North West and Arts & Business North West

Soft Rains
> pages 072-073
Soft Rains was commissioned by FACT in association with Creative Capital, New York

Retrieval Room
> page 088
Commissioned by FACT and Liverpool Biennial *International 04*

Close to the Sea
> page 089
Commissioned by FACT and Liverpool Biennial *International 04*

Rear Projection (Golden Rod)
> pages 114-115
Rear Projection (Golden Rod) and Rear Projection (Molly Parker) commissioned by FACT, British Film Institute (BFI) and Centro Andaluz de Arte Contemporáneo. Funded by Film London through the London Artists' Film and Video Awards and Arts Council England

Obscure Moorings
> pages 120-121
Commissioned by FACT and Liverpool Biennial *International 06*

Untitled
> pages 122-123
Commissioned by FACT and Liverpool Biennial *International 06*

Faith
> pages 124-125
Commissioned by FACT and Liverpool Biennial *International 06*

Kaff Mariam and Uña de Gato
> pages 140
Commissioned by FACT in association with Film London Artists' Moving Image Network and Arts Council England

The Carriers' Prayer
> pages 148-149
Commissioned by Film and Video Umbrella. Supported by Arts Council England

LAND
> page 170
Commissioned by FACT and Liverpool Biennial *International 08*

Opertus Lunula
> page 171
Commissioned by FACT and Liverpool Biennial *International 08*

The Making of W.I.L.D.
> page 176
FACT Young People's commission. Funded by First Light Movies

A Theory of Entanglement
> pages 182-185
Commissioned by FACT in partnership with V2_ Institute for the Unstable Media, Rotterdam

Primitive
> page 187
Commissioned by FACT and Haus der Kunst, Munich with Animate Projects, London. Produced by Illuminations Films and Kick the Machine

Additional Credit Information:
–

> page 111
Referenced from *The Wall Street Journal*, March 12, 2005

> page 113
Everything Fell Together was organised by the Des Moines Art Center, Des Moines, Iowa, USA.

> page 129
Instincts are misleading (you shouldn't think what you're feeling) (2006) was commisioned by FACT. *The Black Moss* exhibition was organised by Ikon Gallery, Birmingham.

> page 134
Engage's *enquire* programme is funded jointly by the Department of Culture, Media and Sport, the Department for Children, Schools and Families as part of the Strategic Commissioning Programme for Museum and Gallery Education, and the Foyle Foundation. The *enquire* programme is managed by engage and has been developed in association with Arts Council England.

Geographic Spread
of Artists who have
exhibited at FACT
—
2003 – Present

-01-

-22-

-02-

17-

16-

-23-

09-

12-

-19-

-14--15-

-18-

-10----13---20-

-21-24-

-08-

14-

-25-

-07-

-06-

-01-

-03-

-05-

-04-

01
USA (22.84%)
-
West Virginia
California
Indiana
New York
New Jersey
Texas
Massachusetts
Pennsylvania
Ohio
Tennessee
Alaska
Illinois

02
Canada (1.29%)
-
Ontario

03
Brazil (1.72%)
-
Rio De Janeiro
Sao Paulo

04
Argentina (0.86%)
-
Buenos Aires

05
Uruguay (0.43%)
-
Montevideo

06
Mali (0.43%)
-
Bamako

07
Algeria (0.43%)
-
Mascara

08
Spain (0.43%)
-
Barcelona

09
UK (30.60%)
-
London
Stoke on Trent
Wirral
Liverpool
Birmingham
Middlesex
Bedfordshire
Plymouth
Kettering
Barnsley
Manchester
Blackpool
Southend on Sea
Surrey
Glasgow
Belfast

10
France (3.44%)
-
Paris
Saint Etienne
Lyon

11
Belgium (1.72%)
-
Ghent
Brussels
Wervic

12
Netherlands (0.43%)
-
Kaatsheuvel

13
Switzerland (1.29%)
-
Saint Gallen
Zurich

14
Italy (0.86%)
-
Turin
Alessandria

15
Germany (4.31%)
-
Berlin
Solingen
Wolfen
Gottingen

16
Denmark (0.43%)
-
Copenhagen

17
Norway (0.43%)
-
Stavanger

18
Hungary (0.43%)
-
Túrkeve

19
Poland (0.86%)
-
Warsaw
Mulawicze

20
Austria (1.29%)
-
Graz
Vienna

21
Serbia (0.43%)
-
Belgrade

22
Finland (1.29%)
-
Kirkkonummi
Helsinki

23
Latvia (0.43%)
-
Riga

24
Bulgaria (0.43%)
-
Sofia

25
Israel (1.29%)
Jerusalem
Tel aviv
Afula

26
India (0.43%)
-
Mumbai

27
Russia (0.43%)
-
St Petersburg

28
China (2.15%)
-
Beijing
Chongqing
Shanghai

29
Thailand (0.43%)
-
Bangkok

30
Taiwan (1.29%)
-
Taipei

31
Korea (1.29%)
-
Busan
Seoul

32
Japan (3.87%)
-
Tokyo

33
Australia (9.48%)
-
Sydney
Brisbane
Melbourne
Blue Mountains
Canberra
Adelaide
Perth
Edinburgh

34
New Zealand (2.15%)
-
Aukland

· Represents artists

17,074

Credits and Acknowledgements

—

FACT:

Editors
-
Angelica Cipullo
Karen Newman

Design Manager
-
Alison Ferguson

Content Manager
-
Jen Chapman

Photography
(unless otherwise credited)
-
Brian Slater

Publication Intern
-
Michael Kelly

Proofing
-
Susie Stubbs
Leon Seth

Smiling Wolf:

Creative Director
-
Simon Rhodes

Book Designer
-
Leon Russell

3D / 2D Illustration
-
Jason Wood

Book Authors
-
Lewis Biggs
Sarah Cook
Sean Cubitt
Andy Miah
Laura Sillars
Mike Stubbs

Book Contributors
-
In addition to the list below, there
are countless individuals who helped
contribute to this publication by
providing insight, inspiration and
research, all of whom we are
indebted to:

Eddie Berg
Sir Drummond Bone
Simon Bradshaw
Heather Corcoran
Kathryn Dempsey
Steve Dietz
Patrick Fox
Ceri Hand
Roger McKinley
Marie-Anne McQuay
Nick Lawrenson
Sally Olding
Susie Stubbs
Kenn Taylor
Helen Tookey
Austin-Smith:Lord

FACT could not exist without the
support of its funders. There have
been so many throughout the years,
all contributing to FACT's work in
their own unique way. We would like
to thank all funders, past and present
for their support. In addition to the
list below of current annual funders,
there have been numerous financial
contributors over the past 20 years,
all of whom were critical to the
work FACT has created.

2009 Annual FACT Funders:

Liverpool City Council
Arts Council England
Arena Housing Group
Biffaward
British Council
Cultural Leadership Programme
DCMS
FACT Fifty
First Light Movies
Liverpool Primary Care Trust
Northwest Vision and Media
Paul Hamlyn
Pro Helvetia
The Foyle Foundation
The Mersey Partnership
Youth Opportunity Fund
UK Film Council
Wellcome Trust

2009 Abandon Normal
Devices Funders:

Arts Council England
Liverpool City Council
Northwest Vision and Media
UK Film Council
UK Legacy Trust / We Play

©FACT, the authors and artists
as credited

Notes on Authors

—

Lewis Biggs

—

Lewis Biggs, Director of Liverpool Biennial since 2000, has developed the Biennial as a commissioning agency working at the intersection of the local and the international. The company works with a range of partners in taking art beyond traditional show-cases, and helping create a better ecology for artists. As Director of Tate Liverpool 1990 to 2000, he helped build and nurture some of the most influential contemporary art organisations in the North West of England. He was co-founder and director of *Artranspennine98* (with Robert Hopper), and a Director of Oriel Mostyn, Llandudno. During 2008 he was Chair of both Liverpool Culture Campus – linking Liverpool's arts organisations with its universities - and the VAiL campaign (Visual Arts in Liverpool). Through his leadership, Liverpool Biennial has won a place in the public imagination, expressing a passion for the power of art in public spaces shared by artists and audiences in the Northwest.

Sarah Cook

—

Sarah Cook, co-editor of CRUMB (the *Curatorial Resource for Upstart Media Bliss*: www.crumbweb. org) and research fellow at the University of Sunderland, has curated exhibitions and commis-sioned new work for *AV Festival* (North East England), Eyebeam (New York), BALTIC (Gateshead), Edith Russ Haus (Oldenberg, Germany), the New Media Institute and Walter Phillips Gallery (Banff, Canada), the Bellevue Art Museum (Seattle), the Walker Art Center (Minneapolis), the Reg Vardy Gallery (Sunderland), and the National Gallery of Canada (Ottawa). Sarah's book about curating, co-authored with Beryl Graham, will be published by MIT Press in 2009. She has published widely on curating new media art and recurring themes in new media artworks such as databases, simulation, re-enactment, visualisation and mapping.

Sean Cubitt

—

Sean Cubitt is Director of the Program in Media and Communications at the University of Melbourne and Honorary Professor of the University of Dundee. His publications include *Timeshift: On Video Culture*, *Videography: Video Media as Art and Culture*, *Digital Aesthetics*, *Simulation and Social Theory*, *The Cinema Effect and EcoMedia*. He is the series editor for Leonardo Books at MIT Press. He was on the board of FACT for ten years, five of them as Chair. His current research is on public screens and the transformation of public space; and on genealogies of digital light. He is currently co-editing *Rewind: British Artists' Video of the 70s and 80s*.

Patrick Fox

—

Patrick Fox is currently the Programme Manager of tenantspin, a joint community initiative led by Arena Housing Association and FACT. Patrick holds a BSc in Multimedia and a Masters in Cultural Leadership and has a background as a community filmmaker and activist. He is also a board member of AXIS, a UK-based organisation tasked with supporting and assisting the development of the visual arts. Patrick has commissioned leading international artists to work in collaborative settings, both in galleries and in the public realm, as well as strategically developing partnerships across various sectors including health and higher education. Patrick is currently exploring the impact of Web 2.0 principles on the cultural sector and alternative platforms on which artists can showcase works.

Roger McKinley

—

Roger McKinley currently holds the post of Digital Production Manager at FACT. He has been with the organisation since 1999. He is an award-winning artist (*The Variable-D Gallery*) and writer (*Jackson Pollock the Musical*) and is currently the editor of *Corridor8*, a new independent arts magazine whose first edition launched at Urbis in Manchester in 2009. This large-format magazine focuses on maverick artistic activity in the Transpennine region and beyond.

Andy Miah

—

Andy Miah, is Chair in Ethics and Emerging Tech-nologies in the Faculty of Business & Creative Industries at the University of the West of Scotland, Fellow of the Institute for Ethics and Emerging Technologies, USA and Fellow at FACT. He is author of *Genetically Modified Athletes* (Routledge, 2004), co-author with Emma Rich of *The Medicalization of Cyberspace* (Routledge, 2008) and editor of *Human Futures: Art in an Age of Uncertainty* (Liverpool University Press and FACT, 2008). Professor Miah's research discusses the intersections of art, ethics, technology and culture and he has published broadly in areas of emerging technologies, particularly related to human enhancement. He has published over 100 academic articles in refereed journals, books, magazines, and national media press on the subjects of cyberculture, medicine, technology, and sport. Andy regularly interviews for a range of major media companies, including the BBC (*Newsnight* and *Start the Week* with Andrew Marr), ABC (*The 7:30 Review*) and CBC (*The Hour*). He currently writes a monthly column for the *Guardian* on contemporary ethical issues in science and technology.

Karen Newman

—

Karen Newman has been Curator at FACT since 2005. With a background in supporting artists' production development she has commissioned more than 30 artworks by international artists. Recent exhibitions and new commissions include Mark Lewis, *Howlin' Wolf*; juneau/projects/ *Instincts are misleading: you shouldn't think what you're feeling*; Anna Lucas *Here and Your Here*; Al and Al, *Eternal Youth*; Bernie Lubell, *A Theory of Entanglement* and *Primitive* by Apichatpong Weerasethakul. Karen was a member of the Liverpool Biennial 2006 and 2008 curatoriums, and curator for *Human Futures*. She is currently developing *Persistence of Vision*, a group exhibition that investigates how technology has changed the role of vision, with Andreas Brøgger.

Laura Sillars

—

Laura Sillars is Programmes Director at FACT, where she has worked since 2005. She leads FACT's artistic programme, overseeing the development and delivery of exhibitions, projects and education and collaboration programmes. She developed and oversaw FACT's 2008 Human Futures Programme and 2009 UNsustainable Programme Previously Curator: Public Programmes at Tate Liverpool and an Associate Lecturer for the Open University, she holds an MA in Art History from the Courtauld Institute of Art, a PGCE in Adult and Community Education from the Institute of Education and a BA from the University of York in History and History of Art. She is Senior Research Fellow: Centre for Architecture and Visual Arts Liverpool, a current Clore Leadership Fellow and a Fellow of the RSA.

Mike Stubbs

—

Mike Stubbs has been Director of FACT since May 2007 when he was jointly appointed by LJMU as Professor of Art, Media and Curating. Previously he was Head of Exhibitions at the Australian Centre for Moving Image (ACMI), Senior Research Resident at Dundee University's School of Television Imaging, and was the Founding Director at Hull Time Based Arts (HTBA). During his career, Mike has commissioned over 250 interactive, site-specific, performative, sonic and moving image -based works and instigated award winning exhibition *White Noise* and blockbuster 20 Years of Animation, Pixar. Originally educated at the Royal College of Art and Cardiff College of Art, Mike's own internationally commissioned artwork encompasses broadcast films, video art, large-scale public projections and new media installation.

TWENTY
YEARS OF
FACT